BOAT BABY

a memoir

VICKY NGUYEN

SIMON & SCHUSTER

New York Amsterdam/Antwerp London
Toronto Sydney/Melbourne New Delhi

Simon & Schuster
1230 Avenue of the Americas
New York, NY 10020

First Simon & Schuster hardcover edition April 2025
SIMON & SCHUSTER and colophon are registered
trademarks of Simon & Schuster, LLC.

Simon & Schuster strongly believes in freedom of expression and stands against censorship in all its forms. For more information, visit BooksBelong.com.

For information about special discounts for bulk purchases, please contact Simon & Schuster Special Sales at 1-866-506-1949 or business@simonandschuster.com.

The Simon & Schuster Speakers Bureau can bring authors to your live event. For more information or to book an event, contact the Simon & Schuster Speakers Bureau at 1-866-248-3049 or visit our website at www.simonspeakers.com.

Interior design by Joy O'Meara
Manufactured in the United States of America
3 5 7 9 10 8 6 4 2

Library of Congress Cataloging-in-Publication Data
Names: Nguyen, Vicky, author.
Title: Boat baby : a memoir / Vicky Nguyen.
Description: New York : Simon & Schuster, 2025. | Includes index. |
Identifiers: LCCN 2024041694 | ISBN 9781668025567 (hardcover) | ISBN
9781668025574 (trade paperback) | ISBN 9781668025581 (ebook)
Subjects: LCSH: Nguyen, Vicky. | Television news anchors—
United States—Biography. | Journalists—United States—Biography. | Refugees—
Vietnam—Biography. | LCGFT: Autobiographies.
Classification: LCC PN4874.N47 A3 2025 |
DDC 070/.92 [B]—dc23/eng/20240930
LC record available at https://lccn.loc.gov/2024041694

ISBN 978-1-6680-2556-7
ISBN 978-1-6680-2558-1 (ebook)

Dedicated to my mother, Liên,
and my father, Huy,

for reasons that will be abundantly clear by the end of this book

Contents

Dear Reader,

I wrote this book to honor my parents, and by extension the millions of parents who make incredible sacrifices to provide the best life for their children. Our family's story, like so many others, is one of grit, resilience, community, and a "why not" attitude. The actions my parents modeled took me on a path from boat baby to network news correspondent.

We struggled to find our footing after the tumult of starting over in a new country as refugees of war. My father and I were born in the Lunar Zodiac year of the horse. We are overflowing with optimism, and our charisma has carried us out of tough situations. But horses can be selfish and careless too. My mother and husband, possessed of patience and kindness, can attest to this. They counterbalance our impulsiveness with calm and logic, filling in what's missing.

In these pages you will also find a love letter to the country that helped raise me. Nowhere else does the preservation of liberty and the pursuit of happiness appear in abundance like it does in the United States of America. Even in polarizing times, my job as a journalist enables me to travel and meet people who show me at every turn that the bedrock that makes us American is strong. People are kind, they care, and they want to live lives that matter.

In an information age dominated by algorithms and artificial intelligence primed to stoke outrage and clicks, there is an antidote to the poisonous thoughts—connecting in real life with real people. When we stop thinking of people as "others" and "they," we can find out for ourselves who lives in our neighborhood, who attends school with our kids, who we work with. One quality conversation or exchange of thoughts can trigger a butterfly effect and grow our perspectives.

I often ask myself how I, a Vietnamese refugee, landed at 30 Rockefeller Plaza in New York City, in one of the best jobs in the world, telling stories that help people live healthier, wealthier, smarter, better lives. The short answer is timing, luck, hard work, and acceptance of what I can and can't control.

At work I focus on giving you "news you can use," takeaways from every story that make you think, teach you something new, and inspire you. Here, I aim to do the same. I hope in reading my story, you'll recognize some of the challenges you've overcome, the crucible that you were forged in, the shared experience we all have on this earth as people with one life to be lived with purpose and intention.

1

Big Tears, Mountain View, CA, 2019

I was sobbing in the shower, my back turned so my husband couldn't see my face. I tried to hold in the tears, but my whole body heaved in resistance. I wasn't crying out of sadness. These were stress tears, frustration tears. I felt caged in.

I'd just come home after a six-hour flight from New York to San Francisco. I should have been celebrating. I had somehow survived two days of interviews with twenty-one people across all platforms of NBC News, a process so brutal it's nicknamed the "NBC Wheel of Death" by those who've experienced it.

I met with the legendary executive producers of *Dateline*. I interrogated the head of *NBC News Now*. The vice president of MSNBC welcomed me into his office with a high five. After the first two minutes of our conversation, he looked around the room at an imaginary audience and asked, "Why haven't we f***ing hired you already?"

I opened my arms wide and broke into a big grin. "I like the sound of that. Should I just head to the studio now?"

He probably only wanted to move the interview along since I wasn't actually applying for a job under his purview. *My* job would be the consumer correspondent with the investigative unit at NBC News:

reporting news you can use in your life. It felt amazing. I was crushing it at every meeting.

No trick questions, just round after round of chitchat with different executives as they tried to assess whether I would fit in with the smart and talented teams of producers and correspondents already at NBC News.

For every question they asked me, I asked three. I felt confident I could do the job. I'd already been a local reporter for nineteen years in Orlando, Reno, Phoenix, and the San Francisco Bay Area. I was ready to try my skills at the network level for a national audience.

What I was less sure about was my ability to live in New York City. I was skeptical of how my California-born husband and three daughters would survive on the East Coast, where you can't wear flip-flops year-round and the weather can literally kill you. I had no idea how people navigated neck-deep snow or how they decided where to live. And what about the infamous rats? Our Chihuahua, Tofu, would not like to come eye to eye with Pizza Rat no matter how famous he was.

I didn't hesitate to ask all my burning questions.

"How long does it take you to get to 30 Rock? Ah . . . You take a taxi . . . Every day?" I asked one executive.

To another, "So you walk home. And it takes forty minutes . . . And you like that?"

He assured me, "It's my time to decompress."

I pressed on. "What about in the winter, when it's snowing everywhere?"

I laughed when he said he still walked, thinking he was joking.

But he was not.

Coming from California, where people jump in a car to drive three minutes to the grocery store, I didn't get New York walking culture.

I quizzed everyone about their families. I wanted the daily rundown of how people got their children to school, which schools they attended, and what it took to get into schools in New York City.

"Your kids take the subway to school?"

"Ah, okay . . . They go in groups with friends." I nodded.

"You live in Connecticut for the taxes? But you work in New York.

Oh . . . a lot of people do that? And they just commute on the train? For ninety minutes each way?" In my head I wondered, *Does "train" mean "subway"?*

Was this what I was in for? It would be a tough sell back home. I could see myself adapting. But most people, namely my husband, do not like change. And when the change involves going from literal sunshine and poppies to concrete and skyscrapers, it doesn't scream YAY! New York sounded like hard living. *If you can make it here, you can make it anywhere* is not a slogan for the weak.

I stepped out of the building and walked toward Fifth Avenue, the one with the actual Saks Fifth Ave store and its towering windows showcasing dresses that cost a month's rent. I imagined myself as a New Yorker. *A Nu Yawka.* But that wasn't what registered most in my mind. Pursuing this role wasn't just for my family and me. I would be representing a lot of people—refugees, immigrants, and little girls who rarely saw themselves reflected in media. It felt like I'd be making the leap and taking a risk for those folks too. So few reporters and anchors at the national networks are Asian, let alone Vietnamese. In 2007, the Smithsonian Channel lauded Betty Nguyen, daughter of a Vietnamese woman and a Caucasian American soldier as "the first Vietnamese-American to anchor a national television news broadcast in the United States."

There hadn't been another since then.

Every time I saw Betty on TV, I thought, You go, Betty! So when NBC News came knocking, the sound was amplified by the significance of having someone with my background and my face featured regularly before a national audience.

What was the worst that could happen? I might fail miserably and have to leave the news business and start a *bánh mì* sandwich chain. We could go back to California. Brian would get an anesthesiologist job easily. People would always need to be sedated. And what was life without taking chances?

I felt good about my prospects of getting the job. It would take some persuading, but I was confident I could convince my family to jump into this adventure with me.

Record scratch.

When I returned from New York City to our quiet suburban neighborhood in Mountain View, California, Brian greeted me at the door, and I wheeled my carry-on into the foyer. I was on cloud nine from the adrenaline of nailing two days of interviews and loopy from lack of sleep.

"Welcome back," he said, leaning down for a kiss. "Glad to hear it went so well. I knew it would."

"Dah dah dah dah dah, I want to be a part of it, New York, New Yoooooork," I sang with my arms stretched out to the sides, resting on the shoulders of my fellow imaginary Rockettes. I gave a little prance and kick for emphasis. I was giddy. We were going to the city that never sleeps!

He laughed.

"Brian, I think we can make it work. The girls will love being New Yorkers. Maybe Renley will pick up the accent and tawk like Dustin Hoffman in *Midnight Cowboy*, 'Ey I'm walkin' heah, I'm walkin' heah.' Seriously, it's gonna be great."

"Vicky, nothing has changed," he said.

My brow furrowed. "Bri . . . it's the *Network*. Everything. Has. Changed."

"I know it's the network. We've always known it's the network. But what is the offer? We need to see what the deal looks like."

"Pfffft. The deal will be fine. Of course, the number has to be right for us to move out there."

"I knew you'd nail the interviews," Brian said, turning to haul my carry-on bag upstairs, "but nothing has changed. We have no idea what the offer will be." He was like a broken record yucking my yum.

My husband was technically correct, but it was still infuriating. His practical take on this situation was not what I needed in that moment. I wanted to celebrate and imagine this new life; he wanted numbers and details. How dare he be so practical.

Later, as the hot water steamed up the shower glass, Brian walked into the bathroom and picked up his razor. "Vick, great job. I'm so glad you feel good about the interviews." He couldn't see my puffy red eyes.

I breathed out and turned to face him. "Yeah," I said to his reflection in the mirror. I looked down and smoothed the tangles out of my hair. I thought the hard part was over. Nope.

My six-foot-six-inch-tall drink of rational water, who I've known since I was fourteen years old, the father of my three darling daughters, my best friend and my till death do us part husband was about to become the number one obstacle in my path to NBC News.

2

The Escape

Growing up, my family didn't talk about it much. It was a fact of life. My parents and I were "Boat People"—just three of the more than roughly 3 million people who left Vietnam between 1975 and 1995. It was no big deal because we survived it. We made it through. I was too young to remember the trauma, and they were too busy trying to make a life in America to dwell on the past.

In May 1979, I was an eight-month-old baby with a big bald head. My appearance was so startling that our neighbors in Sài Gòn saved grapefruit rinds to rub onto my scalp.

"It will help her grow hair," they said, encouraging my parents to carry on this home remedy to help me avoid a lifetime of baldness. But my mom and dad had more important things to worry about. It was time to launch the plan they'd been plotting since the Communist government took over four years before—our escape.

We would take my uncles, my mother's two younger brothers, Tâm Đỗ, twenty, and Quang Đỗ, fifteen, along with my dad's aunt, Nga Nguyễn, twenty-nine, who was unmarried. Everyone wanted to go, and these were the relatives my parents felt they could successfully take because they were young, healthy, and mobile.

My parents carefully prepared for the illegal voyage; the communist

regime forbade anyone to leave the country. My father made up a story about heading out of Sài Gòn to visit my mom's relatives in the Mekong Delta so neighbors wouldn't think their absence was suspicious. Everyone collected country clothes. We had to blend in seamlessly with the villagers who lived in that area near the southern tip of Vietnam. Any sign we were from the city could blow our cover, so my mother dressed in black pants and a simple, loose-fitting tunic made of thin viscose. She fitted me in worn baby clothes and a cotton diaper.

Anyone who saw us in the morning wouldn't think much of our departure, but it was an anxious trip to a riverside village in Cà Mau. We rode for eight hours on an old bus, watching the familiar cityscape turn into a blur of dense green jungle. Dust from the road filled our nostrils during the bumpy ride. By late afternoon, we reached our temporary destination. All that was left to do was wait for nightfall.

My parents had hired smugglers who would meet us at the docks in a sampan, a small rowboat. We'd glide down a river about ten miles to meet a larger boat, which would take us into the South China Sea toward Malaysia. The hope? To join a refugee city that was already teeming with thousands of people who had taken the same risk. As the sun went down, my parents cheered our good fortune. The night we chose for our escape was moonless. The darkness would make it easier to hide.

When the sampan approached, my mom wrapped me in her favorite pink towel from the American commissary where she had worked just a few years earlier, a job that felt like it was from another lifetime now that she was attempting to flee her homeland. She carried me as we silently crept toward the riverbank. *Please God, let us make it.*

The adults had left everything behind except one small bag each and what they could carry in their pockets. A relative of the captain's named Duc joined our group to make the escape. Everyone stepped carefully onto the sampan. The small boat hugged the shoreline as we headed toward the captain's fishing boat.

As we snaked through the dark water, we heard oars splashing behind us. A voice yelled, "Stop," and we were blinded by a flashlight. The smuggler grounded the sampan, and everyone got out in shin-deep water.

At first my dad thought they were robbers. It was worse. These were communist police patrolling the waters for escapees.

My mom, shaking, held me tight to her chest.

"Give us your gold," one officer demanded.

My dad and uncles handed over a few *chỉ vàng*, strands of gold, hoping to appease the men. My parents had expected that we would be robbed at some point or found by the authorities, and my family carried *chỉ vàng* as bribes.

Terrified, my great-aunt Nga held out a few pieces of her jewelry. The officer swiped them from her hand.

"Your glasses!" he barked. "Take them off."

Nga's eyes teared up as she removed her thick prescription glasses and handed them over.

"Go. Get out of here," the officer ordered.

We loaded back onto the sampan, and the officers retreated to wait for the next group of escapees. That was the first in a series of lucky moments for my family. Instead of being taken into custody and punished for trying to escape, we encountered officers who preferred bribes over enforcing the law.

We rowed for a few more miles before hitting the shore at the entrance of a path through the jungle. The journey was all on foot from that point, and it was extremely difficult to walk through the dense foliage and uneven groundcover in the dark. My parents took turns carrying me and trying to keep mosquitoes from biting my bald head. When my dad realized he could no longer see the smuggler in front of him, his heart sank.

"Where is he?" my mother frantically whispered to my father.

He scanned the darkness, but there was nothing to see. "Gone."

The man had abandoned us and disappeared. We were alone with no idea how to reach the fishing boat.

"What are we going to do now?" my mom whispered, trying to conceal her panic.

"Wait. We wait for daylight," my dad told the group. There was no other choice. We had come too far. No one was ready to give up.

Without a clue of where we were or where the captain's boat was, the adults dozed in fits and starts, taking turns as sentries on guard. As soon as dawn broke and we could see through the morning mist, Duc climbed a tall tree. From his high perch, he spotted a person walking. It was another guide who had just helped smuggle a group to the boat we were looking for.

"Anh Ba—Brother Ba—help us! Where's the boat?"

"What are you still doing here? You're late! They're leaving!" Anh Ba called back, pointing to the direction of the boat.

Duc shimmied down the tree, and we scrambled through the brush as quickly as we could toward the sound of Anh Ba's voice.

My dad carried me in one arm, using the other to push branches and leaves out of the way and cut a path toward where we thought Anh Ba had called to us. Even at dawn, it was so dense and dark, five feet felt like five yards, and no one could get a sense of direction because the jungle canopy blocked the sky. Sweaty, with arms and legs aching, out of breath in the suffocating humidity, my dad knew we were close. But would we get there before the boat pushed off?

Finally, we broke through a mass of brush to the water. There, about a hundred feet away was the boat.

My father wrapped his arms tight around me, and my family ran to the beach just as the boat was about to leave. The captain, a distant cousin of my mom, smiled and gestured for us to hurry. He had always liked my mom and hoped we would arrive in time. We were the last ones to get there. As soon as we climbed aboard, the boat's engines roared to life, and we took off into the sea.

3

Huy Nguyễn

There couldn't have been a better person to lead our little family on a daring escape from the stifling oppression of communist Vietnam than my father. Even as a young boy, Huy Nguyễn was hustling. Up with the sun, my dad would creep around his neighborhood cemetery in worn tire-soled flip-flops. He navigated the tombstones and moist soil, lifting loose stones in search of his next prizefighter.

"Gotcha," he whispered as he cupped his hands over a giant black cricket. He was careful not to damage the wiggling insect, as this guy was a sure winner. Depending on the season, hunting for crickets was dusty or muddy work. My dad sold the fighting crickets to neighborhood kids for two thousand *đồng*, the equivalent of two pennies. Children built mini boxing rings for epic battles.

Huy also invested in glass marbles and trading cards with cartoon characters and superheroes. His small body was an asset as he dug deep into garbage cans and fished out Coca-Cola and Pepsi bottle caps—envied collectors' items. He always hoped for the rare Orange Fanta cap—a true jackpot. On the way home, he spent his hard-earned money on street food. His favorite was *chè,* a sweet mung bean dessert sold by street vendors.

My dad's family was not dirt poor, but they were close. He learned

the value of money early, and he was always creative when it came to business ventures. Even when there was no money to be made, he enjoyed the art of trading. Back then, cigarettes came in colorful paper wrappers. Once people used up their smokes, they tossed the square papers. My dad collected them and traded with other kids, who folded them into triangle origami shapes they flicked at one another.

My dad was born in the northern city of Hà Nội in 1954, the year that France conceded a nine-year battle to the Việt Minh. The war's end divided the country in two. Hà Nội was the capital city of the new Democratic Republic of Vietnam, or North Vietnam.

Huy's dad, Toàn, had been in the French army. Not wanting to live under Hồ Chí Minh's communism, the family moved south to Sài Gòn—which became the capital of the new Republic of Vietnam, or South Vietnam.

My grandmother Ty took care of their seven kids: three boys and four girls. On top of that, she ran her own small business, cooking and selling breakfast foods from a cozy stall. She offered *xôi*, a mixture of boiled mung beans and rice that can be served sweet with sugar sprinkled on top or savory with broiled red pork sausage, sugared donuts, and *bánh rán*, a round sesame ball pastry with sweet mung bean paste inside.

My grandpa Toàn later got a job with the Supreme Court in South Vietnam, driving one of the justices around Sài Gòn. Toàn was always busy working. He was strict, quiet, and serious. He provided for the kids, but he kept his emotional distance.

Safety wasn't the highest priority in a family with seven kids. In fact, my dad almost died when he was twelve. He had just gotten out of a minibus with my grandma, who was pregnant and heading to the hospital. His job that day was to watch her food stall while she was at her doctor's appointment. It was early in the morning, still dark. As he crossed the street, one of those old army-style jeeps with big tires rumbled toward him. The driver was making a U-turn and didn't see my dad. The jeep's bumper knocked him down, and the massive vehicle rolled right over him. Luckily, the jeep had just enough clearance underneath for a small boy. Huy Nguyễn was in the right place at the right time—dead

center underneath the massive vehicle—to avoid being crushed under the wheels.

But he didn't escape unscathed. Something in the undercarriage of the jeep cut a nasty three-inch gash into my dad's forehead, which instantly started to bleed, leaving him woozy. The driver jumped out and helped my dad and grandma into his jeep and raced to Nguyễn Văn Học Hospital. Doctors put twenty-two stitches on the right side of my dad's forehead to seal the cut. He kept asking for numbing medicine and they kept telling him "Just a second, it's coming."

But he never got any. Because of the location of the cut, the medical staff couldn't give him any drugs. He sat still and felt every time the needle pierced his skin as the doctor tugged the stitches through. Incredibly, he didn't pass out.

When my grandpa got home and saw my dad, he yelled at him for being run over by the jeep.

Years later, in America, my dad raised me the same way, scolding me for being careless anytime I cried from falling down or getting scraped up. This is a tradition handed down from generation to generation by Vietnamese parents.

Berating the survivor for getting hurt in the first place is our language of love.

4

Army Life

After finishing high school, my dad knew his fate was sealed. The year was 1972, and Vietnam was at war. His eldest brother, Hùng, had joined Thủy Quân Lục Chiến, the Vietnamese Marines, two years before, when he was eighteen. Draft dodging was not an option. Anyone who tried to avoid joining the military was arrested. College was out of the question because my dad's family didn't have any money for tuition. A medical exemption wouldn't work either; he was healthy. Besides, my dad believed that Russia and China were using Vietnam as a testing ground for new weapons, and he wanted to fight for South Vietnam to defend freedom against the communist threat of Hồ Chí Minh.

During basic training, recruits took a math and language test so that army leaders could assign them to posts. No one had enough time to finish the entire exam. You just did your best and hoped for a good assignment. Were you a gunner, a communications specialist, a front-line soldier? Out of my father's army class of 670, 18 were selected to be medics. My dad scored high enough to be one of them. He received six more months of training, which delayed his joining the war effort. Some of his friends were killed within weeks of deployment. The fighting was brutal.

During his tour of duty, which began in May 1973, when he was

nineteen, my dad moved secretly with his regiment through the jungles and plantations surrounding Sài Gòn. His days consisted of learning what medications the soldiers needed and administering first aid. During intense firefights with the Việt Cộng—the guerrilla soldiers supporting the North—he scrambled to find and treat the wounded. He was also responsible for wrapping the bodies of the men killed.

The South Vietnamese army did not have body bags at that point in the war, nothing to place someone in and respectfully zip up. Each soldier carried a poncho made of lightweight nylon, like the kind used to make parachutes. When you were alive, you used that poncho to cover yourself at night while you slept. If you were killed, the medics wrapped you in that poncho to be carried home.

The first time my father had to wrap a soldier's body, his hands trembled, and he felt a melancholy unlike any he'd experienced before.

This is my job. Like it or not, I have to do it, he repeated in his mind to avoid thinking too much about the task.

On sticky, hot days, soldiers languished in a field of rubber trees or camped on a coffee plantation. Under the tropical sun they wondered whether they would live or die. Some days were easy, almost like being on a camping trip with friends. They listened to the radio for news and music, smoked cigarettes when they could, and even snuck into little villages to play pool. My dad knew that there were American soldiers fighting on their side, but he never saw them in the field. His unit was left on its own; there weren't enough U.S. advisers to support South Vietnamese ground soldiers.

At night he slept on the ground or in a hammock strung between the rubber trees. The troops ate rice and whatever else they could purchase from local markets to cook over a campfire. They carried on with the routine of life under the strain of war, never knowing what orders would come next. Other times, it was a fight for their lives. Suddenly the battle would come to them—mortars and rockets exploding in every direction. My dad didn't carry a weapon. As a medic he wasn't required to, and he didn't want to. He left his assigned M16 at the base near his locker.

My dad always had a sense of humor. He coped with the stress by making jokes to break the tension.

"*Có quả đạn nào với tên mình đã khắc trên vỏ đạn?*"

"I wonder if any of the rockets have our names already carved into them?"

His platoon mates laughed.

When mortars rained down and exploded all around them, my dad slowed his racing heart with a mental mantra: *It's not good to be scared. If anything's going to happen, it's going to happen. It's up to fate.*

Eventually, fate found him. During one firefight, a rocket exploded over his head. My dad was in a foxhole with another soldier. Suddenly, his back was on fire. A pearl-size piece of metal tore through his uniform and lodged just to the right of his spine. My dad went to the hospital, and the doctor said the shrapnel was embedded about an inch underneath the skin and muscle.

"See how it feels," the doctor said. "If it doesn't bother you, we're going to leave it there." It was so close to his spinal cord, the doctor thought it would be too risky to operate.

My dad had been in the army for nearly two years when Sài Gòn fell on April 30, 1975. Just like that, the war with the North was over. Hồ Chí Minh succeeded in bringing all of Vietnam under his control. The Americans were leaving, and thousands of Southern Vietnamese begged to be airlifted to safety.

My father, with a metal souvenir forever planted in his body, went home as a reluctant citizen of a new country called the Socialist Republic of Vietnam.

5

Liên Đỗ

It was always hot and humid in the small fishing village near the southernmost tip of Vietnam where my maternal grandparents were producing a lot of kids together in rapid succession.

Grandpa Đỗ Công Minh approached each birth as he did life in general. He was a practical man. He didn't bother going to the town hall office in Bạc Liêu to register each baby. That was not a good use of time or money. It was an hour-long bus ride, and even though villagers didn't have a lot to do, nobody wanted to go to Bạc Liêu unless it was absolutely necessary.

When my mom, Liên Đỗ, was born, my grandfather scribbled down the date. Then he waited a few years for a couple more kids and set off for Bạc Liêu. When he finally got to the government records office, my grandpa couldn't find the notebook where he'd written my mom's birth date. So, he just chose a date in January 1947, and that's what they recorded on her birth certificate. His best guess.

When my mom was twenty, her best friend, Tâm, did her own analysis. Tâm looked at some astrological charts and concluded that my mom's birthday is March 8, so that's when we give her presents. I think this is part of why my mother is so easygoing and unfussy. From the start, she's never been hung up on technicalities like an official birth

date. That disregard for certainty or having everything line up "the way it's supposed to" made her comfortable with the unknown.

Another reason my grandpa had a hard time remembering birth dates might have been the sheer number of children he fathered. Aside from the nine children he would have with my grandma, he was the father of three boys with his mistress. A whole *nother* family. He met the Other Woman at his general store. She sold trinkets in a small space nearby and eventually moved her wares into a section of his store.

My grandfather's mother disapproved and told her son it was wrong to carry on this way with two families. My mom's older sister, Vân, hated the Other Woman. When Vân was fourteen, she went to the woman's home, told her off, and said to stay away from her dad. Well, the Other Woman didn't take it so well. She went to my aunt Vân's middle school, found her, and beat her with an umbrella. My aunt's friends ran over and chased the woman away.

In contrast, my grandma was surprisingly progressive about the second family. The Other Woman was wise and sent fruit, meat, and special groceries from the city on a local bus that stopped near my mom's house. They were care packages for my grandpa, but the whole family benefited. My grandmother never knew the woman, but her sons often came to help out on the farm. My grandma had a big heart for kids. She loved those boys like her own, and they loved her like a second mom.

My own mom was too young to really understand that her dad had a second family. She remembers him as tall, thin, very handsome, and loving but quiet. She says he always took care of the kids and treated everyone the same.

Everyone in the village was poor. There was no plumbing or even an outhouse. When nature called, you had to walk to the river and squat on rickety wooden slats above the water. My mom despised it. Sometimes she'd have to wait, barely able to hold it, because all the spots were taken. Other times she'd be squatting right next to someone who was also pooping into the river. *So awkward.* It was a long way down and she was terrified of falling in. She always tried to do her business as quickly as possible.

My mother spent a lot of time at her grandmother's home in the coun-tryside. Her grandma was blind and everything in her small, thatched bamboo house was hung from the ceiling or hooks on the walls to protect the food from mice. Bananas, tangerines, and mangoes had to be off the ground. My mom played beneath the plump red fruit on the pomegranate trees in the front yard and listened to her grandmother praying with a string of wooden beads.

As she grew up, my mom imagined a world beyond her tiny fishing village. Her mind and heart tilted her toward adventure, and around age eighteen, she left home on her own for the big city of Sài Gòn.

6

Miss Sài Gòn

It was 1970, and Sài Gòn was the place to be. The war had been going on since 1964, creating a booming economy in the southern capital. Fashionable young Viets rode motorbikes and pedicabs in the crowded city center. Thousands of American, South Korean, Australian, and Thai troops landed at the airport with hundreds of private contractors swarming into the chaos.

American military police officers in helmets and short-sleeved uniforms patrolled the city. The war that raged in the jungles and villages sent refugees into Sài Gòn. Hungry children in worn clothes slept on cardboard and begged foreigners, "Gimme some gum...gimme money." Sometimes they'd ask for their favorite brand of cigarettes in broken English, "OK, Salem!" At night, American flares illuminated the sky.

The presence of U.S. troops in Sài Gòn transformed it into a bicultural city with a soundtrack of American rock music mixed with Viet folk songs. People had a living to make, and they weren't afraid to do it illegally. Back alleys hosted impromptu black markets where you could buy anything to forget your stress. Illicit drugs, medicine, and sex were all available with a little discretion. If you were a savvy shopper with money to spend, you could buy Levi's jeans, Johnnie Walker whiskey, Tide detergent, and Zippo lighters.

For my mom, this was the only city life she'd ever known. She didn't obsess over the war because it was out of her control. One of her favorite songs was Doris Day's "Que Sera Sera." *Whatever will be, will be. The future's not ours to see.* The lyrics perfectly captured the feeling so many had, living in a country occupied by two fighting armies.

My mom moved into a tiny studio apartment in Phú Nhuận, on the outskirts of the city, with her older sister, Vân, and her sister's husband. She took special classes to learn English and saved money to help with rent and to buy records by her favorite artists, Khánh Ly and Bạch Yến.

She dressed in beautiful *áo dài,* the classic Vietnamese woman's two-piece garment made in different colors for different occasions. Her *áo dài* were sewn from delicate, flowy material. The long tunic dresses had high collars and draped elegantly over her figure, the sides open, allowing the dress to glide over wide-leg silk pants. She also spent her wages at the seamstress shop, where she was fitted for Western-style dresses she found in the dog-eared pages of a Sears catalog.

Ironically, she hummed Louis Armstrong's "What a Wonderful World" as she walked past American tanks on her way to work. In the office, the radio broadcast American deejays spinning records by Frank Sinatra and James Brown.

In her early twenties, my mom worked for a consortium of construction companies contracted by the U.S. military. She woke before dawn and rode her Honda moped to the post office, where she parked it alongside dozens of other multicolored scooters. From there, she rode a bus for an hour to get to Long Bình, where the company stored all kinds of military jeeps and trucks. Her job was to inspect them for dents and dings and detail any issues in a report. She practiced her English by carefully writing down the damages.

She also honed her English by speaking with American soldiers at the Tân Sơn Nhứt air base. It was home to a huge post exchange, or PX, for American military members to buy goods from home. The PX had all kinds of merchandise, from American candy and snacks to a Kodak photo studio and a tailor shop that made custom men's suits. My

mom worked in the gift shop, where they sold wooden artwork inlaid with mother-of-pearl, handcrafted teak jewelry boxes, and ceramic elephants—as well as soft coats made of mink. She couldn't picture where anyone would ever wear such a heavy coat.

My mom loved the fluffy pastel-colored cotton towels. They were buttery soft and luxurious. She saved her money for a set, but she couldn't buy them herself. This was a store for American purchasing power only. So, she and her friend Thu practiced their English, smiled often, and made friends with the American soldiers. My mom got the towels. Her friend Thu married an American Air Force captain.

While my mom loved all those American home goods, she was still partial to her own country's flavors when it came to food. One day she brought in some durian, a yellow-green Asian fruit with a spiky exterior and a creamy white flesh. It is extremely pungent. Some say it smells like rot or death. It's an acquired taste—so acquired that some Asian countries ban durian from common spaces because the smell is overpowering. My mom was a huge durian lover. She thought nothing of bringing it to work as an after-lunch snack. That morning, as the workers filed in and got ready to open the store, they started looking around.

"What is that smell?" said one American clerk, a tall blond guy with a mustache.

A curly haired woman chimed in, "Is it coming from the back?"

"No, I smell it over here. I think it's by the door," the security guard said, motioning.

No one could figure out why the store smelled so bad. The tall American manager followed her nose around the store. Another employee called the local gas company and reported a potential gas leak inside. My mom finally realized everyone was looking for the source of the putrid smell: her beloved durian. She quietly scooped up her lunch bag and took it outside. She and Thu had a good laugh about it at the end of their shift, and for years afterward.

Despite the war, these were fun times for my mom. She was a beautiful slip of a woman enjoying her twenties, working hard, and improving her English. She had no control over world politics, but she could work

at American companies and enjoy the independence of living on her own in Sài Gòn.

When she was offered a job at Holt International Children's Services, an adoption agency based in America, she jumped at the chance. Holt matched orphans from Vietnam, Korea, India, and China with adoptive parents in the United States. My mom worked in the sponsorship division, processing paperwork for adoptions and putting together packets of photos and information about each child who needed a family. It was gratifying work as she imagined these children's new lives with loving parents.

It would be to this company, years later, that my mother would write a life-changing letter.

"Dear Holt, my name is Liên Đỗ. I'm an employee of Holt, and I'm at a refugee camp right now. I need you to sponsor our family."

7

Huy and Liên's "Meet Cute"

My parents met as their divided country was sutured uncomfortably together after North Vietnam won the war. Their friend groups overlapped, and Huy Nguyễn was intrigued by this petite young woman who always smiled and seemed so independent. One day he offered her a ride home.

"Liên, I have my bike," my dad said, taking a chance. "I can give you a lift if you want."

My mom glanced outside and considered the midday heat already flattening the dusty streets. She thought my dad was charming.

"Sure," she agreed, "better than having to walk."

Her house was on the way to my dad's neighborhood in Phú Nhuận, a small suburb a few miles outside of Sài Gòn.

On the ride, they chatted easily, my mom holding tight to the bar behind their shared seat, her long black hair flowing behind her.

"Thanks, Huy"—she hopped off the bike—"see you around."

"Hey, do you like to swim?" my dad called after her.

"Yeah."

"Okay, let's meet at the pool next time," he suggested.

It was late 1975, and there was a lot of uncertainty in Sài Gòn—now officially named Hồ Chí Minh City—although no self-respecting

citizen of the South ever called it that. No one knew what the future would be like under a communist regime. In that environment, romantic feelings intensified quickly. If you found someone you loved, you didn't dilly-dally.

My dad was confident for someone six years younger than my mom. Skinny and tan, he could tell stories for hours and make her laugh. Their courtship lasted about a year.

My dad, more practical than romantic, didn't propose. Their engagement was more of a mutual verbal agreement.

"We get along pretty well."

"Yeah."

"We have a lot in common."

"Sure."

"We should marry."

In 1976, my parents exchanged vows.

It was not a festive or celebratory time in Vietnam. Many families had lost loved ones. Villages were rebuilding after being burned to the ground. Everywhere there were reminders of the death and devastation of the war. My dad's eldest brother, Hùng, twenty-three, was missing in action, a grim reality that haunted the family daily. After the fall of Sài Gòn, my dad and his family expected Hùng to return. They last heard that he was fighting near Đà Nẵng in central Vietnam. Weeks, then months, then years went by. Hùng never came home. No one ever sent an official notice of his whereabouts. He just disappeared.

My parents' wedding happened on a rainy day in Vĩnh Mỹ, where my mother's family lived. Only my dad's mother and his aunt's husband from his side attended.

My mom wore the traditional wedding dress, a red silk *áo dài*. My parents didn't have the celebratory processionals where the groom's side of the family lines up with gifts—a roasted pig, fruits, candies, and desserts—to prove to the bride's family that he's worthy. They missed out on the fun of hiding the bride until her family is convinced that the groom is rich and strong enough to be allowed into the bride's home. The somber mood of the country stood in the way

of those celebrations. They simply exchanged two small gold rings to symbolize their union.

There are no photos from the wedding day. The only way to get pictures was to travel to a studio miles away, pay a photographer, wait for the film to be developed, and travel back to pick up the pictures. No one felt up to doing all that.

They did take a small trip, their first as a couple, to Đà Lạt. Not a honeymoon, but close enough.

8

Postwar Hustle

To make a living in communist Vietnam, you had to hustle. The communists shut down all capitalist enterprise, and there weren't any government jobs for people who had fought with the South or worked with the Americans.

My parents fell into both categories because of my father's service in the South Vietnamese Army and my mother's employment with several American contractors. If you weren't on the side of the winning North Vietnamese, your neighbors knew it, and so did you. The tension between supporters of the North and of the South made everyone paranoid.

If you hated communists, like my parents did, it was impossible to find a legitimate job, so you had to be enterprising. My parents entered the drug business. They bought prescription and nonprescription medicines from a pharmacy that had been shut down, and they sold them on the black market. They needed to make money because my mom was pregnant. And they didn't want to stay in Vietnam forever.

Every day my mom and dad packed up their products in a duffel bag. All kinds of medicine: painkillers, cough syrup, penicillin, Phenergan, amoxicillin, and assorted steroid ointments—anything they could get their hands on.

They carried the drugs down to Nguyễn Huệ Street, where all the

illicit vendors placed boxes of their products on whatever piece of cardboard or blanket was available. The boxes were for display only. This prevented thieves from grabbing the goods and running off. More important, the vendors needed to be able to pack up quickly. Every few days, police raided the market, confiscated what they could, and arrested anyone who was too slow to get away. During one of those raids, when my mom was six months pregnant with me, the cops came out of nowhere. My mother thought about running and grabbed her contraband.

"Lady, stop! You're under arrest."

She realized she couldn't really sprint with me in her belly.

"Yes, sir. I'm not going anywhere."

My dad stayed by her side, of course. The cops took them both into custody and led them to jail. After seizing all their medicines, they released my mom after a few hours. My dad had to stay behind bars for two days.

The next week, it was business as usual, and they were back on Nguyễn Huệ Street, their blankets filled with black market meds.

My mom, once a full-time employee at respectable American companies, was now hustling and running from police officers on the regular. What prompted this transformation? Like my dad, Liên Đỗ looked at the wreckage of her beloved country and made a choice to survive. Selling on the black market wasn't her chosen profession, but she didn't hesitate to do what was necessary. My mother wanted to get out of Vietnam, for her baby and for herself—even if she had to take an unorthodox path to get there.

My parents made decent money and saved every bit they could. At night, they spoke in whispers about how they would leave the country as soon as they had enough to pay a smuggler to help them escape.

As a couple, they made a good team: my dad, decisive and driven by his gut, my mom, willing to take risks. They envisioned what life would be like raising a child in communist Vietnam and compared it to a free country with a thriving economic system and access to public education.

They knew they were not alone. Many of their friends were quietly

plotting to escape as well. There was a well-known saying muttered in safe company: *Cây cột đèn nếu biết đi nước ngoài.* If the lamppost knew how to walk, it would leave this country too. Friends and neighbors would be there one day and the next, gone. No one said a thing or asked where they went.

Since the end of the war and the victory of the North, it was illegal for citizens of the Socialist Republic of Vietnam to leave the country. If you were caught trying to escape, the punishment was incarceration and forced "re-education" in hard labor camps, with little food and the constant threat of violence from the guards. It was an open secret among those who were planning to flee that there were only two ways out. One was on foot through the jungles of Cambodia, which ceased to be an option in 1979, after Vietnam went to war against Cambodia's Khmer Rouge. The other way was to cross the South China Sea, where, if you could reach the coast of Malaysia, you would have a chance at survival.

My parents lived in constant fear of arrest at any time and for any reason. Walking home with groceries, my mom hid the contents of her basket from the prying eyes of neighbors who would try to see if there was meat or sugar or eggs in the bag.

Where did you get the means to buy those nice items?

More than anything, my dad hated communist propaganda. Everyone was required by the new government to attend a Communist Party meeting twice a week.

"Brainwashing," he complained to my mother.

My mom knew that schoolchildren were instructed to report their parents to the police if they overheard them speaking against the government. She saw neighborhood families torn apart when indoctrinated sixth graders turned on their mothers and fathers.

Every day my parents came home exhausted and tucked away a little more money in the hope they could someday flee.

Then I was born in the summer of 1978. Baby Yến.

I came into the world two weeks late—so late the doctors had to perform a C-section and pull me out through a long vertical incision in my mother's abdomen. The experience scared my dad so much that

years later he would say it was part of the reason they never had any more children. I came into the world in the same Sài Gòn hospital where my dad got stitches to sew up his gashed forehead after he was run over by a jeep as a kid.

Rather than casting doubt on their plans to leave, my birth strengthened my parents' resolve to escape. Now that they had a child to raise, communist Vietnam was unbearable.

"There is no future if there is no freedom," Dad would say. My mom agreed.

9

Boat People

After the initial euphoria of reaching Captain Nguyễn's boat in the nick of time, my mother began to doubt her decision.

At night on the water, the darkness was the hardest part—not being able to see added to the fear of not knowing what was to come. She cradled me close while I slept, sedated by a children's medication they got from their "pharmacy" to make sure my squeals didn't alert the government patrol boats. I was a healthy baby, top heavy with my giant round head, eyes so dark brown they were almost black, and chubby cheeks. Without moonlight, no matter how hard she tried, my mom couldn't tell my face from the black of the sky and the sea.

Sometimes my mom's eyes played tricks on her, and she thought she saw shapes and faces. Occasionally one of the children on the boat cried out in his sleep and broke the stillness. Mostly it was quiet, except for the creaking of the wooden fishing boat.

As exhausted as she was, my mother couldn't sleep. She was tortured by the stories told by well-meaning friends and frightened family members who warned of the risks she would be taking. Back in Sài Gòn, she had been just as convinced this was a good idea as my dad was. But now she was worried. So many families never heard from their loved ones again after they silently left. Many boats overloaded with refugees

capsized. Some got lost at sea, rations ran out, and refugees starved or died of thirst in the equatorial sun.

There was another threat even more terrifying. Right after the war, Vietnamese fleeing by boat became targets for Thai fishermen. The fishing business was difficult, and the Vietnamese refugees, holding all the precious gold, money, and valuables they could carry, were easy targets. Some Thai fishermen found it more lucrative to prey on refugees and turned to piracy.

The pirates varied in their level of brutality. Some pulled gold teeth right out of the mouths of refugees, chopped off fingers when rings were too tight to remove, and raped and murdered women in front of their husbands before throwing the men overboard. Sometimes, the pirates took an entire boat, kidnapped the refugees, and dumped them on deserted islands.

These stories played in a loop in my mom's mind.

Why did I do this, Con *(my child)? Was life in Sài Gòn really so bad?*

Captain Nguyễn Tung was a distant cousin of my mom's; they had lived in the same village. After taking several groups to Malaysia and returning home, he decided that on this voyage, he would take his extended family members who wanted to leave Vietnam, and he would never return.

Captain Nguyễn was a fisherman who knew the South China Sea well and could navigate at night by looking at the stars. He planned for the journey by sneaking rations into the boat's hull over many days to evade suspicious neighbors who might turn him in to the authorities. There were sixty-eight of us, including eighteen children, on board the thirty-foot boat. My mom and dad knew we were fortunate; a professional smuggler would have packed two hundred onto a boat this size. From many who couldn't pay the $1,000 USD per person that Captain Nguyễn charged for the voyage, he accepted a promise.

"You can pay me when you are able to," he told his passengers. "When you get to your final destinations and get jobs, when you have your families safe, then we can settle up."

This would have been unheard of if we had needed to hire smugglers. Instead of giving the captain money up front, my parents were able to stash $700 in American bills in various hiding places: a tube of toothpaste, a pack of baby crackers, the lining of a blanket.

When dawn broke, people on the boat stirred. The sun was brutal. My mom moved me into the shade of the tiny cabin. By late morning, Captain Nguyễn, surveying the sea with his spyglass, saw a dark spot in the distance. He was navigating as far east as he could from the Gulf of Thailand to avoid pirates, but this boat was coming from the west and moving very quickly. A hushed fear came over us as everyone watched the speck take shape.

The Thai boat was heading straight for ours. Within minutes, the pirates tied up alongside us. My mother held me tight and covered my head with my pink towel. The tanned Thai captain wore a khaki-colored shirt and shorts. He scanned our group confidently, knowing he and his crew had the upper hand out here. Behind him stood another man, his face painted white like a ghost.

They motioned for the captain to board their boat. With a tight jaw, Captain Nguyễn asked one of the passengers, a Vietnamese English professor, to come with him. It was not likely anyone on the Thai boat spoke Vietnamese.

"Where are you going?" the Thai captain asked in English, friendly at first, and the professor translated for Captain Nguyễn.

"We're going to Malaysia," he replied.

"You should go that way," the Thai sailor said, pointing to the southwest. "What can we help you with? Do you need anything?"

"No, nothing," replied Captain Nguyễn. "We don't need anything."

"Okay then, go back to your boat," the Thai captain commanded.

Captain Nguyễn and the professor turned around and stepped back onto the boat, the passengers watching in horror as four of the pirates followed them onto the deck. One pulled out a revolver and fired into the air, yelling in Thai.

The entire boat froze.

My dad inched closer to my mom, his heart pounding. My mom, stone-faced, watched from the open cabin below. She pulled me into her body and prayed I wouldn't make a sound.

The pirates boarded, shoving passengers aside and rifling through the cabin looking for weapons. The white paint smeared on their scowling faces made their eyes look wild and desperate. They walked the deck demanding *"Tong tong tong!"* Everyone knew they wanted gold and started removing anything that shone: rings, necklaces, bracelets. The pirates filled their hats with everything they could grab. One woman desperately tried to pull off her wedding ring, but her fingers were swollen, and it was impossible. For a few seconds, a pirate glared at the woman, then moved on to the next person, barking out *"Tong tong tong!"*

My parents had no gold or jewelry, and my aunt's jewelry had been stolen by the Viet police in the jungle. As the pirates approached my parents and me, my dad edged in front of my mom to shield us from their view.

He had a thought and whispered to Captain Nguyễn.

"I can give them two hundred of my American dollars. Maybe that will keep them from hurting us?"

Captain Nguyễn nodded his head slowly, unsure. "You can try."

My dad tried to keep his hand steady as he held out two faded green bills with the face of Benjamin Franklin.

The pirates' reaction wasn't what anyone expected. They looked at the pieces of paper, then each other, and burst out laughing.

"No, no"—they waived my dad away—*"tong tong tong."*

The most valuable material thing that my parents had with them was completely useless in the South China Sea.

The pirates climbed back onto their boat. We motored on, shaken but alive. Captain Nguyễn pushed into the ocean, praying the rest of the voyage would not be disrupted.

According to the American calendar, it was May 2, 1979, but my parents followed the Vietnamese calendar, which meant it was March. The old adage *"Tháng ba bà già đi biển"* applied to us: In March, the ocean is so calm even an old lady can cross.

We reached Pulau Bidong Island after two days and two nights on the open sea. The mile-wide island sits just off the coast of Malaysia and had become an official camp for Vietnamese refugees. It was a mass of humans. Up to forty thousand people lived inside temporary shelters haphazardly put together. To us, it was paradise.

"*Xuống, xuống,*" "Get down!" the captain instructed everyone. He had successfully shepherded sixty-eight souls one step closer to freedom.

All of us clambered off the boat, grateful to touch the sandy ground. "*Trời đất ơi, tới rồi, tới rồi.*" "Oh my God, we made it, we made it!" My great-aunt's voice mixed with everyone else's as we splashed through the warm shallow water to get to the beach.

Our family of six got in line to be processed. Everyone had to have an ID photo taken. My uncle Tâm, who loved to cuddle and toss me in the air, carried me on his hip to face the camera.

With his shoulder just out of frame, I stared into the black box. *Whirrrrck.* The camera snapped my picture. The chalkboard sign they held in front of me said my government name "Nguyễn Đỗ Quỳnh Yến" M17485, the same ID number as my parents.

After that, we were on our own.

My parents asked the other refugees what to do.

Kiếm chỗ ở. Find shelter. The first order of business was to find a space for our family to occupy.

In a stroke of luck, my dad ran into a woman he knew from the black market. She was about to leave the island and wanted to sell her patch of land in Section D. *Million Dollar Listing: Refugee Style.*

We hit the jackpot. Finally benefiting from having those American dollars, my dad paid $175 USD for a space about ten feet by ten feet. One section was the bed: a thatch of branches tied together with strips of cardboard to lay on. All six of us slept together under mosquito nets left by the previous owner. The other section was reserved for cooking. A few bricks set up like a teepee served as a stove to rest a pot on, the fire beneath fueled by kindling and wood from the island. Walls made of dark green tarp separated us from the other families. Most people

had flimsy tents that leaked when the tropical rains fell. We were lucky. Our space had a tin roof. It was our new home.

My great-aunt and my uncles took turns carrying me. Sometimes after the sun went down they'd walk me out to the beach and play with me on a patch of sand. Five people taking care of one baby made the days manageable and helped pass the time.

Every day families lined up for their rations of rice, mung beans, sometimes tinned sardines, and water. Vegetables amounted to half a cabbage a week. Hardly anything fresh was available on the island, which was mostly rocky mountains, tropical trees, and sand. Everything was sent in by the United Nations and its partner agencies. The rations were only enough to survive on. Occasionally, when we couldn't eat another bite of mung beans, my parents dipped into their dwindling stash of cash to buy the day's catch from the local fishermen.

A boat full of people arrived almost every day. The aid workers announced arrivals on the loudspeakers, and my parents and my aunt and uncles ran to the beach with hundreds of others to see if we knew any of the newcomers.

Other than "Who's Coming to the Island," our days were monotonous. Every refugee there wanted to leave. After a while, it was our turn to be interviewed by the UN workers.

"Where do you want to go?" they asked.

"America," my dad said.

"Do you have any ties to the United States? Will anyone sponsor you?"

My dad told them about his service in the South Vietnamese Army, fighting on the same side as American troops against the Việt Cộng. My mom explained her connection to Holt International Children's Services.

We had a choice of several countries: Canada, France, Belgium, Australia, which had generous governments accepting refugees from Vietnam. If you chose one of those countries, you could get off the island much faster, sometimes in just a few months.

We had a family meeting in our shelter.

"America is best," my dad said simply. "Bigger and better. We wait."

He'd developed this belief from witnessing American military regiments during the war and years of reading about the Land of the Free and Home of the Brave in newspapers and magazines. America represented capitalism, and Huy Nguyễn, a born salesman and hustler, was all in. He had an unwavering belief that the United States of America was the number one country in the world.

No one pushed back. My dad was in charge. If he thought it was best to wait, we'd wait.

The sun browned our skin as the months crawled by. Every few days, a voice blared over the loudspeaker with people's names, the number aid workers had assigned to their boat, and the day they needed to go to the office to learn when they were leaving the island and where they were going. My dad, unwilling to compromise, encouraged us to be patient.

People roamed all over the island like it was one big outdoor waiting room. Refugees waited for news about their loved ones. They waited for word about when they could leave. They waited for papers saying where they would go. We waited and we wondered. The mood was anxious but resigned. Our fates were once again not up to us.

The unsanitary conditions in the camp made a lot of people sick. One night my mom woke to find me throwing up, my skin burning hot. My parents rushed me to the French medical ship, terrified it was meningitis. I was listless. I had a fever. The doctors told my parents I could stay on the ship in a cool room. They gave me IV fluids and some children's pain relief medicine. My dad offered to volunteer on the ship with his background as an army medic. In exchange, he got VIP treatment and was allowed to stay with me in an air-conditioned cabin. After two days out of the tropical heat, I got better. It was just a bad case of diarrhea.

In the mornings, when it was cooler, my parents took me to the shore to watch the waves and play in the sand. Eventually, I took my first steps on the island, our neighbors in the tent city cheering me on.

Finally, after ten months in the camp, we heard our names and numbers on the loudspeaker and made our way to the office.

It was time to go.

10

Destination USA

In 1979, Wannell Ware, a petite fiery redhead, was working as an administrator for Holt International Children's Services when she opened a letter my mom sent from Bidong Island to the Holt offices in the United States. My mom hadn't known exactly who to address it to. But in it, she explained my family's situation and how she hoped to raise her daughter in America so I could receive an education and grow up in a free country.

"Dear Holt, my name is Liên Đỗ. I'm an employee of Holt, and I'm at a refugee camp right now. I need you to sponsor our family," the letter began.

Wannell's eyes got wide. "Of course, we *have* to help them!" she announced to her colleagues. "As far as I'm concerned, they're coming!"

She set to work looking for more information on my mom and our situation. Then she gathered everyone who was willing to help bring us to the United States, among them, Dean and Cindy Hale, who also worked at Holt.

Wannell's husband, Don, was not at all surprised by his wife's latest mission. This was typical of his big-hearted partner. The couple had three adopted children, two from Korea and one from Vietnam, and raised them alongside their two biological children. The Wares saw

the world as a place they could constantly make better. Don's favorite mantra was "A life lived just for yourself is not of value. A life lived for other people is of value."

We touched down on American soil at San Francisco International Airport on March 10, 1980. Now we were on the American calendar. It was our first flight, followed by our first American bus ride. We crossed the Golden Gate Bridge and got off at Travis Air Force Base in Fairfield, California, where thousands of Vietnamese refugees had landed before us as part of the United States' effort to make things right for the South Vietnamese they had left behind in 1975.

In the mess hall, my parents lined up with dozens of others, tired, hungry, and ready to eat anything other than the rice and cabbage rations from the refugee camp.

They nodded eagerly when asked if they wanted a scoop of *mass pohtayos.*

"What do you think this is?" my dad asked, poking his fork into the white mush.

"I have no idea," my mom said, having never eaten white potatoes mixed with milk.

They loved the main course. My dad's first bite into that crispy, greasy, battered and fried chicken was a culinary revelation.

"*Ngon quá.*" "So delicious." He didn't look up until the only thing that remained on his plate was a stripped chicken bone. The tendons were the best part. "Do you think they will give us more?"

My sixteen-year-old uncle Quang, thin to begin with and even skinnier after ten months of refugee camp rations, stood up from the table. "I'll go ask."

After the adults had seconds of the fried chicken and my mom fed me some mashed potatoes and tiny bites of chicken, we each received a warm jacket. The temperature was probably in the fifties, but we were tropical people, and we were shivering. We slept on cots that night in a room with about thirty other families. In the morning we were back on a plane for the next chapter of our lives.

This was our family unit now. My parents, me; my two uncles Quang

and Tâm; and my dad's aunt Nga. We had all made the journey from Vietnam, survived a pirate raid, endured the refugee camp, and now we would settle in Eugene, Oregon, a college town known for hosting elite track and field events.

The Holt team worked with the generous congregants of two churches, Wesley United Methodist Church and Our Saviour's Lutheran Church, to help us resettle in the United States. Don and Wannell were the angels on earth who organized it all. Together they outfitted a small apartment with everything we could possibly need. It had two bedrooms for the six of us, and that felt grand. There was even a proper second floor for the bedrooms and a bathroom.

The apartment came with a nine-inch TV that made our jaws drop. This marvelous wood-framed box with a glass screen and metal antenna could transmit color pictures and sound in English.

This is ours to watch whenever we want? We were taking it all in.

The cupboards were full of food, including the two most important staples of our diet: *nước mắm* and *cơm*. Fish sauce and rice. These thoughtful Americans had found exotic ingredients to help a group of Vietnamese refugees feel as close to home as they could, 7,500 miles away.

My dad appreciated the tiny electric range in the kitchen. No need to gather wood for a cooking fire, just turn on the hot coils and wait for the pot to boil water for our vegetable soup. You couldn't find the variety of fresh Vietnamese basil and greens he had taken for granted growing up, but he would supplement our rice and stir-fry meals with homemade pickled carrots and daikon.

My mom, a waif at five feet tall, eighty-eight pounds, was not used to dressing in the heavy cotton and denim fabrics from the local Goodwill. But she accepted the oversize hand-me-downs and wore them with enthusiasm, like an Asian Twiggy draped in eighties knits and geometric prints. Her favorite outfits were the wide-leg jeans and cotton shirts she bought on sale at the local Kmart. She never left home without a jacket, sometimes even a puffer coat, because even summer in Eugene was colder than any winter day in Sài Gòn.

Thanks to Wannell and Don, along with Dean and Cindy from

Holt, I celebrated my second birthday in the Holt offices, where my mom worked. Debbie and Sharon, sisters on the staff who had Martha Stewart–level cake-decorating skills, treated me to not one but two beautiful homemade cakes, one of them perfectly frosted and shaped like Mickey Mouse. It was as American a birthday party as any kid could have wished for.

While I enjoyed toddler life, my uncle Quang enrolled at South Eugene High School. He was a handsome, skinny kid with an Andy Gibb haircut minus the waves. Even though he was still learning English, for him it was a happy and exciting time in a new country. All of us loved hearing the news about his American teenage life.

"There is a lot to learn, because everything is new," Quang told our little family in a debrief over dinner. He was one of ten or so Vietnamese high schoolers fresh off the boat. "Every time I meet a Vietnamese at school, we get excited to see each other."

He said the American kids were nice, and some even volunteered to be student aides for the refugees, coming to class to take notes and tutoring them after school. "We are better than the Americans in classes like math, chemistry, physics," he said. "But it's harder to keep up with the English writing and reading for sure."

Quang was a good student. He went to after-school English-language classes and attended extra sessions on the weekends and during the summer. While there was a lot to adjust to—the weather (it was cold, gray, and drizzly almost all the time), the food, and the language—my uncle and his friends were on an adventure with the help of curious Americans.

One year Quang got to spend a few weekends at a teacher's horse ranch. The teacher drove him and his buddies three hours outside of Eugene to the woods near the Three Sisters Mountains in Bend for a summer camp of sorts. We heard the stories of this exotic adventure when he came home. "We chopped wood and hung out with horses," Quang said. "In the morning, we ate pancakes and eggs for breakfast," he told us. And with a laugh he added, "We think our teacher is a cowboy!"

Holidays like Thanksgiving gave us all another glimpse of American traditions. Students' families welcomed their refugee classmates into

their homes for turkey and mashed potatoes, tart cranberry sauce and pumpkin pie. My parents had no time to think about or research these customs, so we'd learn about them through Quang. He also found a place on sports teams, playing tennis, badminton, and soccer in high school. Nothing was more of an equalizer than sports, and my uncle excelled.

Quang loved and looked up to his big brother, my uncle Tâm, who was twenty-one when we arrived in Eugene. Tâm had an angled jawline, jet-black hair, almond-shaped eyes, and sky-high cheekbones. He quickly passed his driver's license exam and picked up his younger brother every day from high school after leaving his drafting class at the local community college. Tâm was confident and charismatic, loved cars, and soon developed a vibrant social life. It took him no time to start dating American girls. It was Oregon in the eighties, and Uncle Tâm had plenty of party invitations from other twenty-somethings.

My mom was happy her younger brothers were finding their way. She was too—taking care of me, working for Holt, and attending language classes at the community college.

Everything about America was proving to be as good as advertised for our family. After so many years living in fear, there was finally space to breathe.

Then just one year after we arrived, two Eugene police officers knocked on our door and that feeling evaporated.

Uncle Tâm had been staying over at a friend's house. It was mixed company, guys and girls. Late in the evening, an acquaintance showed up. He and Tâm got in an argument about one of the women. The man took out a knife and stabbed my uncle to death.

My parents were devastated. My mom especially. She felt tremendous guilt for bringing him to the United States. My parents didn't know anything about the legal system, and they didn't follow the court case. The man who killed my uncle was convicted of manslaughter. He got out of prison after serving less than two years.

By that time, we were long gone. But it wouldn't be the last time we saw the killer.

11

Bossy in the Biggest Little City in the World

My parents couldn't bear to stay in Eugene. Too many reminders of my uncle Tâm everywhere they went. My dad's aunt Nga heard there were casino jobs in Reno, Nevada, and it was far enough away from Oregon for a new start.

Reno, "The Biggest Little City in the World," is like a mini Las Vegas. Harrah's, Silver Nugget, and Circus Circus were the hot spots in town. Working at a casino was a decent job. My mom could make $3.20 an hour plus tips. After attending a course on how to deal blackjack and one hundred hours of practice, she applied for a job on the casino floor at Club Cal Neva.

My petite Vietnamese mother, dressed in black slacks, a crisp white shirt, and black vest, spent eight hours a night on her feet, breathing in thick gray swirls of secondhand smoke, collecting money from gamblers, and making small talk in her soft voice with locals and tourists. One week into the job, someone swiped her purse from the spot where she kept it underneath the blackjack table. She lost eighty dollars in cash, almost two nights' wages. She blamed herself. "Why did I leave my bag on the ground? So careless!"

My dad worked the graveyard shift at Harrah's washing dishes. He

stood and swished hot water over hundreds of cups, plates, bowls, and glasses each night. Although he wore gloves, his hands were raw and cracked from all the hot soapy water.

Once again, my parents didn't think about the means as much as the ends. This was work and a way to save money. When the next opportunity arose, they'd make a switch.

I started kindergarten at Rita Cannan Elementary. I didn't speak English fluently, but I was a chatterbox. At home, my parents and I spoke Vietnamese. At school, I spoke to the other kids in Vietnamese too. It didn't matter that there wasn't a single other Asian kid in my class, let alone any Viet kids. When it came time for the parent-teacher conference, my teacher told my parents I was a bit "bossy" and "very talkative." My parents nodded respectfully but left me to conduct myself as I saw fit in my new school.

I hogged the blocks and tried to give directions when we played House. When the other kids couldn't understand me, I just used a lot of hand motions and raised my voice. How else was anyone going to get my games right?

My parents worked a lot. When they were home, they made food and caught up on sleep, so I got used to playing alone. I loved animals, and I was always begging for "a friend." My parents were used to being around animals in Vietnam, but those animals served a purpose. You ate chickens and pigs. Geese and dogs were your alarm system. You raised fish to sell.

Out of guilt, or maybe from being worn down by my constant nagging, my parents bought me an orange goldfish I kept in a round glass bowl with bright blue rocks.

"I *promise* I will clean the bowl," I said, fully meaning it at the time. My mom cleaned the bowl.

Eventually, I graduated to parakeets, one yellow and one green, because I needed more excitement than one small fish could give.

"Yến, what's happening?" My mom looked at my watery, red eyes. "Stop rubbing your eyes."

"I can't, they're so itchy," I said, digging my knuckles into my eye sockets.

After a few weeks, we figured out it was "the birds" and we had to give them away.

My next dream pet came soon after. We lived on the third floor of an apartment complex, and one day a neighbor girl came knocking on the door.

"My cat had kittens. Do you want one?" she said. "My mom says you can have it for free."

I lost my mind.

"A kitten? Of course, I want it!" I screamed. By first grade, my English had improved enough to accept free pets. "Hang on. Let me tell my parents."

I pleaded, I whined. I used my best six-year-old lobbying skills and explained how cute cats were and how they could live inside. Then I went into shameless begging mode.

"It will be my best friend. *Please,* if you love me, you will let me have this cat. Look at it!" I held up the tiny orange tabby kitten.

I turned up the charm and hit them with the closer.

"And guess what? She's FREE!"

My parents did love a freebie. They knew I didn't have many friends to play with. They sighed and gave in because I was a persuasive beggar. I constantly negotiated with the two people in my life to bend them to my will. When there are other kids in your family, you have to learn to compromise. I had two tired parents who wanted to find ways to keep me occupied.

"This whole store selling thing for *animals?*" my mom asked.

My parents scanned the shelves at the pet store. This was not their upbringing. Stray dogs and cats wandered the streets in their neighborhood or lived on their land, but you didn't *pay* for them, and you certainly didn't buy plastic bins to keep in your house for them to poop in.

But this was Reno, Nevada, USA, 1984, and their daughter was getting a kitten. They asked the store clerk what to buy.

"You'll need a litter box, of course. This is where we have all the cat food. Do you want wet or dry or a mix?"

My mom nodded.

He threw a bag of Friskies and some cans of Fancy Feast into our basket.

We got a little red plastic feeding tray with one side for kibble and the other for water. The clerk even got my parents to buy a feather cat toy.

"Yes, this is a toy. For the cat. See, you wave it around like this, and the cat will chase it."

All of this mystified my mom and dad. We were spending money on supplies for a cat. They put everything in the cart, and we checked out.

Sugar was a medium-haired orange tabby with tiger stripes, a fluffy tail, and green eyes. I carried her out onto the third-floor landing of the apartment so she could get some sun. I always held her tight around her middle so she wouldn't run away.

I loved Sugar, but it wasn't meant to be. Like the parakeets before her, Sugar would make my eyes so itchy and watery that I couldn't stop rubbing them. Eventually my eyes swelled shut, my throat closed, and no amount of nasal spray or kids' Benadryl touched my misery. I had a serious cat allergy. Sadly for me, Sugar went back to my neighbor. This time I cried. It took several days for my puffy eyes to deflate from the tears and the allergies.

Sugar was far from the last animal I begged for. My mother, born in the year of the Rat but deathly afraid of rodents, made the ultimate maternal sacrifice by allowing me to have two guinea pigs and a hamster a few years later. Once again, I promised to clean their cages and faithfully take care of them. And once again I shirked my duties because the smell of rodent pee and poo was too much for my nine-year-old self to handle on a consistent basis.

It fell on my mother, every week, to face her phobia, taking care of Frisky, Squeaky, and Creamy as though they were her own. Her true love for me shone with every fresh exchange of cedar chips to line their cages.

12

The Food Truck

We didn't stay in Reno long. After a year, my dad said it was time to move out of the mountains.

"Too much snow," he announced.

It didn't help that my dad's risk-taking behaviors, which got us out of Vietnam, were trouble in a town known for its casinos. My mom was ready to leave the secondhand smoke and gambling behind.

Through the Vietnamese grapevine, my dad heard that San Jose, California, was the place to be. It was brimming with Viet refugees who opened restaurants, nail salons, Asian markets, and other businesses that catered to the quickly growing community resettling in Northern California. San Jose was home to the second biggest population of Vietnamese people in America after Orange County in Southern California. There were more than forty thousand of us, mostly living in East San Jose, an area unofficially known as "Little Sài Gòn."

You could walk around Little Sài Gòn without hearing one word of English, pick up Vietnamese snacks like *chà bông,* pork floss; *xí muội,* salted prunes; *bánh tôm,* shrimp chips and chase it all down with an iced *sữa đậu nành,* soy milk. By the end of the 1980s there were even fledgling Viet newspapers, magazines, and radio stations serving an audi-

ence eager to connect with the Vietnamese community in the United States and anxious to hear what was happening at home too.

I was seven when my parents joined thousands of their countrymen as American entrepreneurs and bought a food truck with their casino job savings. But how and why would these two Vietnamese refugees try their hand at a food truck?

One day, on our way from Reno to visit family in California, we got stuck in the snow. My parents were unprepared for the blizzard conditions. The road signs blinked CHAINS REQUIRED on this stretch of Interstate 80, high up near Donner Pass, and the California Highway Patrol was serious. *Chains?* No one could pass through the checkpoint unless they had chains on their tires. Luckily for my parents, several stores were set up along the route with men selling and installing chains on hapless drivers' tires for $30.

It took the guy an hour to outfit the tires on our Chevy Chevette with the appropriate safety gear. We were hungry by the time we got to San Jose, and went straight to Lee's Sandwiches, a popular Vietnamese chain restaurant that serves all kinds of *bánh mì* sandwiches with meat, pate, *đồ chua,* pickled daikon and carrots, jalapeños and cilantro tucked into a crispy baguette. There, we happened to run into a man my parents had met in the refugee camp in Malaysia years before.

The conversation went as usual:

"Hey! You're in America!" my dad said.

"Yeah, you too!" Fellow Refugee said.

"What are you doing?"

"We're working at a casino in Reno. What about you?"

"Casino?" Fellow Refugee shook his head. "Naw, man. You should come to Cali, run a food truck like me. You make good money. Lots of Vietnamese in San Jose."

They talked over lunch, and Fellow Refugee convinced my dad that the food truck business was profitable. He said you could make two hundred dollars a day driving around and selling food to tech workers. My dad was intrigued.

A few weeks later, they met up with Fellow Refugee for a field trip

on his truck to see how the business worked. As they wound through the lunch route, the smell of hamburgers made my mom carsick.

My dad was undeterred. "This is doable," he told my mom. She was never afraid of hard work, but my mother was always the practical one and worried about the investment. The truck cost $32,000. My parents could only afford to put down a third of that and had to take out a loan for the rest. My mom had doubts but tamped them down with her faith in my dad.

Back then, food trucks were not trendy and chic. They were utilitarian fast-food restaurants on wheels, often rickety, underinspected, and dangerous to operate. They were known as "roach coaches" because they were inexpensively run, food was cheap, and they often catered to blue-collar workers who had time for only a quick meal outdoors before returning to work.

My parents' truck served a mix of technicians, assemblers, and engineers from Silicon Valley companies where hundreds of workers made things like microchips and semiconductors. This was decades before companies like LinkedIn and Google wooed their staff with things like gourmet cafeterias and dry-cleaning services. These factories had parking lots, where the workers lined up for thirty-minute lunch breaks.

My dad kept to a strict schedule so he could hit every company on his route. While he raced up and down Highway 101, my mom cooked in the back. You were supposed to cook only when the vehicle was stationary. But you couldn't operate that way if you wanted to make money.

My mom quickly mastered the art of making cheeseburgers and fries, spaghetti with marinara sauce, bean-and-chorizo-stuffed burritos, fried rice and egg rolls. Except for the Americanized Asian dishes, it was all food she never ate herself until many years later.

Perhaps it was the trauma and experience of surviving war and escaping a communist country that gave my parents the ability to accept uncertainty. In turn, that made them into decisive people, unafraid to seize opportunities and try new things. They were more likely to ask "Why not?" than "Why?" In those early years in America, they figured they had nothing to lose, so, *why not?*

And that is how I wound up squatting on my haunches in a giant metal box on wheels careening down Highway 101.

"Yến, move!" My mom yelled at me to get out of the way, but I didn't have room to go anywhere. We were both wedged in the back of our food truck. I had begged to come along, certain anything would be better than my boring days with the babysitter. Now I was regretting it. It was 5:00 a.m. I felt carsick and hungry, a bad combination. "Go here. Move there," my mom ordered as she tried not to step on me while using hot oil and sharp knives to prepare food.

"Stay in this corner," my mother said as she pointed and scooted past me while unwrapping chorizo, her shoulder-length hair tied back in a low ponytail. We were moving fast toward our first stop, the breakfast crowd at National Semiconductor in Santa Clara, a company that made circuit boards and chips and other computer stuff. My parents didn't know much about Silicon Valley except that the workers had short meal breaks. If we didn't hit our stops on time, they'd have fewer customers. Fewer customers meant less money.

"Hang on," my dad yelled from the front to let my mom know he was swerving onto Highway 101, about to hit sixty miles an hour. She held on to me to make sure I didn't lose my footing, and we felt the truck pick up speed. Then she was back to work, a blur in the cramped kitchen, grabbing bread, slicing tomatoes, cracking eggs and scrambling them in a metal bowl like a ninja.

"Má, I don't feel good."

"Yến! I told you, but you want to come."

I silently watched her grab bacon and cheese to make breakfast sandwiches. She patted my head. "We stop soon. You can stand up, drink water."

I always got carsick, but this was next level—the smell of cooking oil mixed with truck exhaust, and the endless motion. And it was so early, still dark outside, and my stomach was empty, churning on acid.

It seemed like a long time to the first stop, but finally we got there. My dad jumped out of the truck wearing a belt with a plastic contraption attached to the side. It had slots for quarters, dimes, nickels, and pen-

nies. Every time he pushed a lever, the designated coins would tumble out so he could make change for the customers.

"Hello . . . hello." He greeted the line that had already formed in the parking lot with a friendly nod.

"Bacon, egg, and chorizo burrito with cheese" was the first man's order through the window. My mom smiled and repeated, "Bacon, egg, and chorizo burrito with cheese, okay," then quickly grabbed a tortilla and put it on the stainless-steel grill, which she repeatedly warned me not to go near.

"*Phỏng tay,* okay, Yến?" *You'll burn your hand. Got it? Don't touch.*

She poured the egg mixture and sizzled some chorizo, putting it all together and topping it with a slice of cheese. She wrapped the burrito in butcher paper and handed it out the window. Someone grabbed a banana, a carton of orange juice, and asked for an egg and bacon sandwich.

The delicious smells made my stomach grumble. My dad was out walking down the line of customers, asking for orders and precollecting payments so people only had to tell my mom what they wanted and pick up the food when it was done. I was impressed. *My dad is smart.* He did all the math in his head, putting the dollar bills into his fanny pack and dishing out change from the plastic coin contraption.

The sun was coming up and it was going to be a hot day in San Jose. I didn't know what to expect on this trip, but I was finally getting to see what my parents did all day. I was ready to go home, but we still had the lunch rush. Wanting me out of her way, my mom handed me an egg sandwich. I ducked back into my corner to unwrap my breakfast as we sped off to the next stop.

13

Friends and Foes

In San Jose, my parents rented a room in a single-family house. The house had four bedrooms, and the Vietnamese owner leased three of the rooms to other Viet families. My dad, mom, and I shared a queen-size bed. The room was spare, and my parents never thought to decorate, because who knew where or when we'd move next. We hung on to just the basics: pillows and a bedspread, and, for me, one small *gối ôm,* a pillow to hug between my knees.

Every night, my parents used the main kitchen to prep food for their truck, chopping vegetables, cutting, seasoning, and marinating gobs of meat and chicken. They felt guilty hogging the kitchen, prepping massive amounts of food when their housemates just needed to make dinner, but they had no choice. This was the only place they had to get ready for the next day.

I didn't have many friends. Unlike Rita Cannan Elementary in Reno, Santee Elementary in San Jose had many Asian students. Their faces and haircuts were similar to mine, but these first-grade Vietnamese girls already had their cliques and spoke Vietnamese to one another. They weren't interested in the new girl who spoke Vietglish.

My best friend was a girl named Dong, a.k.a. Donna. Her dad was Chinese, and her mom was Vietnamese. We met when my parents moved

into the apartment above theirs. We spoke English with each other, and we bonded over our love of flea markets and jelly shoes with glitter embedded in the plastic. We obsessed over Madonna and memorized every song on her *Like a Virgin* album. We had no idea what the lyrics meant, but we loved singing and dancing like maniacs about being "touched for the very first time."

I wanted to do everything Donna did. I copied her style whenever I could. She didn't get mad about it. We wore matching leg warmers and pink leotards to our roller-skating lessons at Star Skate. Donna had lace gloves and a Gap jean jacket. I begged my parents and got the lace gloves and the same acid-wash jacket. She wore neon jelly bracelets from her wrist to her forearm. So did I. When Donna got chicken pox and couldn't play with me, I couldn't bear it.

"Mom, I should go over to Donna's so I can catch chicken pox from her," I said in my most authoritative tone. "It's harmless, I swear. I should just get it now and get it over with. *All* the kids are getting it."

My parents looked at each other and shrugged. "Okay."

They said "Okay" a lot when I told them stuff they weren't familiar with. Since I was so American after just a few years of being in school, they figured I knew what I was talking about when it came to these kinds of things.

At Donna's house we played Monopoly and Life for hours. Sure enough, I got chicken pox. I was miserable. No amount of pink calamine lotion could keep me from scratching those red bumps. I woke up at night digging one spot on my chest so hard with my fingernails that it bled and made a nasty scab, which left a permanent scar.

Donna could make everything an adventure. She invited me on grocery store runs to Pak 'N Save, where my parents never shopped because it was too far away. I was mesmerized by the bulk bins, where Donna said we could help ourselves to candy, nuts, and dried fruit. We "sampled" until we were shooed away by the store clerks or got too many glares from the paying customers. We usually managed to fill a bag with gummy worms and got Donna's parents to pay for them. We chewed

them all on our ride home. Donna could always make me laugh, and she wasn't afraid of anything or anyone.

But she wasn't there to hang out with me during the school week. We were in the same grade, but Donna went to a private school that was forty-five minutes away. I only got to play with her after school and on weekends. At my school, I was a loner.

By then my English had improved from watching episodes of *Sesame Street* and *Who's the Boss*. I still only spoke Vietnamese with my parents at home, and in Vietnamese, the way you speak to your elders is different from the way you chat with peers. I didn't have the vocabulary to relate to kids my own age.

I did have one skill that got me some schoolyard credibility—I excelled at Chinese jump rope. I made the jump ropes out of long strands of rubber bands double-hooked together. I could always get some girls to join me, and we would see how high each girl could jump in and out of the rope. We started with two girls and looped the circular rope around our ankles. The jumper would hop over the first band into the center of the loop, then hop out the other side. Then we'd move the loop higher to our knees, then our waist. I could jump in and out of the rope even when it was looped neck high by raising my foot enough to hook the band and pull it down before hopping out.

It wasn't enough to stop the Vietnamese girls from ganging up on me.

"Why can't you speak Vietnamese?"

"I can."

"Then speak it," they taunted.

I was silent, wincing inside.

I didn't know the cool slang, and I didn't think in Vietnamese, I thought in English. Even though we looked alike, I was an outsider.

One day I was in the girls' bathroom, and I heard a noise.

A bunch of small faces with dark, straight hair suddenly peered over the wall into my stall. There's something very vulnerable about being cornered when you're sitting on a toilet peeing. The gang of girls taunted me in Vietnamese.

"Dummy, you can't even speak Vietnamese."

They wouldn't let it go.

"What do you think you are, *mỹ trắng*? An American white girl?"

My cheeks got hot, and my eyes filled up. I bit my tongue to keep the tears from spilling out.

I didn't have to worry about them for long. After second grade, we moved again. This time, my dad was ready to try his entrepreneurial talents in a city two hours north of San Jose, where I'd once again be surrounded by children who didn't look like me. Still, Santa Rosa would be the place where I figured out what it meant to feel like an American kid on the inside, even though I was still learning how people saw me on the outside.

14

What's in a Name?

From kindergarten to fifth grade, I switched schools and homes four times between apartments and rented rooms in Reno, San Jose, and Santa Rosa. I was constantly picking up and moving. Because we didn't have a lot of material items or furniture, moving was easy. It generally involved only a few boxes and suitcases. We didn't own any furniture worth taking, so the feeling of impermanence was familiar to me. Change was the only part of life I could count on.

By 1987, my dad had decided that San Jose was oversaturated with Vietnamese-owned businesses. Always looking for the next big thing, my parents sold the food truck, and we moved to Santa Rosa, an agricultural suburb about a fifth of the size of San Jose and the most populated city in the Sonoma Valley. There were no Asian supermarkets and only a couple Chinese restaurants. There were very few Asian anythings in Santa Rosa.

My dad was fine with it. There were enough commercial spaces to lease, and he had a business idea.

My parents enrolled me in third grade at Piner-Olivet Elementary.

"Hi, welcome to class. Your name is *Yennn . . . Na-goo-yinn*?" the teacher whispered to me, butchering my Vietnamese name in phonetic English.

"Uh, yes." I nodded.

I did not want to draw any further attention to myself as the new girl. "Class, say hi to our new student, Yennn."

A sea of white kids turned to greet me. "Hi, Yennn!"

My family name, like more than 40 percent of Vietnamese people on the planet, is Nguyên. The Americanized pronunciation is *Win* but with a soft start and stop. In Vietnamese it sounds more like *Wee-unh?*, but with a nasally *n* at the top. Before the 1800s, most Viet people didn't have last names. French colonizers arrived and told everyone to pick a name. In a tradition of showing loyalty to a leader, most people opted for a royal last name. The final family dynasty in Vietnam ruled from 1802 to 1945. Can you guess what dynasty it was?

My full name was Nguyễn Đỗ Quỳnh Yến (in Vietnamese we put the last names first). My parents named me Yến after both a celebrity and a bird. Bạch Yến was the beautiful Miss Vietnam who sang in the Bob Hope Chrysler special in 1966. Yến is also the name of a white swallow that builds its nests in remote seaside cliffs. The saliva these birds use to build their nests is a coveted medicinal elixir sold in liquids and gels. Vietnamese people believe it keeps you healthy and gives you glowing hair and skin. My second name was after my mom's distant cousin Quỳnh, the nurse who helped deliver me in the government hospital in Sài Gòn. Đỗ is my mom's family name.

All of this had seemed completely reasonable when we lived in San Jose.

Santa Rosa was a rude awakening. It was bad enough that most people in this part of Sonoma County had never met a Nguyễn and butchered the name every possible way. *NewJin. NewYin. Nie-Jin. En-Goy-En.* When you pronounce my first name, Yến, in Vietnamese, it sounds like Ian with a question mark after it. *Ian?* Some kid told me that was a boy's name. When my teacher pronounced it, Yến sounded like Japanese currency. *Yenn.*

I was only eight years old, but I was sure I did not want to spend a lifetime with a name no one could say correctly, and I hated trying to

teach American kids and grown-ups how to speak in a proper Vietnamese accent. It was way too time-consuming, and their tongues didn't seem to have the necessary skills. I had to do something about this.

"Mom, I need an American name," I said.

"Your name is Yến."

"Mom, no one here can say my name right. They say Yennn. I don't like my name." I sounded it out with a "Yuh" so she would understand.

My mom thought for a bit, then shrugged. "Okay, Yến. If that's what you want."

I knew it would be even easier to get my dad to agree. My parents' motto concerning issues of American identity was "Go with the flow," even if it meant abandoning the precious name they had selected for their only child. They would continue to call me Yến, so what did it matter if I wanted an American name?

My father's only pressing concern was practical, not sentimental.

"But how you will choose new name?" he asked me.

Not to worry, I told him. "I already have one."

When we got to America in 1980, *Three's Company* was *the* television show, and I grew up watching it with my parents. The sitcom was about two career women, Janet and Chrissy, who need a third roommate. They find this guy Jack, and he's a good cook. But the landlord, the prudish and nosy Mr. Roper, is certain there will be too much hanky-panky if men and women live together, so they convince him Jack is gay.

In reality, Jack has a girlfriend who is a tall, sophisticated twenty-something flight attendant, glamorous but still down to earth, the perfect combo of classy and bubbly. She has a big-tooth smile and that dirty blond eighties bob with curled bangs. To me, she was perfect. Her name was Vicky. My name would be Vicky. It was that simple.

It's true my parents indulged my whims by letting me do or get what I wanted. But like a lot of Asian parents, they never said, "I love you" or "I'm proud of you" or "Good job." We didn't hug. My mom gave me "sniff kisses" when I was little—the kind where you

smush your nose into a kid's chubby cheeks and inhale. Nothing with the lips.

They raised me, and they didn't explain themselves. I was forbidden from slamming doors. They spanked me when I talked back. And if I was particularly disrespectful, I had to *quỳ gối khoanh tay lại*. That means kneel on the ground with your arms crossed, usually facing a corner. Five minutes of that felt like five hours.

We weren't close the way you might think a family of three people would be. They did what they did, and I did what I did. The only time we needed to interact was if there was a conflict about whether I was allowed to do something. Sleepovers were a big source of disagreement. My parents did not understand the concept.

"Mom, can I sleep over at Olivia's house? Gina's going to be there too. Please, please, please, pleeeeeeeease?"

"Why? Is your bed not good? Why you need to sleep at someone else house?" my mom answered. "They can come here."

"No, that's *not* fun. At. All. I sleep here every day. It's a sleepover and we're gonna have tacos and it's going to be soooo fun. Pleeeeeease?"

"No," my mom said. She always said no.

My dad always said yes. That was a source of tension because I often pitted my parents against each other. If my mother said no about anything, I campaigned my father to say yes. He generally could not be bothered to care too much. He was usually sitting at the kitchen table, reading a newspaper or book, and his attitude was "If you want to go, go." He didn't think we could get into that much trouble as elementary school kids and didn't worry about me the way my mother did.

In addition to her concerns about my safety, my mom's love showed up in my food-truck-worthy school lunches. She sent me to school with a full-size turkey, ham, or roast beef sandwich on its own paper plate, wrapped in plastic so tight I spent half my lunchtime unwrapping it. Freshly cut fruit and chips were always in the brown paper bag, along with a Handi-Snacks package of buttery crackers and a square of pro-

cessed cheese accompanied by a red plastic spreading stick—unhealthy, but so salty and tasty.

Of course, I complained.

"Mom, the tomatoes are making the bread so soggy!"

"Mom, ham again?"

"Mom, can I just have peanut butter and jelly in a Ziploc like everyone else?"

I didn't think about how early she had to wake up to make those lunches every day or that after a long day at work my parents would still make a multicourse traditional Vietnamese dinner with rice, a meat dish, and a vegetable soup. I nagged them for Happy Meals and pizza.

At my new school, I stood out like soy sauce on spaghetti, one of my dad's favorite combos. Kids weren't mean, but they weren't nice. They were ambivalent to the new student with the weird name and mostly left me alone.

As an only child, I wasn't scared or bored being alone. I was used to finding ways to stay occupied. If I wasn't begging for a pet or a game or my favorite dinner of steak and shoestring fries, I was lost in a book: The Baby-Sitters Club, Sweet Valley Twins, Encyclopedia Brown, and all the Beverly Cleary books. Reading about spunky Ramona Quimby and her nosy, interfering big sister, Beezus, didn't make me long for a sister. Instead, it made me appreciate that I didn't have someone bossing me around.

I did make one good friend, and I learned then that you really only need *one* good friend most of the time. When we first moved to Santa Rosa, we lived in an apartment that was small, but we didn't have to share it with other families and roommates. Somehow my mom found a babysitter for me in that complex named Kathy. On *The Cosby Show* and *Silver Spoons,* grown-ups were called Mr. Something and Mrs. Something. Vietnamese grown-ups are always called by formal titles that depend on their seniority. I always had to ask my mom if someone was a *Chú* (Uncle) or a *Bác* (Older Uncle). I knew *Ông* was reserved

for the *really* old guy. But Kathy, who was about my mom's age, wanted to be called Kathy, and I thought it would be rude not to obey. Kathy's daughter, Nicole, was at the same school and in the same grade. We became fast friends.

For my ninth birthday, Kathy got me a Cabbage Patch Kids Preemie, the cutest doll, which smelled like baby powder. I loved that gift so much because it was something my parents would never know to get me, and somehow Kathy did. It seemed like everyone else already had one, and owning that Preemie made me feel like I really belonged.

Nicole's older brother, Nathan, was fascinating to me, a daredevil who gelled his hair into stiff spikes. He rode his BMX bike around like a tornado, jumping off curbs and skidding to make brake marks all over the sidewalk. He alternated between being really kind to us and tormenting us by stealing our dolls or pinning Nicole with some wrestling move until she screamed "Get off me!" at the top of her lungs. I was not used to all this boy energy and tried my best to keep up. They loved to get on the apartment swing set and see who could stand up and pump the swing to get the most air before jumping into the sand. I always chickened out and lost.

Kathy and her husband, Rich, were so different from my parents. They told jokes and played games. They asked me questions and waited with interest for me to answer. My parents' conversations with me were about necessities, not niceties. *Are you hungry? What have you eaten? How did you get that bruise? I told you to stop jumping off the swings!*

Kathy also knew things my parents did not. One day, she heard me talking about using an "eye-rawn."

"Honey," she said, kindly, "it's pronounced *eye-urn*."

"What? No. It's '*eye-rawn*,' like '*eye-rawning board*,'" I said, indignantly.

I pronounced it like it was spelled, and like my mom said it.

Yến, don't touch the eye-rawn, it's hot.

Con (My child), give me Dad's shirts to eye-rawn.

Kathy and I went back and forth a few times. I, being a stickler for

rules, insisted we look it up in the dictionary. There it was, plain as day, "i-ern." The dictionary spelled out the pronunciation. Kathy was right. For years I had been saying "iron" wrong.

Huh.

I wondered how many more American things I was saying or doing wrong.

15

Contemporary Design Furniture

While I navigated my way through white suburbia, my dad was on his own mission. Back in San Jose before we moved, he'd grilled a friend of his who owned a successful furniture store about that line of work.

In our new town, he drove around in our gray Honda Accord looking for a place to open his new venture. He searched for all the other furniture stores. He wasn't trying to avoid them. On the contrary, he wanted to set up shop right next to a successful one. That was his logic. Burger King and McDonald's should be across the street from each other because that's where people go when they're craving hamburgers. You attract more people, you get more customers. In Vietnam, that was how it worked. In the big markets, all the chicken sellers had their stalls in one section, the fishmongers sold their catch in another. You could size up your competition easily and, if needed, try to steal their customers by shouting out a better price than the guy next to you.

As soon as we arrived in Santa Rosa, my father tracked down the owner of a vacant retail building right across from the biggest furniture store in town, Scandinavian Designs. My dad offered the owner $7,000 a month rent. It was significantly under market value for the 7,000 square foot space, so the landlord turned him down. My dad went back again and again, undeterred. For a few months, the place remained vacant.

Finally, with little credit history and no retail business experience, my father convinced the building's owner to take a chance on him.

My dad always taught me to ask more than once if you don't get the answer you're hoping for. If at first you don't succeed, try, try again was one of his mottos. It got him out of Vietnam, and now it was getting him an empty building in Santa Rosa to fill with bedroom sets and sofas.

My parents signed a lease and became the proud proprietors of a giant furniture store they christened Contemporary Design Furniture. Why that name? They sat together at the small table in our apartment looking through an old dictionary for the word "modern" and found that "contemporary" was a fancy-looking synonym. They were across the street from Scandinavian Designs, so that's where the word "design" came from—minus the *s* at the end.

It's a funny thing about Vietnamese business names in America. Vietnamese love to drop the *s* on words that need it and add an *s* to words that don't. Happy Nail. Pretty Nail. Lucky Nail. My favorite was the sign posted at What's the Pho Vietnamese restaurant with a quote from the famous "Steve Job" of Apple. Below it was another sign that said, "We are out of beefs meatball."

But in this case, Design with no *s* made sense!

My parents were not so happy when it was time to buy the light-up letters to spell out "Contemporary Design Furniture." The name had twenty-seven separate letters. That sign cost a fortune!

One thing my dad could always do was bargain. It's a survival skill and a way of life in Vietnam. Never take the first price. That's just the opening bid. He was an expert at getting a good deal for something and, in this case, paying it forward to his customers. Our store became the go-to furniture warehouse, where middle-class Santa Rosans could find what they needed for their homes, get a discount for repeat business, and—if the item was in stock—free delivery on the same day. My dad would bring the furniture straight over in his red Toyota pickup truck and assemble it on the spot.

By 1989, my parents were bona fide successful entrepreneurs. Aside

from inventory, the lease, and gas money for deliveries, they had no costs. The two of them got up early to make sure I had a hot breakfast and my dad had time to prepare his lunch. He always brought his own rice and vegetable soup to be reheated in the microwave tucked in the back of the store. My mom ate the same or the occasional Cup O'Noodles. They only bought Kentucky Fried Chicken or Carl's Jr. fast-food meals on the weekends when I complained about eating rice all the time.

My parents' store was open 10:00 a.m. to 6:00 p.m., except Sundays when they opened at 11:00 a.m. to get one extra hour back. My uncle Quang moved back in with us. He'd completed some college courses in Oregon and wanted to be closer to the family. This arrangement worked out great because he could help watch over me, and he also worked at Contemporary Design Furniture.

My parents again saved every penny they could.

One day they saw an advertisement in *The Press Democrat* for a brand-new housing development called Mark West Estates. They fell in love with the Windsor, a four-bedroom trilevel home with a three-car garage. It was $199,000 in 1988, a hefty price for a brand-new home.

"Yến, we moving," my mom said. "You make new friends. You can still see Nicole. New house is even bigger so she can come play."

I was sad I wouldn't be close to my friend Nicole anymore. Plus, leaving the apartment meant going to yet another new school, where I would be the new kid again. None of this was relevant to my parents. I was ten. I had no voting rights. They were thrilled to have saved enough to move us into a real house.

With four bedrooms, the Windsor had plenty of space for all of us, including Uncle Quang, and a spare bedroom for all the relatives who would later come live with us when we sponsored them to immigrate to the United States. I didn't want to leave Nicole or enroll in a new school, but I was excited about living in a new home with my own room.

My mom and dad saved enough for a healthy down payment. Within a few years, fed up with paying 15 percent interest on their mortgage, they paid off the house. "Why keep paying money to borrow money?"

my dad said. Most people took fifteen or thirty years to pay off a house, but here were the Nguyễns, moving on up just like the Jeffersons.

We were in America now, making our way with skills from the old country, and my parents embraced this way of life.

As the "most" American of the three of us, I was often asked for my advice.

"Yến, what color you think for window blinds?" Mom asked me.

With the confidence that came from having my parents' trust in me, I was more than happy to oblige. Soon the entire house was shrouded in metallic magenta and teal green miniblinds. It felt very futuristic, and we were all pleased with the outcome.

My bedroom looked completely different from my friends' rooms. Because my parents owned a furniture store, they always had catalogs of different products. Formica was all the rage in the late eighties, and I picked out a super modern full-size pink and white Formica bed with matching nightstands, dresser, and desk. Almost everything else in our house was pure *Miami Vice*. Every floor except the kitchen had wall-to-wall polyester-blend bright teal carpet. Our living room had white fabric couches with pastel ribbons splashed across the cushions.

No one would have suspected that a family of Vietnamese boat people owned this house just a decade after landing on American soil with one hundred dollars to our names and a pair of flip-flops each. The only signs that there were Asians living here were the twenty-five-pound bag of rice in the pantry, my mom's Vietnamese straw broom, and of course, the shoes. There were "inside" flip-flops and "outside" flip-flops. Each of us had another pair of *đôi dép* outside near the back door or garage—every exit with shoes on standby. I always thought it was crazy that my American friends went inside and walked around their houses wearing shoes. Outdoor shoes on indoor carpet? No way Jose.

The Windsor was our "We made it in America" home. So American, in fact, that we didn't have a proper place for the altar found in most Vietnamese homes.

"Mom, why don't we have pictures of Ông Ngoại (my maternal grandfather) or Ông Nội (my paternal grandfather) in the house?" I

asked. I'd seen enough Vietnamese TV shows depicting the homeland to know everyone had an altar, or *bàn thờ,* in a prominent place right when you walked inside. The altar was a space with one or two black-and-white photos of a long-deceased grandparent or relative, or several dead family members. They always looked somber because back then people didn't smile for photos. A proper altar also needed a bowl of fresh fruit and a bowl of uncooked rice grains where you pushed in the incense sticks. You lit the incense once a day and burned it all day. Every day.

"Ehh. Where can we put it?" my mom asked. "Too cold here by front door . . ." I followed her around, inspecting each teal-carpeted room.

"It can't go here. This is where TV is. Too noisy."

I was confused. Too noisy for my grandfathers buried in Vietnam?

"Too many mirrors here, bad luck," she said in the dining room. Then she looked up. "White ceiling, get dirty."

I nodded.

"The house too American. *Ông Ngoại wouldn't feel at home.*" Besides, she said, *"Má không thích mùi khói."* "I don't like smell of incense and smoke. I have allergy."

We were Buddhist but not religious or traditional. The only time I felt like a Buddhist was when we'd go to San Jose and celebrate *Tết,* the Vietnamese New Year. The beautiful temple had a yellow stucco exterior and ornately carved red trim decorating a fancy hat-like roof. Once inside, I took my stick of lit incense, whispered an awkward prayer like "I wish we will be rich, and I will get pink Isotoner gloves for Christmas," bowed my head three times, and planted the stick of incense in the rice. The whole temple thing was pretty basic. I was much more excited about the *bún thịt nướng,* vermicelli with grilled pork, lunch at Vũng Tàu restaurant after our temple visits.

I attended Sunday school here and there with friends who invited me to church services with their families. I thought it was strange that everyone listened to one person, up on a stage, telling them about stories from the Bible. I never saw a woman pastor or priest giving the sermons. It was always a man preaching about God and sinners. The bottom line

was, If you don't believe, you're on the Devil's side, and eventually, you'll end up in Hell.

But what if you're a good person? I wondered. What if you're my aunt Dì Hai, and you were born halfway around the world, and no one ever told you about Jesus and God and the Holy Spirit? Dì Hai, the kindest, hardest working mother of seven, who treated people well and did right by those around her—was *she* going to Hell? It didn't make sense to me at all.

I did start to pray, though. I saw a catchy verse on a ceramic sign at the Classic Duck, a home décor store in Santa Rosa's Coddingtown Mall. It was easy to remember, and I thought it couldn't hurt to hedge a little in case God really was vengeful and sent nonbelievers to burn for all of eternity.

The prayer went, "Now I lay me down to sleep / I pray the Lord my soul to keep / If I should die before I wake / I pray the Lord my soul to take." I modified it a little to cover my parents, who were Buddhist, and so potentially doomed. Now I lay *my family* down to sleep / I pray the Lord *our souls* to keep / If *we* should die before *we* wake / I pray the Lord *our souls* to take."

Every night before I fell asleep, I clasped my hands together on my chest and said the prayer in my head. It would be too weird to kneel next to my bed like they did on TV, and I didn't want my parents to see me praying because they would have asked me questions about where I learned that and why I was doing it. I didn't want to explain it was insurance for us in case something bad happened.

16

Running into the Killer

In 1988, I was ten. It had been six years since we left Eugene to escape the sad memory of my uncle's murder. We had a rhythm now. My parents' business was thriving, and I was settling into life as an American tween. Still, we were living in a Vietnamese food and vegetable desert. So every six weeks, my parents dragged me, continually carsick, on the two-hour drive south to San Jose to stock up on food staples: dried *bún* rice noodles for vermicelli bowls and my mom's favorite crab noodle soup, *bún riêu*. We also had to stock up on *bánh tráng*, rice paper, fresh mung bean sprouts, daikon, and vegetables, *rau quả*. We purchased all the Viet herbs and greens you couldn't find at the Santa Rosa Safeway, and jars full of hoisin, *tương,* and chili, *ớt,* seasonings for *phở,* and huge fifty-pound bags of a specific jasmine rice.

On this day we hit up multiple stores in San Jose's Little Sài Gòn district. Fresh plain baguettes and *bánh mì ba lẹ,* pork and pate sandwiches from one deli, roast duck and *thịt quay,* crispy pork, from the hole-in-the-wall store that sold only those specialties. At Lion Supermarket, I stocked up on salted prunes, White Rabbit milk candy, and fruity flavored Marukawa bubble gum, which came four perfectly round balls to a box. No single store sold everything we needed.

The only part about these marathon shopping trips that was semi-

fun was stopping at one of our favorite restaurants to get delicious, affordable Vietnamese food. My mouth watered as soon as we walked in. The familiar smells of coriander, cloves, cardamom, and star anise triggered an automatic response—time to eat.

My parents always ordered their favorite dish: *bún chả,* a bed of rice vermicelli noodles topped with crispy fried egg rolls and sliced grilled pork, fresh herbs, and julienned carrots, all drenched with the uniquely umami *nước mắm* fish sauce spiced with *sambal oelek,* chili paste. Sometimes there was a *nước chanh*, freshly squeezed lemonade, for me, and always for my mom, *cà phê sữa đá,* Vietnamese iced coffee, French dark roast dripping through the metal filter on the table into a glass filled with ice and an inch of sweetened condensed milk.

I usually chose *phở đặc biệt,* the classic Vietnamese beef noodle soup. *Đặc biệt* translates to "special," but it really means "pho with the works." It's a delicious mix of thinly sliced raw meat that cooks in the hot broth, meatballs, flank steak, and my favorite—chewy white strips of tripe, a.k.a. cow intestine. I squirted in a healthy dollop of brown hoisin sauce and a couple drops of sriracha.

My mom had been on edge lately. She was always worried that I might be kidnapped, but her anxiety was getting worse. Now, on an uneventful day of shopping in San Jose, she seemed more stressed out than ever. I didn't know why at the time, but just a few months earlier, we had taken a vacation to Eugene, Oregon, to visit our sponsors, Wannell and Don Ware, who were delighted to see us and hear that we were doing well in California. On that trip, my parents also caught up with some of their Vietnamese friends still living in Eugene. One of the friends brought up my uncle's killer.

"Do you know he's wanted for murder now?" the friend asked my mom.

"He killed his ex-wife. Now he's on the run."

My mom was stunned. "What? *How?*"

My parents knew this man had served less than two years for manslaughter for the murder of my uncle Tâm. But they had no idea

he had shot and killed the mother of his two children after weeks of stalking and harassing her. The toddlers were in the car as he gunned down their mom. It was a high-profile case, and producers from *America's Most Wanted with John Walsh* traveled to Oregon to do a story on the killing.

At the time, *AMW* was a prime-time hit on Fox. The shows were based on criminals from the FBI's most wanted list, and actors re-created violent, unsolved crimes committed around the country. The goal was to help authorities find these fugitives. John Walsh had created the show after his son Adam was kidnapped and murdered in 1981.

It was a brilliant concept. Cops needed help to put bad guys in prison, and who better to assist than an audience of millions? *AMW* led to the capture of serious criminals.

My mother couldn't shake her fears about this man who had killed her brother and now had murdered someone else. She thought about using her savings to offer a cash reward to help find him. But fate intervened before she could discuss the idea with my father.

After our marathon shopping spree, we stopped for a late lunch. The host gestured for us to find a seat. It was a simple restaurant, standard fluorescent lights shining down on the dark wood chairs tucked under metal-topped tables. It was after the lunch rush, so most of the tables were empty. We chose a spot near the back and sat down. My parents glanced at the worn laminated menu, but they'd been here before, and we were ready to order. I took three sets of chopsticks from the metal holder on the table and wiped them down, pairing each set with a paper napkin and white soup spoon.

"Here you go, *Má, Ba*," I said to my parents.

When my dad looked up to give the waiter our order, he froze. The man who had stabbed my uncle to death was standing right there, asking for our lunch order. My father would never forget that face.

As soon as the killer left the table, my dad locked eyes with my mom. There was no doubt.

"That's him."

My mom nodded slowly. "Should we call the police?" she whispered.

My dad got up from the table. My mom stayed with me, doing her best to act normal. Within a couple minutes, our food arrived.

"Yến, eat," she encouraged me, not wanting to act in any way that might spook our server.

I was oblivious, slurping my *phở* noodles and dipping my meat in hoisin sauce. My dad had quickly walked to a pay phone outside the restaurant to call 911.

"I need help," he said, trying to steady his voice. "I'm reporting fugitive. He wanted for killing someone. I'm sure it's him."

The operator asked him to describe the man.

"Vietnamese. Black hair and mustache. He has tattoo."

"What is your location, sir?"

Right after the call, my dad spotted a San Jose police patrol car and flagged it down, telling the officer what he had just told the 911 dispatcher. Within minutes, another police car arrived. The officers blocked off the entrance and the back door of the restaurant.

"San Jose Police, hello, can we take a look in the kitchen?" The officers scanned the restaurant as they moved between the tables.

My parents were both back at our table, their food untouched, their eyes following the police as they pushed through the swinging door to the kitchen.

The other diners noticed the black-and-white cruisers out front and started looking around, whispering to one another. One couple got up, paid their check, and left.

I was still eating, unaware that my parents had just caught the man who had killed my uncle, now a fugitive wanted for murder.

"I wonder why the police are here," I said, but my parents ignored me.

The police later explained to my mother and father what happened in the kitchen.

"When we asked his name, he gave us an alias and handed over a fake ID. He said he has friends in San Jose and told me he's never been to Oregon," the officer said. "But he was carrying a notebook that had a bunch of phone numbers written in it that started with 503."

"That's Oregon area code!" my mom exclaimed.

The officer nodded.

That notebook, along with the man's tattoos, helped the police decide he was who my parents said he was.

They arrested him and loaded him into a squad car. One officer came out of the kitchen and asked my parents if they could stay for questioning.

"What's going on?" I asked, still unsure why my parents looked so shaken.

"Oh, they just ask questions about the waiter. We think we know him from Oregon," my mom said.

It was dark by the time we got back to our car. I climbed into the back seat, careful not to crush the *bánh mì* and tightly tied plastic bags of groceries piled high next to me. The warm air in the car was scented with herbs and roast pork. I fell asleep on the ride home.

It was another pivotal moment in our lives. Out of all the restaurants in San Jose, my parents had picked the one where the killer had started his job just three days earlier. He wasn't even supposed to take orders; he was hired to work in the kitchen. But the waitress had called in sick that day, so he came out and happened to encounter my parents. Remove any one of those circumstances and he might have gotten away with murder. The name of the restaurant where my parents recognized a fugitive murderer who would eventually be sent to prison was *Tự Do*. It means "freedom."

My mother was never a big believer in spirits or ghosts, but after this incident, she felt that my uncle Tâm had guided her and my dad that day. While she was deeply sad about losing her brother, and felt guilty for bringing him to America, she found some solace in the fact that she and my dad had helped put his killer behind bars.

Life is made up of a lot of coincidences and lucky moments. I believe in God and a higher power. How can I not? So many things have happened in my life and in my parents' lives that we can't take credit for or explain with logic. The way my parents managed to help catch my uncle Tâm's killer is one of them.

17

Growing Up Asian/American

Like my name and my modern bedroom décor, my parents let me choose my clothes and how to wear my hair. I had my first perm at three years old. My babysitter had a home perm kit, and when she suggested the curls, I begged my parents until they relented. By the time I reached my tweens, I had a dramatic new look: skater boy haircut, long on one side, shaved on the other. I ate Doritos and Chips Ahoy cookies before dinner without anyone warning me that I'd ruin my appetite. And my parents never pushed me in school. That was my responsibility. They had their work, and I had mine.

There were, though, places where they drew a red line. They said no to gymnastics. "You can break neck, break bones, no good." They considered swimming but decided against it. "Too much water and chemical. Not good for your eye." They only said yes to taekwondo lessons because knowing martial arts would help me if I was kidnapped. "Self-defense? That okay."

I didn't know at the time how rare it was for me not to have Tiger Parents, the stereotypical Asian parents who want their kids to take violin or piano lessons, excel academically, and pursue a safe and lucrative career as a physician, lawyer, or engineer. Rarer still, they did not

pressure me to be a perfect student. That pressure would come later, from myself, when I realized I could guarantee myself a spot at the ninth-grade awards ceremony by doing two things: getting straight As and achieving perfect attendance.

I saw the greater world through TV, my best friend back then. It was all in black and white, mostly white people, with a few Black people sprinkled in—except two of my favorite shows, which had all-Black main characters: *The Fresh Prince of Bel-Air* and *The Cosby Show*. They were all about families misunderstanding one another, learning life lessons, and outwardly showing love and affection by saying things like "I'm proud of you, Will" or "I love you, Dad." *So American.*

I never saw a single Asian anywhere, not even in the commercials. Those kids eating Kix cereal? White. That little girl with her Barbie? White. Sure, I could always find a Bruce Lee film or Jean-Claude Van Damme movie (I watched *Bloodsport* on a loop), but when it came to mainstream, prime-time shows, there was nobody who looked like us.

One of the few Asians I ever saw on screen was Long Duk Dong, the fictional character in the coming-of-age movie *Sixteen Candles*. Here was Hollywood serving up a super-dorky, emasculated Asian teen boy for all of America to see. That image damaged my generation's perception of Asian American men for decades. But at the time, I didn't have much context. The shows reflected the town I lived in and the school I attended. The lack of representation didn't register for me. As much as I wanted to be "normal" and accepted, it was a given that people like me were invisible to the mainstream media.

By sixth grade, I was one of a handful of Asian kids in my school. The others were obviously second- or third-generation and much more American. I was relatively fresh off the boat, and my severe bangs and blunt bob stood out. I saw myself as an American kid. But to a lot of my peers, I was the Vietnamese girl with the bowl cut.

My nemesis was a white kid named Alan, with a mass of thick brown hair and a constantly chapped bottom lip. He had a bad habit of sucking on his own face so intently it left an angry red, U-shaped

ring under his mouth. He was a couple of grades younger than I was and lived across the street from me. Any chance he got, he would sing, "We are Siamese if you please. We are Siamese if you don't please" from his bedroom window when he saw me walking home from the bus stop.

Even though I thought it was stupid that he was comparing me to a cat (which had nothing to do with my actual culture), it stung. Alan managed to weaponize a Disney song with his taunting sing-song voice!

"Ching chong ding dong" was another refrain he'd yell from his upstairs window. If I glanced in his direction, he'd stick out his tongue and pull back the corners of his eyes. His buddies, twin boys who also lived on my street, copied him.

I was almost at my doorstep one day when he launched another verbal attack from above. "Hi-yah-ohh ka-ra-tay ching chong Mr. Mi-ya-gi you so stu-pid reee-tahd," I looked up at Alan and decided I was done.

I was taking him out.

"You're a *dick,* Alan! Don't ever talk to me again, or you'll be sorry."

"Wahh . . . I'm so scared. Ching chong! What are you gonna do about it?"

"You'll see, *asshole.*"

I really hated that kid, but I didn't know how to hurt him with words the way he was hurting me, so I threw out some swear words to emphasize my point that if he kept messing with me, I'd find a way to get him back. He closed his bedroom window, and I went inside my house, fuming.

I knew I was going to run into Alan later because it was Thursday. Every Thursday we went to Jade's house to jump on her huge backyard trampoline.

Jade was my next-door neighbor and the raddest person I had ever met. She was thirteen, two years older, with long, wavy blondish brown hair and huge bangs teased up in a fan above her forehead. Her

pouty lips were always coated in some flavor of Bonne Bell lip gloss, and she had a big smile with square teeth like Chiclets. Jade showed me how to make the perfect salami, lettuce, and mustard sandwich on a sourdough roll and introduced me to Whitesnake's "Here I Go Again," which we lip-synched in front of the mirror and rewound until the cassette broke. I adored Jade, and when she gave me her black denim Guess miniskirt with leopard-print side panels, I said a silent thank-you to Buddha. Problem was, she was also nice to Alan. She had no idea he was my mortal enemy.

When we showed up for the weekly jump fest in Jade's backyard, nothing seemed awry.

I didn't exactly know how I was going to murder or maim Alan, but I came prepared. We started bouncing: Me, Alan, Jade, and the annoying boy twins.

I was ready to do some damage but also totally unskilled in combat. I was still only an orange belt in taekwondo, and you didn't start sparring until at least green belt.

"I"

bounce

"hate"

kick

"your"

double bounce

"GUTS!!!"

I did my best to kick Alan as hard as I could every chance I had.

Then I pulled out my weapon. There was a gasp. I saw fear in the eyes of my opponent.

"Vicky, no! Whoa . . . whoa, what is going on?"

Jade ordered a truce.

"Stop fighting, you guys! Vicky, is that a *butter knife*?"

I didn't ever tell my parents about how I had brought a butter knife to a trampoline playdate—not to mention the racist slights I endured. It was hurtful to have someone make fun of my eyes or pretend to speak Chinese to me and run off laughing. But my mom and dad never talked

about prejudice or racism, and I didn't bring it up. I suspected they were targets too, but they did not complain or explain. We just endured it. Their attitude was *Why bother being upset?* Who cares if some people treat you badly? Life is too short to dwell on those indignities and injustices. Just find another way.

18

Việt Kiều Heading Home

They say in order to know who you are, it helps to know where you came from. I didn't have any real concept of the country where I was born. My parents never talked about the past or their escape from Vietnam. They also never said much about *why* we left Vietnam. Occasionally, I'd ask about it, and they would say, "We don't want to live under Communist" and "We want you to have education." I imagined communism was some sort of evil government, focused on taking people's money and punishing anybody who opposed them. My parents didn't elaborate. Never complain, never explain.

When I was eleven, my parents decided to take me "home" for the first time since we left, when I was eight months old. We would see all those people they sent money to and called on the phone every few months. I would finally meet my grandmothers and aunts and cousins and see where my parents grew up. A place familiar and foreign at the same time.

It sounded like an adventure. The plane ride alone would take forever. We'd be flying in a Boeing 747, and my dad said the plane was massive. I had only flown to Hawaii the previous summer, and that plane had seemed enormous. I couldn't imagine an even bigger one.

We would be gone for three whole weeks in January. My mom

talked to my teacher, and Mrs. McAleece sent me home with a folder of assignments I would miss during our trip. We did not want to go in the summer, which is monsoon season in Southeast Asia. Also, *Tết*, the Vietnamese Lunar New Year, was in January that year.

By this time, I'd been unofficially Vicky Nguyen for a couple of years. My dad made it official when he went to get my passport for our upcoming trip. He filled out all the name change forms with the United States government. I posed for that passport photo feeling like the coolest kid ever. Vicky Nguyen, American tween, side-shaved hair like the hip-hop duo Salt-N-Pepa, a dozen rainbow plastic bracelets up my arm, and a neon fanny pack holding my Hello Kitty collectibles.

After dinner, I checked my backpack to make sure I had everything I needed. I set out my jeans and an Esprit shirt for the next day. We would be leaving at 9:00 p.m. from the San Francisco Airport. I hoped I'd get to sleep for at least half of the fourteen-hour trip. There were no Western airlines traveling directly to Vietnam, so first we would go to Bangkok, then arrive at Tân Sơn Nhất airport in what was now Hồ Chí Minh City but what my parents and all Vietnamese living in America still called Sài Gòn.

I wanted to get a good night's sleep before the long flight. I knew from previous trips with my dad that we would probably be running around the whole time.

Our first family vacation to Hawaii went like this:

Phwoooooosh. "Time to get up," my dad said as he yanked open the curtains to let the Hawaiian sunshine into the worn hotel room. "You sleep away vacation!"

"Dad, it's *so* early." I covered my eyes and rolled away from the window.

My mom was already up, getting our clothes ready, accustomed to my dad's early morning routine.

"Today we go to Honolulu see the city, go to the beach, then the Polynesian Cultural Center for luau."

I kept my eyes shut.

"Yến, get up."

Since his military days, my dad always woke up early. And when Ba's up, so is everyone else. He clink-clacked around, making Vietnamese coffee with the *phin cà phê* we brought from home. My parents never went on a trip without the metal filter and a Ziploc of ground Don Francisco's French dark roast coffee.

I sat up, scanning the floor.

"What are you doing, Yến?"

"I'm making sure there are no roaches in the bathroom, Dad."

"Ahhh, just bug. They not gonna do anything. Where? Tell me if you see, I kill."

My dad always chose a budget hotel for travel because "we aren't here to see hotel. We only come to hotel for shower, for sleep. The rest of the time we out anyway."

Traveling with my dad was not a "relaxing vacation." It was a sightseeing whirlwind. The agenda was packed. For the five-day Hawaii trip, my father had eight beaches planned.

"These are top beach on the tour book. We want to see them all. Why not? Tomorrow night, we see Elvis!"

We showed up at the dinner, my dad dressed in his best floral shirt, my mom in her nice sandals. "Elvis" was dressed in a white costume with a stiff collar, a deep V in the front, rhinestones bejeweling every square inch of the outfit. I couldn't tell if his giant sideburns were real or pasted on, but his tan face was glistening with sweat under all that hair.

"Wise men sayyyyy, only fools rush in," he crooned as I slurped my spaghetti.

My dad snapped photos. "Good music, huh? He sound just like Elvis."

Then Elvis the impersonator caught sight of our table and walked straight toward me, singing *to* me. My face got hot. I looked down at the table. Suddenly he was right next to me, and everyone in the restaurant was staring at us, cheering.

"I can't help . . . falling in love with youuuuu," he sang in his deep voice.

Everyone started clapping. I snuck a peek at him. The photographer for the show appeared out of nowhere to snap a picture of Elvis and

me. Of course, my parents spent fifteen dollars for the photo of me and the King in Hawaii.

My parents didn't frequent fancy restaurants, only the fast-food chains we recognized. And when we traveled, my dad could not go more than forty-eight hours without white rice. If he did, we heard about it. "I haven't eaten rice in three day," he would grumble. "I can't just eat bread and hamburger every day." Travel became my time to gorge on American food because my mom couldn't pack a rice cooker in her suitcase. Even then, we ended up in Chinatown in whatever city we visited. From Hawaii to Vegas to Washington, DC, we always found Vietnamese food to make sure my dad had his fix of rice. Then Mom and I had to hear his assessment. *Cơm khô quá. Cơm nhão quá.* The rice is too dry. The rice is too wet. The meat is bland. The soup is too sour.

As I pulled the covers up and turned out the light, I wondered how many places my dad would drag us to see in my birth country. I fell asleep imagining how my American self would fit in Vietnam.

In the morning we piled into the Honda, me in the back sandwiched between several bulging cardboard boxes wrapped in multiple layers of plastic tape. This was the custom. Families going back to Vietnam brought "American" products as gifts, inventory to sell, and bribes for customs officials and other gatekeepers who might not be so welcoming to American Vietnamese coming home. Jumbo bags of chocolate and peanut M&M's, Dove soap, Spam, Vienna sausages, Laughing Cow cheese, cases of Marlboros, and Colgate toothpaste. At the time, those were coveted items, nearly impossible to get in Vietnam.

We drove an hour south down Highway 101 to the airport, crossing over the Golden Gate Bridge, the first landmark my parents had seen when they arrived in America a decade earlier.

The flight was the longest I'd ever been on, with a layover in Thailand. When we finally touched down in Vietnam and got off the plane, I knew I was not in California anymore. The air smelled totally different—sweet and smoky. I had never felt humidity like this. My

armpits were instantly sticky. My denim jeans and cotton T-shirt felt heavy and clung to my skin. Walking into the airport was another surprise. Black hair and stern-looking Vietnamese faces everywhere, soldiers carrying big guns and wearing sashes of ammo like guys I'd only seen in the movies. No one smiled.

The soldiers and immigration officers stared at me, at us. *Việt kiều*, overseas Vietnamese, those of us who had left the country. We had abandoned our homeland and we were returning. Everyone who wasn't *Việt kiều* could see it immediately in the clothes we wore, our hairstyles, the way we carried ourselves. We were no longer the same people, even though we came from the same country. I got the feeling they didn't like it.

My parents walked me through the slow customs line, following orders barked at us. *Passports! Name? Why are you here?*

The customs officers looked me up and down. I tried to smile, but they didn't return the gesture. It was clear we were allowed to be here, but we weren't welcome. My dad, his jaw set, tucked some American dollars into our passports and handed our paperwork to the customs officer.

After a few more stern looks, he waved us through.

Outside, it was a totally different story. Throngs of people waited beyond the gates, chatting noisily and calling out to family members who emerged pushing carts that overflowed with cardboard boxes and luggage. These were miraculous reunions every day. *Việt kiều* who had survived the journey to America, Europe, Australia, Canada were back, in the flesh, to tell stories of life outside Vietnam, to share goods from our adopted countries, and most important, to see and hold our blood relatives, whose lives were now so different from ours.

I wasn't ready for the barrage of hugs and sweaty sniff kisses from people I'd never seen before. I knew we were related. These were my aunts and uncles and cousins surrounding me and smooshing their moist faces against my cheeks. It was sensory overload. Rapid-fire, shrill voices shouted in Vietnamese, everyone talking all at once.

"Oh my, her Vietnamese sounds *cứng*," noted one auntie.

The word means "hard," and I took it as "solid." They were compli-

menting my Vietnamese language skills! By the third or so reference to my Vietnamese being so *cứng,* I wasn't sure it was a compliment. I asked my dad what they meant by it.

"It means you have an accent. Your Vietnamese sound American."

Yến is so big. Yến has such short hair. Yến looks like a boy. The hits just kept coming.

I had been around enough Vietnamese people that this barrage of criticism did not surprise me. Vietnamese people say the quiet part out loud, and right away. If you look heavier than the last time an auntie saw you, you'll hear, "*Yến, con mập quá hà?*" "Yến, you're fatter now, right?" If you've lost some weight, "*Yến, tại sao con ốm quá?*" "Yến, why are you so skinny?" There is no correct weight.

When I was younger, I brought this up to my mom because these comments felt insulting and cruel, but she shrugged it off. "They don't mean anything by it." She didn't defend me. But I did notice, over time, my mom herself stopped commenting on my weight.

After a while, I just accepted this way of being greeted. Verbal observations on your appearance are never off-limits. They're the first facts established when you meet someone—as long as that person is senior to you. Anyone older can tell you you're fat, skinny, acne-riddled, pretty, ugly, too made up, not made up enough, no matter the occasion. It could be a wedding, it could be a funeral. The first comment will be about your appearance. It's a given.

I was not actually that big, especially not compared to my friends back home. But here, all my cousins, even the older ones, were lean and shorter than I was. Even though communicating was a bit of a challenge, their huge grins and curious eyes made me feel like family, and their energy was contagious. They greeted me like kids finding the prize in a Cracker Jack box. Here I was in person, someone just like them but totally foreign at the same time.

19

Family a.k.a. *Gia Đình*

To get to the house of Bà Nội, my grandmother on my dad's side, we loaded into a small white taxi, an old Honda sedan. I looked for a seat belt, but nobody was wearing one. It was sweltering with no air-conditioning, so we used the hand cranks to roll down the windows. I sat in the middle in the back, craning my head to see the chaotic street scene as we honked our way into traffic. Nothing in my suburban up-bringing could have prepared me for Sài Gòn traffic. Like in a school of fish made of mopeds, with the occasional car or minibus woven in, everyone was in a mass of fluid motion. Pedestrians raced across traffic from every direction in leaps of faith.

A moped rider honked at us for cutting him off, and we were on our way. The colors of Sài Gòn blended as we accelerated—tan bodies and dusty roads, red-and-white signs with basic words I recognized like *quán ăn,* restaurant, and *xe đò,* bus. There was a whole population of Vietnamese people: kids, teenagers, twenty-somethings—living their lives, going to school, running businesses, shopping on the streets. I had never seen so many people who looked like me, and suddenly here they were in the country where I was born but which I barely knew.

After twenty minutes, the frenzied city streets faded into narrow, bumpy dirt roads. The landscape changed from businesses to neighbor-

hoods, narrow cement homes with angled tin roofs. There were signs of life on every street, mostly older people swaying in hammocks or sitting on low plastic chairs, watching over kids too young to be in school.

We pulled up to Bà Nội's house. My paternal grandmother was already outside waiting for us. Neighbors appeared out of nowhere as we got out of the taxi and unloaded our things. Our return was everyone's business. *Việt kiều* in the neighborhood were a curiosity for all to share. I sensed that life progressed at a much slower pace in Vietnam. The oppressive heat made everyone move like they were walking in syrup so they didn't have to use as much energy. People didn't seem preoccupied with work. They had time to observe.

My grandmother hadn't seen my father for nearly fifteen years, but there were no hugs and kisses. She patted his arm as he carried things inside. His younger brother, Hiệp, came out to help, shaking my dad's hand before picking up some boxes. Aunts, uncles, cousins, and my grandma talked all at once.

"Put the stuff here, come inside."

"Are you thirsty?"

"You look fat [healthy]."

"Is this Yến? Wow! She's so big."

"Come sit, sit. Let me look at you. Wow, all the way from America after all these years!"

I looked around, wide-eyed. I saw an altar with my grandfather's photo above a plate of fruit, rice, and incense standing near the door. Next to his picture was the black-and-white image of Hùng, my father's oldest brother, in his military uniform. Hùng was still MIA from the war, and this was the last photo that had been taken of him.

My grandfather had died when I was seven, and my father hadn't been able to travel home to say goodbye. My dad wasn't outwardly emotional, but this was a momentous visit with his family. He'd lost his father. His brother was unlikely to be found, and now my dad was living thousands of miles away. My grandmother was stoic. These were the circumstances, and there was nothing to be done to change them.

The floor and walls of my grandma's house were all concrete. Win-

dows were simple cutouts with metal bars on the outside. It was still so hot. There was no air-conditioning. We sat on mats on the floor, and I listened as my dad described the flight and how we were treated at the airport.

"I gave them some money and Marlboros," Dad said, "and we got through customs pretty quick." My aunts and uncles were gathered around him, listening intently and studying my dad. The family's oldest surviving son was back to share stories about his new life in America.

I listened to all the adults talking, imagining what it had been like for my dad to leave these people, his family, to start his life over in the United States. As an only child, I was used to being the only kid in a room of adults. Normally it was boring, but I didn't tune the grown-ups out this time. I stared at their faces, all versions of my dad's. His younger brother, Hiệp, was the spitting image of my father, just skinnier and tanner, with a deeper voice.

"Dad, wow, Chú Hiệp looks just like you!"

"Just like me? Nah. I don't think so." My dad looked at his brother quizzically. They were separated by so many years and so many miles, it was as if he could no longer comprehend their physical resemblance because their lives were so radically different.

My dad's sisters looked a lot like my grandmother. With so many of them, I had a hard time keeping everyone's name straight and remembering who was older or younger. I thought a lot about what my life would be if my parents had stayed in Vietnam. Would I live like this, in a cement house with barred windows and fluorescent lights?

Vietnam was fourteen hours ahead of California time, and the tropical air made me sleepy. I asked my mom if I could take a nap, and one of my aunts showed me to a small room with a wooden bed topped with a woven mat and a thin cushion. It was smaller than my mattress at home, and even smaller than the typical twin-size mattress my parents sold in their furniture store. But people here were smaller too, and I was just a kid, so it fit me fine. I drifted off to sleep, not even waking up when kids lit firecrackers in the street anticipating the Lunar New Year. It wasn't

time yet for the official celebrations, but just like the days before the Fourth of July in America, everyone had their fireworks ready to go.

My cousin Hà was the closest to me in age and the friendliest, always grinning and ready to play. When she got home from school, she found me. She asked me questions about what I liked to do and what I liked to eat.

She called me Chị Yến, using the kinship title "chị," which is like "older sister." "How do you like it here?"

I did my best to answer in Vietnamese, referring to myself in third person, which is the norm.

"*Chị Yến thích Việtnam nhưng thời tiết nóng quá.*" "Big sister Yến likes it here. But it's so hot." Through hand motions and by playing games and goofing around, Hà and I had fun getting to know each other.

"*Chị Yến muốn chơi bầu cua cá cọp?*" she asked. "Do you want to play gourd, crab, fish, tiger game?"

She showed me how to play this game, which is kind of like roulette but with pictures of a gourd and some animals. You put your money on whichever animal you think the three dice will show. If none of your animals shows, the banker takes your bet.

"Roll the dice," my cousin instructed. Hà taught me the point of the game: win as much money as you can. One was never too young to start gambling in Vietnam. She showed me her two toys, a stuffed animal and a doll. She shared a room with her sister. It was spare, with just school materials and a couple pairs of flip-flops.

There was nothing fancy about the rest of the house either. In the kitchen were plastic bowls and a flyswatter, a few pots and pans, some pantry goods, and a bag of rice. Bedrooms had mosquito nets and plastic stools for chairs.

The bathroom was the toughest part to get used to. The shower area, sink, and toilet were all in one room, but they weren't separated by glass walls. The corner next to the plumbing was where you bathed.

Mom said we were lucky to have running water in the house, but there was no hot water. If you wanted warm water, you had to have

someone boil it in a big pot, transfer it to a bucket, and carry it into the bathroom. Then you would mix in the cold water. It was too much trouble to do regularly, so I learned to take cold showers, quickly.

"Mom," I whispered, "I don't like the bathroom. Can you help me?" I was used to showering on my own, but it was challenging to scoop cold water out of a bucket with a cup and get myself clean.

Using the toilet was another challenge. It was just a hole in the ground with two rectangular spots, one on either side, to put your feet. You had to squat for number 1 and number 2 and balance to make sure your aim was accurate. And because the spout for the shower was so close by, instead of using toilet paper, you were expected to wash yourself afterward.

Everything was always wet in there. That meant the room had a unique, unpleasant smell that I never got used to. There were flying bugs everywhere in the house, but the place they loved most was the bathroom. They especially loved flying near the toilet. I only went when it was absolutely necessary.

My cousin Hà took us to the nearby market to find clothes that would help me survive the heat—lightweight two-piece shorts and tank tops made of an airy cotton material. These shorts and tank top sets made up every girl's basic wardrobe because they kept you cool and were easy to wash and hang dry. Soon I tanned to a light brown from playing outside. With my new pastel short sets, I was almost indistinguishable from the other kids in Vietnam—unless you heard my broken Vietnamese.

During the day, we visited Sài Gòn's marketplaces. Chợ Bến Thành was the biggest one, right in the center of the city. Walking around Sài Gòn was even scarier than being in a car. There were no crosswalks or traffic lights. Every step took confidence. Either you were in motion or you weren't, and you had to commit when it was time to go with the crowd. I followed my parents and family members, stepping in rhythm with them.

The market had dozens of vendors. Each stall was overflowing with products. Colorful silk fabrics for *áo dài* and custom men's suits and

shirts, ceramic and porcelain bowls and housewares, shoes, and jewelry. You couldn't walk past a stall without someone beckoning you over. "Come in, come, buy here, buy here! I'll give you a deal!" It didn't matter if it was a granny or a young person, they were equally aggressive about recruiting customers, even making a *tsk tsk* sound if you didn't come into their stall.

One day my dad borrowed my uncle's moped and took my mom and me around the city. It was scary at first to zip in and out of traffic, and my dad's scootering skills were a little rusty. I thought it was crazy that no one wore helmets. At home, my mom constantly worried about me getting hurt. But here, all three of us squeezed together on the seat, me in the middle and my mom keeping us together from the back. We all laughed when we saw a family of five on a moped, a toddler in front, then the dad, another small kid, and the mom holding the baby on the end of the seat. That was just how people got around, and we joined in.

The street food was the best. I got used to the flies constantly buzzing around the pots and bowls. Everything was available. *Thịt kho,* salted pork with caramelized eggs served with a bowl of rice and some pickled greens. *Phở* anytime of day, not just for breakfast. We ate *bánh cuốn,* steamed rice rolls with ground pork and strips of black mushrooms drenched in fish sauce and topped with fried onions and fresh basil, *bánh xèo,* yellow mung bean crepes stuffed with shrimp, pork and jicama that we wrapped in lettuce and dipped in spicy *nước mắm.* We snacked on whatever we wanted from the food stands and then came home to family feasts prepared by my aunts and uncles. At night I slept under a mosquito net. My grandma put fans in our room so we would get some relief from the humid air. I fell asleep to the hum of the rotating blades.

20

Bạc Liêu and French Fries

After spending time with my dad's side of the family in Sài Gòn, we took the longest bus ride of my life down to Bạc Liêu, the country village where my mom's family lived. The *xe đò* carried about fifty people and had worn-out leather seats with foam poking through. I got carsick from the way the bus moved, lurching forward with jerky stops, belching out clouds of stinky black smoke.

The roads were only two-laned, with a maximum speed of forty miles an hour. Once we got out onto the rural roads and traffic died down, I could see the open country. It was green and lush. Sometimes I spotted a farm with straight rows of mango trees planted along the road. It didn't look that different from the agricultural suburbs of Sonoma County. We had to cross two big rivers. That meant waiting for a ferry each time. At the ferry stand, dozens of kids my age and younger crowded around us as we got off the bus. They were barefoot and dark brown, their skin tanned from spending every day outside, waiting for passengers like us.

Some were selling lottery tickets or trinkets like bead bracelets. So many were just begging. There were kids who were missing a hand or a foot. Some had grayish eyes; the iris, which was supposed to be brown, was clouded over. All of them looked like they were hungry, their tat-

tered clothes hanging off emaciated bodies. They reminded me of the homeless people I'd see in downtown Santa Rosa, people who looked smudged and worn down, like they rarely spent time inside or in a safe place.

Some kids were maybe twelve, a year older than me, carrying toddlers on their hips. They asked for money for their little sisters or brothers. Some grown-ups stopped to pull out some change. Others brushed past the begging kids without a glance.

They made their way toward me.

"Please do you have some money, any change?"

I froze.

"Please, *Chị,* Sister, just a few cents for us? We are hungry. Sister, please, anything you have, *please?*"

I didn't know what to say.

"Mom, do you have any money?" I whispered. "Dad? Can we give them some?"

My parents dropped a few coins and small bills into the children's hands, and more kids came over, crowding us.

"Yến, that's all we have." My parents waved the children away, "No more, no more."

No stranger had ever called me "sister" before. I wanted to cry. There were so many pleading, high-pitched voices desperate for any pennies we could spare. I couldn't help them, and I couldn't speak to them because I didn't know the right words to say. I just watched as they moved through the crowd. I didn't want to walk around the ferry anymore. I got back on the bus and waited until we crossed the river. I didn't understand how kids could be this poor, this helpless.

I was quiet for the rest of the ride. The same thing happened at the second ferry stop. More kids, more requests for money and help.

"Mom, where are their parents? Why aren't they in school?"

"This is Vietnam, Yến," my mom said softly. "You see how poor it is. In the country it's hard to make a living. Not everyone can go to school, they live too far away. This is how they get by. This is their job. We try to help, but we can't help them all."

When we finally got to Bạc Liêu, another set of excited relatives waited with sticky sniff kisses. My mom was very close to her sisters, and they were all there to greet us: Dì Hai, Dì Ba, Dì Hường, Dì Hoa, and Dì Hồng. It seemed all of my aunties' sons and daughters were there too—a huge crowd of relatives with so much joy and happiness on their faces. I loved seeing my mom laughing with her sisters. At home, I never saw her engaging with women her age. It was always just the three of us.

As an only child, I was overwhelmed by this boisterous group. I felt like they had so much love for me, someone they didn't know, and I didn't feel that I had earned their affection. How could they be so loving toward a kid they'd never met? And yet it felt real, like an instant family. I was so grateful for their welcome.

My maternal grandmother, Trần Thị Tư, was in her late sixties, but to me she looked like she was in her nineties. She reminded me of the grandmas in the Charlie and the Chocolate Factory books, Grandma Josephine and Grandma Georgina. She was very thin, with a drawn face, deep-set eyes, and pursed lips. While there was kindness in the way she looked at me, I didn't spend much time with my grandmother. I just didn't know what to say to her. She was the matriarch, and family members buzzed around her. She'd given birth to all my aunts and uncles and raised them. Now it was their turn to fuss over her. During my time in Bạc Liêu, I remember my grandma seeming like a living statue. She didn't move around much, but she saw everything.

My aunt Vân was the oldest sister in the family and the one who vehemently opposed my grandfather's Other Family. I called her Dì Hai, which means Aunt Number 2. In Southern Vietnamese families, the firstborn is referred to as sister or brother Number 2, the second born is number 3, and so on, which is confusing but that's how it's done. Dì Hai was more of a grandmotherly figure to me. Unlike the other adults, she never commented on my looks or spoke about me in front of other people like I wasn't there. She addressed me directly and always with a smile in her voice and kindness in her eyes.

Dì Hai was also a strong and independent woman. Her husband had been imprisoned by the North Vietnamese in what they called a "reeducation camp," where prisoners were forced to spend long hours doing manual labor and fed barely enough to survive. During the war, he had been a high-ranking military official for the South Vietnamese. For that he was punished when the communists captured him. Dì Hai had raised seven children on her own. And maybe that's why her love language was food.

It totally matched up with mine. She wanted to know what my favorite American foods were.

"*Yến, con muốn ăn cái gì?*" "Yến, what do you want to eat?" Dì Hai asked me.

When I told her I missed french fries and ketchup, Dì Hai whipped out her biggest cutting board and placed it on the ground. Using a sharp cleaver, she cut up the potatoes into the skinny strips I described. I watched in amazement, this gray-haired auntie in a full squat, making a mound of shoestring fries as the oil heated in a pot nearby.

Dì Hai had never heard of ketchup, but that didn't matter. My mom helped me describe the sauce.

"*Làm với cà chua, một chút đường,*" my mom explained. It was made with tomatoes and sugar, and you used it as a dip for your french fries. Dì Hai, always ready to cook new things, assumed her squatting position and mashed the ripe tomatoes with her well-worn mortar and pestle. When it was all pulverized, she mixed in some sugar to cut the tartness.

"Here, try these!" She laughed, pushing a bowl of freshly fried potatoes sprinkled with salt toward me. Next to it she placed a bowl of her homemade ketchup. It was nothing like McDonald's, but I loved her so much for trying to make me happy when I was homesick for American food.

The living conditions in the countryside made Sài Gòn seem modern by comparison. Here, we had no running water inside. There was a pump outside the house for cold water only. The toilet wasn't even a hole in the ground, it was an outhouse away from the main house. The country mosquitoes were savage. We hadn't brought bug

spray, and no one thought to use it because it wasn't stocked in any of the stores. I felt like I had chicken pox all over my arms and legs, big red bumps, swollen and itchy, from the insects gorging on my sweet blood.

I knew even then that physical discomfort was a small price to pay for this life-changing experience. Through my extended family, I learned what it meant to be on the losing side of a war but to still make a life in your homeland. I saw what it meant to live in a country that limited your freedoms and oppressed people of different political beliefs.

I had a three-week glimpse of what my life could've been. Maybe I would have gone to school until ninth grade and then started working at the family rice factory or at my aunt's vegetarian noodle stand. Most of my family was involved in commerce, and only one of my cousins, Tuyến, had gone on to higher education, for engineering. They were happy, yes, but this life was vastly different from what I had in America. My opportunities in Santa Rosa seemed limitless compared to this. For the first time, I truly started to understand the sacrifices my parents had made, leaving everyone they loved behind—largely for me to get an education and "have a better life."

Even though, as a sixth grader, I couldn't explain it, I could feel it. I was on a different path thanks to my parents' choice to escape and the lucky plot twists we had gone through since we arrived in America. We had endured the vicious murder of my uncle, the wariness and discrimination against refugees, and yet I knew I had choices in our adopted country that I wouldn't have had if my parents had stayed in Vietnam. It was enough to flip a small switch in my brain that said, "You don't get to take this life for granted. You have to make the most of it."

When I came back home to the *Miami Vice* house, I felt purposeful. I appreciated the opportunities I had, and I wanted to excel.

Years later, when I traveled back to Vietnam with Brian, Emmy, and Odessa (Renley hadn't been born yet), I went overboard preparing

them for the bugs, the lack of toilets and running water. I warned them it would be wretchedly hot without air-conditioning.

"You don't understand, Brian. It's going to be *so* different. Everything is super basic, and it's going to be hard to adjust."

I was wrong on every count. All my relatives had indoor plumbing. Air-conditioning was now standard—even the taxis had AC! Sài Gòn was home to a fancy new mall with an incredible sit-down food court. There were new hotels all over the city. The girls marveled at the breakfast spreads everywhere we went. Steaming hot *phở,* tropical fruit trays boasting milk fruit and lychees, and chefs standing by to make your eggs to order.

"Mommy, Vietnam is nothing like you said it was going to be," Emmy said, skipping down Main Street at the brand-new Vinpearl Land Nha Trang theme park. It was built exactly like Disneyland but with Vietnamese cartoon characters. Brian and I joked that it felt like we were in Jurassic Park because the contrast was so stark—modern, colorful rides and shops surrounded by dense tropical jungle. But the part that made it feel so eerily luxe was the lack of people.

An attendant manned every ride, but there was hardly anyone waiting in line. We weren't sure if some of the rides were open until a guide in a pristine uniform with a big smile appeared to personally welcome us onto the attraction.

Mosquitoes were a nonissue because we had packed bug spray.

So much for roughing it. My family had a five-star experience in Vietnam, nothing like my first trip home.

21

The Vet Intern

Back in Santa Rosa toward the end of elementary school, I was bored out of my gourd on the days Mom made me go to the furniture store after school instead of letting me stay home alone. Fortunately, I came up with a plan to escape the aisles of upholstery and oak bedroom sets. Guardian Pet Hospital, where a veterinarian named Joy Mueller had a practice with an all-female staff, was kitty-corner to my parents' store. Dr. Mueller had overseen the construction of her animal hospital and took great pride in choosing all the details herself. The walls were a pale mauve. It was warm and clean, with hanging plants and neat shelves displaying prescription dog foods and special flea shampoos. I first met Dr. Mueller when we took our dog, Cali, to her practice for her first checkup and shots. It felt more like a home than a hospital.

Like every other kid who loves animals, I wanted to grow up to be a vet. A doctor who cares for cute, furry creatures. Never mind that cat allergy we discovered in Reno, I was eleven and figured I could have a "dogs only" practice or find a work-around.

One afternoon, when I had finished my after-school snack (two Kentucky Fried Chicken drumsticks, corn on the cob, a biscuit, and a strawberry shortcake parfait), I asked if I could go over to the vet hospital.

My mom and dad looked at each other and shrugged. "Okay." They

didn't see why I shouldn't be allowed to go, and neither one questioned why a sixth grader would want to spend time in an animal hospital. My mom, surprisingly, wasn't worried about my safety. The fact that it was a hospital, albeit an animal hospital, within a stone's throw of her workplace, eased her worry that I might get kidnapped. Plus, they were classically busy refugee parents. As long as I was in school or with reputable adults, they figured I'd be fine.

It didn't seem too busy in the waiting room, so I said hi to the receptionist and politely asked if I could see Dr. Mueller. I had spent so much time as the only kid in the room, I didn't think twice about dropping in without an appointment.

"Hi, Vicky, how are you? Everything okay with Cali?"

"Yes, Dr. Mueller. She's great. She's growing so fast."

"Call me Joy," she said. "What brings you here?"

Here again, an adult wanted me to call her by her first name? That was still so weird to me. She was a grown-up, and a doctor no less, but she wanted me to feel comfortable around her. Joy had a square jaw and slightly bulging gray-blue eyes. She wasn't married, and she spent every day at her vet practice.

"I'm really bored at my parents' store," I told her. "I love animals, and I want to be a veterinarian. Do you think I could come here sometimes and watch what you do?"

Joy said, "Sure."

"Thank you so much!" I was delighted. "Can I start . . . now?"

After that, whenever I was done with my homework, and every day that summer, I showed up at Guardian Pet Hospital. I stood in the exam room with Joy or Cara, her vet tech, for all the visits.

"This is Vicky. She's helping out here," Joy or Cara would introduce me. Oddly, no one ever asked why there was a kid hanging out in a vet hospital.

I was even more excited when they gave me real jobs to do.

"Vicky, can you get those paper towels and spray down the exam table for the next appointment?" Joy asked.

"Okay. Like this?"

"Yep. Get the whole surface."

I dutifully wiped, happy to contribute.

"Do you know why all those little black specks turn red when the spray hits them?" Joy asked. "That's 'flea dirt.' The fleas suck blood out of the dog and poop it out."

"Ohhhh." I nodded, fascinated that these little black specks were turning back into liquid blood when I sprayed them. "Weird."

I graduated from cleaning the tables to helping with vaccines. Cara showed me how to find the right vial in the fridge for whatever shot the dog or cat needed. I read the labels carefully. I learned cats could get a disease called feline immunodeficiency virus or FIV, which was like HIV for people, but there was a vaccine to protect cats. It was the nineties, and I knew humans weren't so lucky. I was careful and studious. I spent several hours there each day.

Sometimes I drew up the shots in front of the pet owners, holding the syringe vertically and tapping with my finger to get the air out. Joy said that if there was a bubble in the injection, it would hurt the dog or cat when you pushed the medicine under their skin. Some days, if it was a calm, big dog, like a golden retriever, or Joy knew the pet's owner well, she'd let me administer the shots myself.

"Be confident," Joy said. "Grab the scruff right back here between his shoulder blades. Use your thumb and your two fingers like this." She grabbed the loose skin on a black standard poodle's wiry neck. Then with her right hand, she poked through the skin and injected the syringeful of liquid in one smooth motion.

I got the hang of it quickly. I felt so cool. *Doggie* Howser, Animal Doctor. I was not squeamish at all. I loved surgery days. I got to see Joy carefully take out the spleen of a German shorthaired pointer and put it into a stainless-steel surgical tray. The dark maroon blob had just been inside a dog and now it was free, a little organ that no longer served a purpose.

I made sure I was in the OR when my parents brought our dog, Cali, in to get spayed. When the surgery was done, Joy gave me the uterus and ovaries suspended in formaldehyde in a plastic specimen cup. I took it to show-and-tell.

My sixth-grade teacher, Mrs. McAleece: "Vicky, what do you have for us today?"

Me, raising the plastic container with its orange screw-on lid: "This. This is my dog's *uterus*!"

"Ewwwww, what?" My classmates were aghast.

"Cool!"

"That is so gross!"

"Weeeeeeird!" was the general consensus.

I carried on with a flourish, explaining the surgery and anesthesia and how Joy sewed Cali back up. "I got to see *everything,* and the vet let me keep this. The liquid is formaldehyde."

I showed my classmates where Joy made the incision in Cali's belly.

"They cut her open right here (I gestured to my tummy), and they snipped this out. She can't have puppies now."

"Awwwww." The kids felt bad my dog would never be a mom.

Mrs. McAleece: "Okay, thank you, Vicky. That was . . . very . . . um . . . *interesting.* Who wants to go next?"

I sat down, satisfied with my show-and-tell. *Who could possibly top that?*

Joy was one of the first adults to make a big impression on me. She was unofficially a mentor. She took me to the fancy mall in Corte Madera, where she introduced me to Boudin clam chowder in a sourdough bread bowl. She and Cara took me to dinners at a bar and grill in downtown Santa Rosa, where I ate spicy fries dipped in ranch for the first time. These two women helped shape my understanding of work and of myself. And once, unintentionally, they said something that would affect my understanding of how some people might perceive my Asian features.

One day at the vet hospital, Joy, Cara, and I were joking around about what kind of dog breed we thought we were most like.

"I think I'm most like a Doberman," I said. "I'm loyal and protective of my family. Plus, I have shiny black hair."

"I would have said a pug or Boston terrier." Cara laughed.

"Why?" I asked.

"Because of their face structure."

Joy chimed in, "They're more flat and smushed, kind of brachyce-phalic."

Breaky-what? I thought.

I didn't feel like they meant anything bad by it. It was just a matter-of-fact observation. When I got home, I looked it up. "Brachycephalic." It meant "shorter nosed and flat faced."

So that's how they saw me. Flat faced.

I'd never thought of myself that way before. But here were two ladies I looked up to, who were really kind to me and treated me like family. They mentored me and took me shopping and out to fun meals at places I'd never been with my parents. The fact that they saw me so differently than I saw myself surprised me and hurt in a way I didn't totally understand. For the first time, I became self-conscious about my face.

I started to pay attention to how everyone else's face looked from the side. Since I was around mostly white people with European features, I definitely saw it. Their noses protruded much farther than mine. Compared to that, yep, I was flat faced.

It was such an innocuous conversation, and I know for sure Joy and Cara weren't trying to be mean to me or belittle me. But it's funny how one comment on your appearance, especially when you're a kid, can stay with you.

22

Mischief and Misdemeanors

By the time I was thirteen, nothing could get me to see eye to eye with my parents. They were overbearing, nosy, annoying, and unbearable to be around. It was a turbulent time. I was learning, on my own, to be a teenager in America. My parents could not offer any guidance. It was a bad combination.

Because they did not grow up in America, they were not equipped to understand how American teens operated. They didn't know that this was supposed to be a time of increasing independence, for me to test boundaries but still have the safety of my family to protect me.

Instead, my normal daily routine looked like this:

Mom pulled up in front of Hilliard Comstock Middle School. The campus was just a few miles from our house. I was perfectly able to take the bus, but Mom was worried I'd be abducted, so she picked me up and let me off at home before heading back to the furniture store.

I slid out of the car with my bookbag.

"Make sure you lock the door, Yến. Don't open if somebody knock!"

"I know, Má."

"Don't open if they say, 'It's okay, I know your parents.'"

"Yes, Má."

"Don't open for any reason."

"Mom, I know! You tell me this every day."

It was always: *Don't talk to anyone you don't know. Stay away from vans.* I was terrified of the Neighborhood Watch sign—that sinister black silhouetted man with the hat and pointy nose.

But my parents couldn't watch me around the clock. So by middle school, feeling bold and in need of some junk food, I regularly snuck down the street and across a field of foxtails to get fries from Buns and Burgers. I watched for any scary vans with tinted windows as I raced home, making sure to get back in the house long before my parents were any wiser.

I had always been obedient. But now I was a teenager with hormones kicking in. I was certain I knew everything. Like the characters I saw on TV, I experimented with slamming doors and talking back when I didn't get my way. Both got me in big trouble. My dad would do the Asian dad reprimand, voice low and slow, eyes locked in a fierce glare that went just far enough to scare me into silence.

I had already been the interpreter of many situations, helping my parents understand small things: back to school night, parent-teacher conferences, school dances. I also explained the big things: why birthday parties and sleepovers mattered, why it was embarrassing that they spoke Vietnamese to me in front of my friends, how they weren't supposed to hover after dropping me off at school.

"Bye, Mom," I'd say.

Mom, lingering and craning her neck to make sure I got past the school gates before she drove off.

Me, turning around, hissing, "Mom, go!" before trying to catch up with my friends, whose parents had already pulled away from the curb.

Everything was new to them about how to raise a teenager, and everything was foreign to them about how to raise an *American* teenager.

My mom reflexively said no to any request I made to meet friends at the mall or go on a group movie date with boys. She was overly protective, and I was tired of having to argue with her, then go to my dad and

get him to overrule her decision. This had worked when I was younger, but now I saw how much tension it caused between them. None of us saw eye to eye. Communication was impossible.

Not that I really wanted to talk to them. I was busy chatting with this kid Greg, who was in my history class. He had devastating blue eyes, freckles, and dark hair. We exchanged phone numbers, and since Greg didn't have a curfew, I would sneak the cordless phone up to my room after my parents went to bed and we'd spend hours talking about nothing.

"What's up."

"What's up."

"So, what did you do after school?"

"Nothing. What about you."

"I just chilled with my homies."

"You're cute."

"Thanks."

I was glued to the phone, sometimes not saying anything, because just *being* on the phone with Greg was fun. After a few nights of that, my dad heard me up at midnight and got on the other phone: "*Yến, cúp phone BÂY GIỜ!*" "*Yến*, hang up the phone NOW!"

Either my parents didn't know how over-the-top embarrassing they were or they didn't care.

I knew that family in Vietnam was a patriarchal system. Asian cultures expect honor and duty to your elders. It was how my parents were raised. Kids didn't converse with their parents, they didn't confide in them, and they certainly didn't debate them. I was expected to figure everything out on my own, from drinking and drugs to dating and sex. My parents didn't think there was that much to figure out anyway. The answer to all of that was "Don't do it, ever."

But like a lot of American teenagers before me, I ignored my parents. I had a huge crush on a boy a grade ahead of me. My journal went on endlessly: *Logan is so cute. Does Logan know I exist? I heart Logan.* At school, I stalked him. At home, I studied a photo of him I had gotten from the

yearbook photographer, my friend Terressa. Eventually and miraculously, I got on his radar. We hung out a few times. I had my first real kiss with Logan, a horribly sloppy and slippery affair at a movie theater.

One day when I was late coming home from school, my mom drove around in our old Honda looking for me. She found me at the neighborhood park. Before I saw her, she spotted me sitting on a bench with my legs draped over Logan's lap. She slammed on her brakes and screamed in her embarrassingly loud and shrill voice, "YẾN, GET IN THE CAR NOW! WE ARE GOING HOME!" It was humiliating. I was red-faced and pissed off. I fumed in the back seat, wanting to die.

When we got home, I yelled in her face for embarrassing me.

"I CANNOT BELIEVE YOU DID THAT. I WAS JUST HANG-ING OUT!"

Before I could get another word out, she slapped me hard. I was so stunned, I didn't cry.

"*Hỗn quá!*" My mother told me I was being completely disrespectful. I put my hand up to my stinging cheek and stormed upstairs. I sobbed into my bed.

We never talked about it again.

Without any other female to confide in about personal things, I took it upon myself to learn the ways of womanhood. When I got my period, I went to my mom's bathroom and grabbed a tampon from the blue Tampax box. I studied the diagrams, followed the instructions, and made it work.

When it came to sex ed, my best source of information was *Cosmopolitan* magazine. There was no way I would ever ask my parents to buy that magazine for me. The headlines plastered over scantily clad Cindy Crawford, Claudia Schiffer, and Linda Evangelista were way too scandalous. Every article sounded like a must-read, though. "How to Act, Not React When He Makes You Crazy," "Relaxing Him (and You) on a First Date," "Do You Think You Really Know Everything You Think You Know About Sex? A Quiz."

I didn't know what I needed to know.

At our local grocery store, I stayed at the checkout stand and read as fast as I could while my mom shopped. So many quizzes about so many things! I never had enough time to get through them all. One day, frustrated that there was so much to learn and so little time, I took a magazine off the rack and carried it into an empty aisle. When the coast was clear, I lifted my shirt and stuffed the magazine into my shorts. I pulled my shirt down over the magazine and walked stiffly to the front of the store to meet up with my mom.

The exhilaration of leaving the store, a *Cosmo* hidden in my shorts, was addicting. It was so easy and, in my thirteen-year-old mind, a necessary means to obtain valuable information. I didn't have an older sister, and my friends weren't much more knowledgeable about these key topics than I was. I had to educate myself, and our set of World Book encyclopedias wasn't cutting it when it came to relationship advice.

However, my shoplifting spree was short-lived. When I tried to repeat my successful five-finger discount, a security guard in plain clothes appeared out of nowhere and confronted my mom and me at the checkout stand.

"What's that under your shirt?" he barked.

"Nothing," I stammered, my face growing hot. My mom was totally bewildered. Who was this man and why was he asking her daughter what was under her shirt?

"Ma'am, I'm undercover security here. I saw your daughter put a magazine under her shirt."

My mother turned toward me with concern and confusion. "Yến, what he talking about?" She always used my Vietnamese name when speaking directly to me.

I lifted my shirt and pulled out the electric blue August 1992 *Cosmo* issue with its blaring headline, "How to Get Over a Bad Love Affair (That Was So Good)." My mom was processing the scene. She didn't know what was worse—being detained by a grocery store security guard or that her daughter had crammed a magazine down her shorts.

The guard made me stand in front of the store while customers

walked by and gawked. This was the most law enforcement action the Larkfield shopping center had ever seen.

Snap. The guard took a Polaroid of my face.

"We won't press charges," he told my mom. "But your daughter is banned from the store."

Oh my God. I was no longer allowed at Molsberry Market because I was a two-bit teen magazine thief.

"Young lady," he went on, "your photo will go *here* on this bulletin board." He stuck a thumbtack through my photo and into the wall of shame. "If anyone sees you back inside the store, we will call the police. Do you understand?"

I couldn't make any audible sound come out. I just looked down at my feet, wanting so bad to have the powers Evie did on that show *Out of This World,* where I could just put my pointer fingers together, freeze time, and run out of the supermarket to avoid humiliation.

My mom nodded at the guard stoically, pushed the grocery cart out of the store, and walked toward the car. I could not get out of there fast enough.

"Yến, what happened? Why you steal?"

I said nothing. My mom didn't say anything more to me about it. She was so embarrassed and surprised that I had just been caught trying to steal a magazine about sex and dating. She did not have a chapter in her parenting manual for addressing this criminal act. It drew attention to us for all the wrong reasons.

There, for all the neighborhood shoppers to see, was my photo on the Molsberry Market most wanted list. The whole thing fell under the category of "Let the authorities and system teach our daughter what to do." My mother figured the security guard's stern warning would be enough to deter me from a life of crime. She also didn't want to get into all the particulars of why I would (a) steal, (b) want to read *Cosmo,* and (c) have questions about boys.

We got home, went inside, and never spoke of it again.

Although I was having a rough time in my early teen years, we never discussed it. If I was anxious or stressed or had any other emo-

tions that needed regulating, I was on my own. My parents had been through their own trauma, and that was all in the past. They didn't talk about any of it with me. All I saw were two people who went to work and provided me with what I needed to be a generally happy kid. They were not stingy with material goods. But they were not expressive with their feelings either.

Not talking about things was our family's way of life. They were the parents, doing their job, and I was the teen, learning how to do mine.

23

Boys

I was not boy crazy, but once I decided to set my sights on someone, I obsessed over him. The first one was a kid named Charlie. He looked a lot like an eighth-grade Kirk Cameron: rail thin, sandy brown hair, big brown eyes, and a sweet smile. And he was wicked smart. Charlie always had the first answer on the board in geometry, and he was always right.

"Thank you, Charlie, for taking on that difficult equation," Mr. Spillane said, because Charlie not only filled out the example correctly and neatly labeled all the steps but routinely took the hardest problems on the board, unlike me. When it couldn't be avoided any longer, and it was my turn to do one of the "public problems," I always got there early and filled out the easiest one.

Charlie and his best friend, Brett, had this habit of walking a big circle around the gym at break time. I got the brilliant idea that my friend Keelie and I should walk that same route, but in the *opposite* direction. You know, so I could casually make eye contact and say "Hi" or "What's up?"

We had two breaks during the day in junior high. Snack was usually long enough to make at least one revolution around the gym. Lunch was enough time to get two or more. That meant I had multiple opportunities over the course of an entire semester to muster up the guts to say

"Hey." Every time we got close to the halfway point, and we could see Charlie and Brett in the distance, I'd say, "I'm gonna say something." And Keelie would nod encouragingly. My heartbeat got faster. My face got hot. We passed Charlie and Brett.

I never *once* said a word. I didn't even make eye contact. Every. Single. Time. Months passed while I listened to the Pixies' "Wave of Mutilation," my favorite song from *Pump Up the Volume,* a movie with Christian Slater, another obsession. I thought about Charlie, stared at Charlie, imagined saying hello to Charlie.

The following year I heard Charlie thought I was cute, and I almost threw up.

I said, "Eww. No."

I repeated the pattern with a redheaded Mormon kid named John. I passed him a note, and for some reason he agreed to go out with me. I immediately broke it off. I did the same with a boy named Finn. Every time I found out that a guy liked me back, I was instantly uninterested and, even more than uninterested, I was thoroughly grossed out. One blue-eyed boy, Malcolm, managed to stay friends with me after we "went out" for about a week, but he was the exception because he was funny and kind and I hadn't obsessed over him.

That was the paradox of junior high. I was always about the pursuit, the wistfulness, the chase, but repulsed if the feeling was reciprocated. If anyone said they liked me first? Oh heck no. I had a few unrequited crushes: Brigham, Ethan, Rob. I was a very late bloomer. I liked the *idea* of liking someone. The reality of being liked or in an actual relationship totally skeeved me out. *Ick.* It made me feel so awkward, like I was having goose bumps on the inside.

That changed in ninth grade, when Mr. Spillane seated a five-foot-eleven, 140-pound eighth grader in front of me in advanced geometry class. It was the first day of school. I wore my cheerleading uniform: a yellow vest and pleated skirt lined with purple ribbon, our winning school colors. *Go, Comstock Crusaders!* Brian wore a green hooded sweatshirt and black XXL basketball shorts that hung off his bony frame. Apparently, he had tested into this advanced class; we were all

a grade ahead of him. Brian had a mouthful of braces and an unusual swagger for someone so skinny and pale. I could barely see the chalkboard around his big head.

Eventually, we became friends. I met Brian at the right point in my life. I was more mature. We developed a wholesome boy-girl platonic friendship. We were always joking around and laughing in class. Once he made me cackle so hard, I spit out my gum. Unfortunately, it got so tangled in my hair I had to borrow the teacher's scissors to cut it out.

When I went to high school, Brian and I talked less. We kept up a friendly acquaintance over the summer because his best friend, also named Brian, lived in the neighborhood next to mine. We talked about our respective crushes. His first kiss was after an Arby's date with a tall, skinny blond girl. He told me it tasted like pickles. I told him about my first kiss with Logan.

Brian played the long game, smartly. He saw a girl who was different, unpredictable, and entertaining. He witnessed my lack of interest in guys who were too easy. He knew it would be better to take his time to win me over. When we started dating a couple years later (I was sixteen), I finally overcame my disgust toward someone who liked me the way I liked them.

24

Cheerleading

I think everyone should be on a cheer squad at some point. Working with a group of competitive, confident, outgoing people who shout encouraging words, both spontaneously and in unison, is a dynamic that prepares you for anything.

I got the idea of trying out from Jill Guidi. Jill was my neighbor, a model-height brunette with thick dark hair and a perfect smile. Think Italian Brooke Shields in a cheerleading uniform. Jill was a year ahead of me and therefore at the top of the food chain as a ninth grader in our junior high, which started at seventh grade. I was just a lowly eighth grader. I got to know her because we waited at the same bus stop and started walking together in the mornings and afternoons. Some days she'd be dressed in her songleading uniform, her hair tied in a high ponytail with a white ribbon. American royalty.

Jill was impossibly gracious to my short Vietnamese self. One day she made a suggestion that would change my trajectory in junior high and high school.

"Vicky, have you thought about going out for songleading or cheer?" she asked. "Tryouts are coming up."

Dancing seemed a lot more fun than just doing the cheer moves, so I asked her what songleading was like.

"So fun! You go to all the games, you learn dances, you cheer at the games, and you'll meet a bunch of new girls."

"I've never taken dance lessons, though. I don't really know if I could pick up the routine," I said.

"Don't worry. I'll help you. Just sign up, and come to the tryouts next week." Jill smiled.

I was totally unsure what to expect, and I didn't know anyone else trying out. The first day, we all showed up to the gym. I waved at Jill, the only familiar face among the dozens of girls in the room.

They broke us up into groups and started by teaching us the routine we'd have to perform at tryouts the following week. I was overwhelmed trying to keep up with the moves. Was it right foot or left foot forward? Was my arm supposed to be up or down? How would I get my hips to do *that*?

When we got off the bus that afternoon, I caught up with Jill and said, "I don't think I should try out. I have no idea what I'm doing."

"Don't worry. Let's practice together. I'll meet you in twenty?"

We dropped off our backpacks, and I met Jill outside her house. She had her boombox ready, with the music cued up on the cassette. Jill watched me stumble through the moves I'd learned that day, struggling to remember what came next. I had never moved my body to an eight-count, much less to the beat of a song in a choreographed dance. She was like a cheerleading Annie Sullivan, the teacher who helped Helen Keller learn words by using touch. I did not speak the language of dance.

"Vicky, what are you doing? Don't squat. That's not the move."

For some reason, I bent my knees every time I moved. I was unknowingly adding a sumo squat to each step.

Miraculously, and thanks to Jill's extra coaching every day after school, I was finally able to perform the routine in rhythm with the music.

On the day of tryouts, I was nervous. I really wanted to make this team. It was incredibly intimidating walking into the cavernous gym

next to two other girls, standing in front of the coach and two of the songleaders (neither of them was Jill), who were going to judge us.

They had their clipboards and pens at the ready. Forty girls were trying out for eight spots. It was time to do or die. I had never felt like this in my thirteen years on earth. My heart wanted to burst out of my chest. I was dizzy and nauseated.

"Up next, VICKY, SARA, JENNY." I ran out across the polished wood floor, clapping and cheering and high-kicking to show my spirit, then lined up on my mark.

The coach hit play on the stereo, and I performed my little heart out. I was probably stiff as a board and smiling too hard, but after a minute or so, the routine was done. I held my final pose, resisting the urge to collapse until it was time to run off and await my fate.

A couple days later, they posted the results on the doors to the gym.

I saw my name: "Vicky Nguyen."

My parents were happy that I was happy, and blissfully unaware that falling from a cheerleading stunt like a full extension or basket throw could result in the serious injuries they were so keen to protect me from. Their chief complaint was that I would have to wear a skirt to school on below-seventy-degree days.

"Yến, too cold. Why you wear that with no pant?" My mom would shake her head as I rushed out to the bus. "Bye, Mom! Don't worry, I'm not cold."

Being on the squad, going to sleepaway cheer camps, competing, and just cruising around school as a spiritleading ambassador helped me develop confidence and taught me how to conduct myself. I was never on the interior with the cool girls who'd grown up together. I didn't have any legacy connection to the team through siblings or even close friends. Still, I was taking in the social cues and figuring out who had a crush on who, who was drinking at last weekend's party, who was hooking up. I was on the fringe, but I was there, always learning about who I wanted to be and what wasn't quite me.

"Hand me a curler please," Kristy said, reaching for a tiny pink foam roller from the pile on the floor.

The entire squad was at her house getting ready for our trip to Santa Cruz for the annual cheer competition on the famous beach boardwalk. Her big sister, Amy, had been on the high school squad for a few years now, and their mom was a gracious hostess, accustomed to having her home taken over by shrieking girls and massive clouds of hairspray.

After stuffing ourselves with pizza and sodas, the eight of us formed a hairstyling assembly line. Each girl was responsible for the girl in front of her. Take small sections of the shellacked ponytail, wet it with a glob of mousse, wrap it around a foam curler, and clip it. That would create the perfect set of curly ringlets the next day when we got to the competition. We tied huge white starched bows to top off the curls, and whether it was our stiff moves or our elite hair, the combination worked to bring us first- and second-place trophies from Santa Cruz and Great America.

I went on to become co-captain of the JV squad before making varsity in high school and even cheering for the Dons at the University of San Francisco too. Cheerleading taught me confidence and how to work with other women in a competitive atmosphere. I learned the subtle ways women can support or exclude others. I tell you, cheerleading is so underrated as a crash course in social skills.

When I wasn't cheering, I was working. I'd inherited my dad's passion for making money. I had a summer job every year from age fourteen until I went to college. It was more of a nuisance for my parents than anything, because I earned minimum wage, and I couldn't drive. The juice was not worth the squeeze for them. My first gig was at a kiosk in Coddingtown Mall. I was the only person manning the stand, and I sold five-by-seven-inch framed name signs. They were made of thick linen paper and had names like Christina and Jacob printed in color in a nice font. I helped my customers, who were few and far between and mostly grandmas, find the names they were looking for. "Oh, Michael,

what a strong name," I would say to help close the sale. Then I guided
them as they selected the color for the mat that would frame the sign. I
used glue to assemble the art piece right in front of them and voilà—for
$7.95 that personalized gift was theirs to take home.

I made $3.50 an hour for my troubles.

The following summer was an upgrade. I served as a hostess at Sweet
River Saloon, again in Coddingtown Mall. I answered the phone with
"Hello, every day is a good day at Sweet River Saloon, how may I help
you?" My parents thought that was hilarious. "Every day is a good day?"
They loved to greet me that way when I came home after a shift. "Hi,
Yến. Every day is a good day." It was their new American catchphrase.

At my job, I kept track of who should sit where. I had to evenly
divide the diners into zones so the servers would not get overwhelmed,
and more important, so they would each have an equal opportunity to
make tips. If I messed up and overloaded one waitress with couples while
another waiter got too many families, I'd hear about it. "Vicky—Shayna
got the last three tables in a row. What the hell?"

It was an inexact science. Unlike the servers, I didn't ever get tipped.
Except once. Joyce, a lady in her fifties, was a regular customer who
always came alone. I brought her to her favorite table, and she smiled
up at me from her chair. "Today is my birthday," she told me. "I want
you to have this!" She gave me a twenty-dollar bill.

"Oh wow, that's so nice of you, Joyce. But it's your birthday! I should
be giving you a gift. I can't take this. I'm just helping you sit down like
normal." Joyce was not having it. She insisted I take the twenty dollars.
It would take me five hours of working to make that much money!
I always think of Joyce and how a generous gesture like that can be
something the recipient remembers forever. My parents were thrilled
but mystified. "Why she give you twenty dollars? You don't even bring
food? Wow, nice lady."

My final two summers of high school were spent at Lady Foot Locker
and Kaffe Mocha. I sold walking shoes, running shoes, cross trainers,
socks, and insoles while wearing a green-and-white striped jersey and
khaki pants. I made minimum wage—$4.25 an hour. I begrudgingly

spent an hour's wage each day eating lunch from the mall food court. That's how I learned the value of an hour of my time. Four bucks could get me a burger combo meal with fries, but add a soda with taxes, and that would put me over the $4.25. I always drank water.

I worked as a barista at Kaffe Mocha before they called anyone "baristas." We were just teenagers making people's lattes and trying not to get burned by the steaming hot milk. I wouldn't develop a taste for coffee until college, so I was the best worker. Like a good drug dealer, I didn't partake in any of the product. I mixed up mochas, cappuccinos, Americanos, talls, shorts, triple shots, whatever people needed to start their day.

My dad drove me fifteen minutes to work every day. It was such a pain. Imagine you just want to relax on your weekends and in the mornings, but your kid's job starts at 5:00 a.m. He wouldn't drop me off and go back home to sleep, because I had to open the coffee shop by myself. It was still dark when we got there, so he stayed to help me set up the patio chairs and umbrellas, then waited until the second worker got there, an hour later. You could say we both had a summer job that year.

25

High School Sweethearts

By my junior year in high school, Brian and I were a couple. We did everything together. We never told our parents we were "official." Unlike other Viet moms, mine was never obsessed with asking me if I had "boyfrenn yet?"

Because our relationship developed gradually, my parents easily accepted Brian. He was a good kid with a nice family, and he seemed like a positive influence on me. He spent the summers working as a pool monitor and selling plants at the local nursery. We both pushed each other to do well in school, and I had been a straight A student since freshman year.

Brian's former chauffeur, his brother, Mike, was older by four years and off to college, so Brian loved having a girlfriend who could drive him to school. My mom always made us both fried egg breakfast sandwiches with salt, pepper, and ketchup wrapped in foil for the road.

Early on, I asked them if they would prefer I date an Asian boy.

"We don't care who you like, but he has to be good boy," my mom said, raising her eyebrows.

"Really?" I pressed. "Would you rather I brought home someone Vietnamese?" That was unlikely. The pool of Asian Americans in Santa Rosa was tiny. The number of Vietnamese guys in my age range? A handful.

"No. Whoever you like, but they have to be smart and treat you nice."

I went further. I wanted to get my parents on the record, and I was curious to know how they felt about people from different backgrounds. I knew some of my Asian friends' parents were very strict about who their daughters chose. It wasn't enough to date another Asian, they had to be from the *same* Asian nationality. Koreans with Koreans, Chinese with Chinese, Japanese with Japanese.

"But what if I was dating a Black kid or a Mexican kid?" I asked, because I wanted a serious answer. This was an actual possibility. There were a fair number of Latino kids and there were more Black kids than Asian ones at my school.

"Black, white, Mexican, doesn't matter to us," my dad chimed in, barely looking up from his Vietnamese magazine. "They have to be good person."

I was proud of my parents for this.

Even though Brian and I had known each other since I was in ninth grade, there were things that we had to get used to since we came from different backgrounds.

The first time I went to the movies with Brian, I introduced him to my dad's concept of the double feature. We'd buy a ticket for one movie and sneak into a second film after making a bathroom stop as cover. It was one of our favorite family excursions.

Brian was skeptical. It sounded like we were doing something illegal. He grew up in a family that was very BTB, by the book—they properly adhered to rules. I peer-pressured him into it.

"I've done it a million times with my parents," I pleaded. "The theaters don't care. It will be fine."

I suggested we go see *Forrest Gump* and *Jurassic Park* on a Saturday. It would be an epic twofer. I really had to practice the persuasive speaking skills I was learning in my public speaking class.

"I don't like this, Vicky," Brian said. "It seems wrong."

"Brian, this is how I see every movie. We're already going to be there. The timing is perfect." I had learned from my dad how to check the paper for showtimes.

Back and forth we went. He finally agreed, and I guaranteed we would not be arrested for seeing two movies for the price of one.

Forrest Gump was excellent. I was convinced Gary Sinise was legless in real life. Brian insisted it was special effects. I bet him five dollars that I was right. There was no way that guy had legs. Look at how he moved around in every scene. He was a paraplegic in real life. I was certain.

We laughed, I cried. The movie ended, and we followed The Plan: exit, go to the restroom, and head to the theater showing *Jurassic Park*.

All went as expected. We were comfortably seated and watching previews.

"See?" I gloated. "That was easy! Now we get to watch the dinosaurs." Brian was hopped up on the adrenaline of making it securely into a second movie without being arrested. We even had half our popcorn left.

When I reached for my purse to pull out the Junior Mints, I didn't have it. I was so focused on coaching Brian in the dark arts of a free double feature, I had left too quickly, and I totally forgot about my bag.

"Crap . . . Brian . . . I left my purse in the other theater," I whispered.

Him, "*What?*"

Me, "I left my purse. In *Forrest Gump* . . ."

He looked at me and hissed, "Are you serious?"

"Can you please . . . get it?"

He wasn't happy, but he knew what he had to do. He dutifully ducked out of the previews and came back, victorious, with my LeSportsac bag, Junior Mints and all.

If ever there was a test for Greatest Boyfriend of All Time, this was it, and he scored perfectly, minus the huffing and puffing.

In another situation a year later, he solidified that title, even if I didn't recognize it—or appreciate it at the time.

Senior year, one of my favorite teachers offered to take me flying. He mentioned it a couple times in class, and I thought it sounded cool. This teacher was smart, and he cared about his students. I was one of his stars. I loved his feedback on my work, and I enjoyed learning from him. Everyone did. He joked around, he made the work interesting, and he reminded us of Robin Williams with his sense of humor and flair.

One of his hobbies was flying. He talked about it all the time. One evening, he called me to find out if I could go with him.

"Vicky, I'm an incredibly safe pilot. If you want, I can take you out to see Sonoma County from the sky."

I thought that was a neat opportunity—a tour of Santa Rosa from a two-seater plane.

"That sounds fun. Let me ask my parents."

"Okay, bye, love," he said. He'd used this term of endearment in class with me and other girls before, but I had no context for that being strange coming from a male high school teacher.

My dad, excited that this teacher might offer to take him flying sometime too, said yes. He knew flying was expensive, and a free tour like this sounded like a fun experience.

Brian heard about the plan and flipped out. "You are absolutely not going on a flight *alone* with Mr. Gallagher. That is totally not appropriate."

I didn't understand why. "He's an awesome teacher and he wants to take me for a flight. He's a licensed pilot. Why are you freaking out?"

"Are you crazy? He's a teacher. And he wants to take you out, just you two, on a plane? What are you not getting about this picture that is totally wrong?" Brian was heated at this point. He told my parents that under no circumstances should they let me go by myself on a flight with this teacher. It was creepy, it was weird, it was totally not a good idea.

The three of us didn't see the problem, but Brian was adamant that this would not, could not happen. He wouldn't let it go. I think the thought of a small plane crashing scared my mom, so she started to take his side. Eventually I canceled.

"Sorry, Mr. Gallagher. My parents don't want me to do it."

"That's too bad, Vicky." He sighed.

I was annoyed with Brian for making it such a big deal.

Now, as the mother of three daughters, I completely understand that Brian was right. But back then, I didn't have a category for creepy teacher. I was naïve, and so were my parents.

My guide to American culture was Brian, and by extension my in-laws, who taught me over time about the importance of family traditions.

Brian's mom, Marilou, must've been a gold-star member at Hallmark. She remembered every holiday. We got cards and candy on Valentine's Day, Pez dispensers for St. Paddy's. She gave me a basket of chocolate eggs and Peeps for Easter, and I was invited to the annual egg hunt at Brian's grandma's house. Her mom, aka Grandma Mary, expected all of us youngsters to participate. We older kids hid plastic eggs stuffed with candy and toys for the little ones to find. After every egg was accounted for, we ate ham sandwiches, deviled eggs, and cookies.

I loved feeling so welcome at these family functions. Marilou has four sisters and two brothers, so Brian has a ton of cousins on his mom's side. Grandma Mary kept track of everyone's birthdays on a massive calendar, and she'd try to get us all together every month for a celebration of everyone born that month. Grandma Mary didn't just display photos of her family. She had floor-to-ceiling wallpaper made up of photo collages. I never saw anything like it. The walls of the living room, family room, dining room were covered in color and black-and-white photos showcasing everyone in the family over the years. Photographs of people eating watermelons, kids riding bikes; traditional group photos of smiling faces beneath haircuts that spanned the decades from the forties to the eighties. Family was everything to Grandma Mary, and by extension, to her daughter Marilou.

I was the only Asian person at these early family gatherings, and for a long time, I wondered what Brian's parents thought of me.

Voted "Most Lovable" and "Jack of All Trades" in junior high, Brian had no shortage of traditional girls to pursue in Santa Rosa. He had known many of them since preschool.

Instead, he brought *me* home.

But Brian was just Brian. He didn't make a big deal about my cultural differences and never complained when we went to my relatives' homes, where they foisted all kinds of mysterious foods on him. He was always along for the ride, and he was my sounding board when I wondered what was American, Vietnamese, or both.

"Try this!" was a command he heard often.

Brian politely ate, hungry or not, all kinds of dishes. Most were deli-

cious, like *gỏi cuốn* and *chả giò,* fresh spring rolls with shrimp and pork or fried egg rolls. But some were acquired flavors, like stinky durian or *rau câu,* Vietnamese Jell-O with coffee and coconut flavors. He was very respectful and always ate everything placed in front of him, though one time we pranked him pretty good.

By the time I was in high school, a host of our relatives had arrived in Santa Rosa from Vietnam. My beloved Dì Hai, who was more like a grandma figure to me, her husband, and three of their children, Tuyến, Chi, and Nga, were all living in an apartment complex nearby, and we visited them often. Dì Hai's husband, whom I called Dượng Hai, had been captured by the Việt Cộng and sent to a prison camp for twelve years after the war. He was beaten severely many times and suffered traumatic brain injuries. In the United States, he had several surgeries, but Dượng Hai was never the same.

Dì Hai, still fluent in my love language of Vietnamese food, indulged us no matter the time of day. She was used to cooking for her family of nine, and it seemed like something was always on the stove when we came over, even when we stopped by unannounced just to say a quick hello or drop off some groceries.

On this day, she made a Vietnamese drink with *hột é,* basil seeds. They look like chia seeds. When they get wet, they develop a slimy gel coating on the outside of the tiny black seed.

You could easily mistake them for little eggs or, as I told Brian, fish eyeballs.

"What do you think they are?" I loved this game. Make Brian guess the foreign food.

He took his first sip. The drink is really refreshing, slightly sweet, but the consistency takes some getting used to.

"No idea, Vicky, what is it?"

"Fish eyes." I grinned.

He blanched and put the drink down. "You're joking."

"No, they're little fish eyes mixed with sugar and water," I said sweetly. "So good, right?" I took a swig.

But he knew better. "I don't believe you."

I cackled. "I had you for one split second, one split second!"

I think Brian liked being with someone who was driven and quirky. I was certainly a handful and a half. I kept things interesting, even in high school. And I was wildly possessive. I didn't like that one of my cheer squad friends was talking to him. Gemma was Korean and White and beyond gorgeous—unique too. This was well before multiracial kids were the norm in the Bay Area. She and Brian had been friends before I even met him, so naturally, I felt threatened.

I called her once, anonymously, and growled, "I heard you're hanging out with Brian. You need to stop," and hung up. It was so dramatic and spectacularly unnecessary, but I had to make a claim on my man.

For junior prom, Brian asked his mom to help him create a memorable night. He had this wild idea that he should make a multicourse dinner, then drive us to the dance.

"Mom, I'm thinking Caesar salad, shrimp cocktail, and salmon."

"Okay, Bri, if you think she'll like salmon . . ." Marilou obliged. "I'll pick up the groceries."

She bought all the ingredients and helped Brian, who had zero cooking experience, make this impressive meal.

Marilou greeted me at the door. "Hi, Vicky, welcome, come on in. You look so pretty." Brian's dad, Gary, smiled. "Hi, Vicky, nice to see you. You ready for the dance?"

"Hello." I smiled back. "Yes, I am. Smells good! What's cooking?"

Brian came out with a corsage for my wrist. "Do you want me to put this on now or after dinner?"

"Let's do it now and take some pictures. Then we'll leave you alone and you can eat," Marilou suggested.

We took our requisite photos, me in my champagne gold-sequined halter gown with a long chiffon skirt and Brian, at this point six-foot-four, 165 pounds, in black pants and a white tuxedo jacket, hair slicked back.

I was self-conscious about our height difference. Even with my heels on, he was a foot taller! Why did I fall for this oversize person, and how were we supposed to dance cute when I was eye level with his armpits?

"Okay, Bri, you know what to do." His mom winked, and she and

Gary disappeared. I wasn't sure where they went, but suddenly it was just us.

"All right, you ready?" Brian went to the kitchen. "First course, coming up."

He put the plate down in front of me and said, "Voilà. Shrimp cocktail."

I had never tasted this dish before. I opened my mouth and took a bite.

"Is it supposed to be so . . . cold?"

"Yes, it's shrimp cocktail."

"Oh."

I had never had ice-cold shrimp before. My shrimp was always stir-fried or grilled or covered in batter and deep-fried with sweet and sour sauce.

This shrimp was wet and unfamiliar.

"They're cooked, right? Or are they raw?"

"They're cooked. But that's just how this dish is served. Cold."

My taste buds weren't ready for chilled seafood at seventeen, but the rest of the meal was delicious and prompted no further questions.

Because it was my junior prom, Brian was one of very few sophomores in attendance. He was the tallest on the dance floor though. On the play-list that night there was a lot of nineties hip-hop: Boyz II Men, Coolio, and Naughty by Nature. *You down with O.P.P?* We "Jump" jumped to Kriss Kross and got insane in the membrane with Cypress Hill. We felt the love while slow dancing to Elton John and Aerosmith's "Crazy."

After the dance, I was allowed to go back to Brian's and watch a movie before my 11:00 p.m. curfew. We sat on his couch downstairs and flipped through the channels, landing on *Waiting to Exhale* with Angela Bassett. Believe it or not, no alcohol and no sex. Prom 1995, a wholesome night to remember!

Brian's parents were like my surrogate parents, counterparts to my parents. We developed a level of familiarity and comfort during my teens that would fortify my relationship with them as Brian and I grew up together.

His family was also very organized, in a "place for everything and everything in its place" kind of way. Marilou could tell you where anything was in her house, right down to the drawer. The lid for that Tupperware? Look in the back right corner of the third drawer down, left of the garbage can.

This contrasted with what was happening inside our family home, the Windsor. My family did what was convenient. We had things everywhere, depending on their purpose. There was a Ping-Pong table and a hammock in the family room next to the big metal dog pen. Our kitchen was full of plastic containers and glass jars that came with our American food because it would be too wasteful, *uổng quá,* to throw them out.

I was grateful to have a second family, well versed in American traditions and ideals. Later, when I became a mother myself, I came to understand the value in having family rituals that everyone looked forward to, like hanging Christmas decorations and putting ornaments on a tree. When you grow up a refugee, you learn to make life work with what's available, so I never put a lot of stock in things having to be a certain way. But when you're no longer in survival mode, you can lean into traditions and embrace the familiarity of doing something again and again. I realized that traditions are part of the glue that makes a family.

There was a learning curve for Brian about my family operations too. When we took him to Las Vegas when I was seventeen, he was totally confused.

"Wait, why are we moving our stuff?" he said, watching my dad pack up at 7:00 a.m. on the first morning of our trip. "Where are we going?"

"Oh, we're staying in a different hotel tonight. And tomorrow, and the next night. Every night is a different place so you can see all the different hotels. Luxor, Venetian, New York–New York, and I think we're doing Bellagio too."

Brian looked at me. "You know that's not normal, right?"

I didn't until I went with him on a family trip to Lake Tahoe and learned his parents took the same vacation each summer. They rented a house and played cards and rode bikes and made sandwiches and stayed

in one place. I had never heard of such a thing. Why would you visit a place more than once? You've already seen it!

The first time my parents went to Brian's parents' home, my mom was friendly but reserved. My dad had his hands twisted and clasped in front of him the entire time. He mostly made eye contact with me while telling the story about the time Brian didn't hear his mom honking to pick him up from my house, so she left him to walk the four miles— uphill. (She did eventually come back to pick him up.) My dad thought that was hilarious. Wow, Marilou was one tough mother! Other than that, he was mostly quiet. It was the least I've ever seen my dad talk in a social situation.

Our next interaction was when my dad wanted Gary and Marilou to provide Brian's health insurance card and a signed contract saying they were allowing him to come on a family trip with us to Las Vegas. He wanted to have all his bases covered.

Having Brian and his family in my life also gave me skills to safely navigate some of the darker sides of a country that my parents trusted wholesale—things that would help me later, as I left the comforts of home and struck out on my own.

26

Go Dons!

Going to college was a given, but I didn't want to be too far from home. In my junior year of high school, in 1995, I narrowed my options down to a few California schools to tour with my parents: the University of San Francisco, University of California, Berkeley, and Stanford University, all about an hour's drive from Santa Rosa. I got accepted into Berkeley, and USF. Stanford rejected me. I was another Asian pre-med student. Very unoriginal.

The massive Berkeley campus, with its auditorium-style classes and huge plaza made me feel like a tiny speck. The vibe was progressive and crunchy granola. People wore Birkenstocks and tie-dye, and the smell of incense and patchouli lingered on my clothes after I toured the dorms. It was very cool; it just didn't feel like me.

USF was smaller, friendlier, more personable. The undergrad program consisted of about 3,500 students, compared to 15,000 at Cal.

"Well, should I go to USF or UC Berkeley?" I asked my parents.

"Which one you like better?" my dad asked.

"USF seem nice, smaller and easy to walk," Mom said.

"Berkeley also good. Very big," my dad added.

As usual, they left it up to me to decide. They were supportive of either school because both were within driving distance. I chose USF

because they offered an academic scholarship that covered 75 percent of my tuition and fees.

Another reason I wanted to stay close to home: I'd be starting college while Brian was a senior in high school. We didn't talk about breaking up. Even while I was in San Francisco and he was still in Santa Rosa, we forged ahead. We had an unspoken and innocent expectation that this was the natural progression of our relationship. It was the *Que Sera Sera* attitude I inherited from my mom.

Around that time, Brian's mom understandably asked him if he was sure he wanted to keep dating just one person while he was still so young.

"When you know, you know," he said simply.

My scholarship made it cheaper for me to go to a private Jesuit university than a public school in the University of California system. I might have chosen differently if I had spoken to anyone "in the know" about how it's usually best to go to the most "name brand" school you get into. The last person in their class at Harvard is still better (on paper) than the first in their class at a less known or smaller school.

But I didn't know any of that. It never struck me to apply to Harvard, even though in high school I was awarded a Harvard Prize Book for "excellence in scholarship and high character, combined with achievement in other fields." Now, I'm not saying I would have been accepted into Harvard, but it wasn't even a dream I knew I could have. No one in my family had been to college, and none of them knew Harvard from Hayward.

When it came time for me to move into Hayes-Healy, the all-girls dorm on the USF campus, nicknamed the "Virgin Vault," my parents drove Brian and me down to San Francisco, our car packed with all the things from Bed Bath and Beyond on the freshman dorm checklist. We had a shower caddy, twin sheets, a desk lamp, towels, a collapsible laundry basket, lotions and shampoos, my backpack, and flip-flops for the shower because each floor shared a communal bathroom. My parents insisted on buying me a minifridge, microwave, and a small toaster oven, worried I wouldn't have a way to store my leftovers or properly reheat my food.

My roommate, a somber girl named Alice, was already in the room

when we arrived. She had dark hair and deep brown skin. We made small talk, and her dad came in, hauling a giant steamer trunk of clothing and shoes that took up most of her side of the room.

My parents assessed my new quarters.

"Okay, so this is it?" My mom scanned the tiny space with two beds, two desks, and two closets.

"*Nhỏ quá,*" my dad said, "so small."

"Welcome to college," Brian said, giving me a smile like, *Wow this is your new life.*

Yes, it was tight quarters, but I was excited. College was a new place, where I'd be on my own—like an extended sleepover but with schoolwork involved.

The dorm hallways were buzzing with movement and chatter. I had never seen so many Asian and Hawaiian and Hispanic and international students all in one place. It already felt different from Santa Rosa and high school.

We walked around the campus, and I showed Brian the cafeteria, the library, and St. Ignatius, the beautiful Catholic church, where they had student mass every Sunday. It was a sunny, breezy August day in San Francisco, and all the most important people in my life were about to leave me at this new school.

"What do you mean, depress?" my mom asked when I called to update my parents after my first night in the dorm.

"Well, that's what she told me. She's depressed. And she's bisexual," I said, wrapping the curly phone cord around my fingers and watching it spring back. I didn't know when my new roommate was coming back to the room, so I had to get to the point at the top of the call.

Right away at our first meeting, Alice informed me she had recently been diagnosed with depression and maybe bipolar tendencies. This extreme self-reveal was totally foreign to me.

"She gay?" my mom pressed, anxious about the stranger who was now sleeping in the same room with me.

"No. Biii-sexual," I emphasized, repeating the word slowly. "I guess she likes guys *and* girls," I continued. "I think she's taking some medication to help her with her depression. It's fine. It's a little weird, but I think it's fine."

I downplayed my own worries because I didn't want to freak my parents out. At eighteen, I was having my own mini freak-out. I grew up sheltered when it came to mental health and sexuality. *Cosmo* hadn't prepared me for this. So when I met Alice, it took a minute for me to process what she was casually telling me about deeply personal issues. She was very serious and matter-of-fact when she told me about herself, almost monotone, and with a sad smile.

I played it cool, but inside I was like, *What in the . . .*

"Maybe you switch room," my dad said. He was on the upstairs line and my mom was on the cordless phone. I could picture them in the Windsor, my mom in the kitchen, my dad sitting on their bed, both worried their only child was sharing a room with someone who said she was on medication for depression.

"I don't think that's an option, Dad." I reassured my parents I'd be fine, even though I wasn't exactly sure how to go about this new relationship.

Alice was nothing but kind. After that initial wave of shock and awe about her identity, we got along fine. We got to know our across-the-hall neighbors, two Chinese nursing students, Cecily and Shirley, who were a couple years ahead of us. They were like big sisters and made me feel secure in my new dorm.

Alice and I rarely saw each other because we had opposite schedules and different friend groups, and she transferred after the first semester. Meeting her, and many other students from around the country and around the world, in my first few months at USF quickly expanded my worldview.

I became great friends with my next roommate, a Vietnamese girl named Kat, and I learned to embrace my heritage in a new way. Before Kat, being Vietnamese was just an immutable characteristic. Nothing I could change, nothing to celebrate, and occasionally something that embarrassed me because it made me so different. But Kat was the presi-

dent of the Vietnamese Student Association, and she organized events that shared this part of our identity and connected us with other Viet kids. We had an Asian culture night, when we dressed in *áo dài* and introduced other students to Vietnamese food.

I started to see that it wasn't only a liability to be Vietnamese; it was something I could acknowledge and even celebrate.

Ever practical and fiscally prudent, I looked for opportunities on campus to earn money. I ran for president of the Associated Students of USF because it came with a stipend to offset my college costs. I also had a work-study job every semester and got free room and board when I was elected vice president of the Residence Hall Association. Anything I tried out for had to have a cash prize or stipend or I wouldn't waste my time on it. Even as a college freshman, I didn't want my parents to spend a penny more on school than they had to. They never talked to me about student loans or financial aid, but I had been aware of the value of money from a young age. I watched my parents clip coupons, and my mom only shopped in the stores' sale sections on our mall trips. Being frugal was second nature to me, and I applied that to college too.

I was majoring in biology, looking to get a bachelor of science degree to become a physical therapist specializing in sports medicine. I thought it would be exciting to work with professional athletes and sports teams. At the time, "physical therapist" was listed as one of the "Top 20 fastest-growing professions," guaranteeing stability and a good income.

The one nonpaying gig I couldn't resist was cheerleading. I did that for my first two years at USF because it was fun, and I enjoyed going to the basketball games for free. Spoiler alert: Brian also ended up getting into UC Berkeley and USF. He chose USF. In my sophomore year, I stayed on the cheer squad because he was on the basketball team. Who better to cheer for than your favorite person?

Overall, freshman year was a relief. I spent only eighteen hours a week inside a classroom. I had so many hours to myself! I managed my own schedule, studied for exams, and got to my work-study jobs on time. It was a breeze compared to the long hours of high school, extracurricular

activities, and preparing for college entrance exams. At night, I used a phone card to talk to Brian and my parents on my dorm room phone. Then I went home almost every weekend to see Brian and do laundry. Freshman year was a safe transition into semi-adulthood.

But by my sophomore year, I started to feel the pressure to adhere to the standard of beauty I saw everywhere. Like a lot of girls who grew up in the nineties, with skinny supermodels like Kate Moss and Christy Turlington plastered on magazine covers and all over MTV, the benchmark for "pretty" was emaciated. That year, my friend Gabe mentioned his mom's weight in a conversation about nothing in particular. "My mom is so tiny. She's like eighty-nine pounds." That random comment triggered something competitive in my mind.

Gabe's mom is my height. How can she weigh so little? Why do I weigh 105 pounds? Am I way overweight?

I aimed to be eighty-nine pounds too. I drank a nonfat latte for breakfast every morning and tracked my calorie intake every day on a wall calendar. I ate a scoop of white rice with soy sauce and steamed broccoli and carrots for lunch. Dinner was the same, or a yogurt with some peanuts, or a salad with chicken. Some days I ate a total of 400 calories. I tried to cap myself at 800. I was constantly at the college fitness center, trying to work off what little I had eaten.

When I went home on weekends, I binged on my parents' home-cooked meals or snacked late into the evening. I ate until my sides ached. It was an unhealthy cycle of disordered eating. My cheeks hollowed out and my shoulder blades jutted from my back. My relatives noticed when I visited, saying "*Yến lúc này con ốm quá!*" "Yến, you're so skinny now," so I was satisfied that my approach was working. No one ever asked me what was going on, and I didn't say anything about it.

College classes were easy compared to what I'd done in high school. But organic chemistry, part of my degree requirement, was killing me. I barely eked out a B+ for my first semester in the class. That was my first grade lower than an A since ninth grade, and I still had a semester to go.

I wasn't about to get another B+, so I set up a meeting with my professor to beg for extra credit.

"Professor O'Shaunnessy, hi. I signed up for office hours because I wanted to know how I can get extra credit."

Him: "Well, you can do the extra credit assignments."

Me: "Yes, I will. But this class is really hard, and I want to make sure I do everything possible not to fail. And by 'not fail' I mean I'm trying to earn an A."

Him: "Then do better on the tests."

Undeterred and desperate, I channeled my dad. *Negotiate. Persist.*

Me: "Yeah... about that. What If I come and clean out the lab, sweep up, wipe down the counters, stuff like that? Can I get extra credit? I can do it twice a week."

Him: "That's unorthodox..."

The generous, fifty-something Irishman took pity on me and allowed it.

I spent two hours a week for the rest of the semester wiping down counters, cleaning out beakers, sweeping and mopping the floors, and inhaling the janitor's industrial cleaning supplies. For years there was a stain on the floor in the Harney science lab where I dropped a beaker half full of hydrochloric acid. It shattered into pieces, and instantly turned the floor a dark shade of brown.

I got an A- that semester.

I could not imagine how I would survive physical chemistry, which was next on the course list for bio majors. Plus, I had done three internships in sports medicine at that point, and I'd discovered that being in physical therapists' offices was, frankly, boring. It seemed like it didn't matter if it was Joe Montana's knee or Joe Schmoe's knee, the mechanics of helping someone heal from injury would be the same day after day. *Do these exercises, increase your range of mobility and strength. Bam, you're better.*

One day I was deciding on lunch options at World Fare, the student cafeteria. You could choose among pasta, Chinese food, or pizza on any given day. Very global. I sat down at a table with some friends and met a new guy, Toan Lam, who was a fast-talking, big-smiling Asian dude with a mustache.

We started discussing our majors. At the time, Toan was majoring in communications. He was going to become a television news reporter.

"What do you mean a 'reporter'?" I asked with air quotes.

"You know, like Thuy Vu on Channel 2. The people who do the news on TV," Toan said. "I'm interning right now at KRON, Channel 4."

I couldn't even fathom it at the time. This Chinese-Vietnamese dude was going to be a TV reporter? For the news? I had never thought of this as a career possibility and here he was, fixing that glitch in my mind and showing me I could dare to try too.

Toan was charismatic, with a smooth voice and a jawline that would make Superman jealous. He had a thousand-watt smile and magnetic energy. He had always been interested in journalism and had watched a lot of local news on TV as a kid.

That conversation over watery marinara on ziti immediately changed my career trajectory. If Toan Lam, who was basically the male version of me—chatty, friendly, curious, Asian—thought he could succeed as a journalist on TV, why not me? I peppered him with questions. He was encouraging and supportive, and he offered a path forward that I could actually see myself on. He explained how to apply for internships, how we could get school credit for working at TV stations during the week, and he made it sound so . . . possible.

Until I met Toan, the idea of becoming a TV journalist had never crossed my mind. It would be like saying, "I'd like to be Taylor Swift." I didn't know anyone who did anything remotely similar. Also, I was *Asian*. Our parents were small business owners because being a merchant is the fastest way to get a foothold when you're an immigrant to a new country. They all expected their kids to do better, and to choose stable, respectable professional careers.

Being different was not commonly celebrated by Asian parents, and I wasn't sure how my parents would react to my new ambition. But that didn't worry me. I was ready to ditch chemistry for communications, and Toan was the catalyst for this career pivot into the unknown.

27

The Intern

Even after switching my major to communications, I still had enough science credits to graduate with a biology minor. Now I was taking classes where I learned how to write news articles and shoot and edit video. No need to draw out chemical molecules or run pesky formulas on a scientific calculator. Communications made sense. It was relatable to my everyday life in a way that organic chemistry was not. I joined the USF newspaper, the *Foghorn,* to write articles and work in the campus newsroom.

My parents, when I told them I was switching my major, took it in stride.

"Intern for new? Where? How you get there?"

My mom was more concerned about the logistics of me leaving the safety of the school campus than this momentous shift in my career choice.

My dad had self-published a book, written in Vietnamese, as a guide for refugees in America. My mom, in one of the few compliments I ever heard from her about my father, said he was a very good writer. For as long as I could remember, there was always a pile of Santa Rosa *Press Democrat*s and Vietnamese newspapers and magazines in a bin next to

our kitchen table. My dad was intrigued by the idea of me pursuing a journalism career.

"You be like Thuy Vu, huh?" he asked. "I wonder how much she make."

Thuy was a local reporter for KTVU in Oakland. Whenever she was on TV, we beamed with pride seeing a Vietnamese person on air. Would there be room for me to follow in her footsteps?

Our school had more of a print program than a broadcast one, so I knew I needed to follow Toan's advice and get into a real TV newsroom as an intern. I was so excited when I landed my first internship: the San Francisco bureau of CNN! How glamorous!

I thought about what to wear on my first day and consulted the expert.

"Toan,"—I called him from my dorm phone—"what should I wear to CNN?"

"Pants and a blouse. You should wear flats because you never know what you'll be doing."

It was good advice. I picked a pair of black slacks and a white polyester top from Express, my most businesslike outfit. I was underprepared though. I wasn't in the habit of walking confidently into a professional environment and introducing myself. I was more of a wallflower, listening to the instructions from the intern coordinator and then doing my best to stay out of the way.

The job was two days a week to get my sixteen hours of intern credit. In the small newsroom that served as the cable network's San Francisco bureau, I answered the phone and transferred calls to the correspondents and news directors.

"CNN San Francisco, this is Vicky" made up most of my shift. It was a gruff news environment, where people had their daily routines and didn't have time for interns so I stayed at a small desk, answering phones and doing my classwork. No one wanted to hold my hand, and I didn't know how to make myself essential.

One time I asked if I could shadow one of the veteran correspondents

on an interview, and he reluctantly agreed. We went to talk with an expert on some healthcare issue, and I eavesdropped on his conversation with the producer. They didn't include me, and I didn't ask questions. I did such a good job disappearing into the background that I think I literally became invisible.

I left that experience discouraged and uncertain. News seemed like a very unfriendly environment, and I wasn't sure I could break in, let alone succeed.

But I still had credits to earn, and changing my major again was not an option. I pushed forward. It couldn't get worse than my first experience, right? I also asked Toan for advice about how to make myself useful. He said, "Talk to people. Ask questions. Find ways to help the reporters."

I applied to my second internship, this time at KPIX, the CBS affiliate in San Francisco. This was a full newsroom, and it was local news —a lot more action and excitement than my first experience. Here, reporters were launched on stories every single day, sometimes different stories for the 5:00, 6:00, or 11:00 p.m. newscasts. I followed reporters on dozens of shoots, covering crime, weather, and rising gas prices.

I started to get my footing. I learned how to be helpful. I called experts and set up interviews. I printed out MapQuest directions to the shoots. I anticipated what the reporters needed, and I carried heavy tripods to and from the news van to help the photographers.

Still, I didn't hit my stride until my last internship, at the Fox station in Oakland. It was the number one news station in the San Francisco Bay Area, and its 10:00 O'clock news was legendary. I was there as the Kaiser Family Foundation Health and Medicine Fellow, which meant I actually got a stipend to be an intern. Back then, news internships were unpaid. I used some of the $2,000 to buy my first real pantsuits. The uniform for female news reporters in 1999 was a shoulder-padded blazer with matching skirt or slacks, worn with a collared blouse. I regularly shopped the sales sections at Petite Sophisticate and Casual Corner.

I was assigned to work with John Fowler, the health and science

editor at KTVU. He covered medical stories and always inherited the Kaiser fellow, whether he wanted to or not. John let me shadow him on some reports, but I also branched out, assisting reporter Traci Mitchell on stories about AIDS research, where my biology knowledge came in handy. She welcomed my questions and trusted my research for her reports. I spoke to as many reporters and anchors as I could at KTVU, including Thuy Vu. I couldn't believe I was finally meeting Thuy in person. She was generous, always treating me to dinner when we went out, and she gave me access to every step of the daily workings of life as a news reporter. She encouraged me to shoot stand-ups and practice telling stories in front of the camera.

"Never let other people make you feel like you can't do this. It's hard, don't doubt that, but you can do it," Thuy said. "There are so few of us, and you can't let other people get in your head. Trust your own gut." Thuy always told me to pay it forward, and to this day we keep in touch; she even gives me investing advice!

When I graduated from USF in May 2000, we had all survived the Y2K mania. It seems crazy now, but there was a time when people thought the world might end because computers wouldn't be able to figure out how to go from 1999 to 2000. When all was absolutely fine on January 1, 2000, life continued as usual. At some point I was invited to write an essay and audition for valedictorian. The high school speeches I had given in front of the Lions Club paid off. The committee selected me to speak at the USF commencement.

As with every accomplishment to this point, my parents reacted casually: NBD, no big deal. From spelling bee champ to cheer captain, "Good for you" was a common response. Maybe it was because I was valedictorian of my high school that this second go-round felt like a movie they'd seen before?

But I laughed it off with other refugee and immigrant friends. We had that shorthand. Our parents were unreactive to these moments that other kids' parents would go wild about or reward with a trip to Chuck E. Cheese. We were expected to do good things, big things. You knew your parents were proud because you would sometimes hear

them telling your aunt or one of their Viet friends in another state. "Yến made valedictorian of college. She give speech."

That afternoon as they sat in the pews at St. Ignatius Church with Brian and his parents, I thanked my mom and dad for all their sacrifices but quickly moved on with my speech. I knew dwelling on my parents would make me cry. I spoke about public service and making the most of one's opportunities. All the guiding principles I learned from my trip to Vietnam at eleven years old had gotten me to this point. I figured I should share them with my classmates.

What I should have shared was my dad's approach to negotiating.

28

Let's Make a Deal

I got my first job in TV news shortly after graduating from college, but I didn't have a car. I had always driven my parents' old gray Honda, but that wouldn't make it all the way to Florida for my new gig. So I asked my dad to help me buy a car.

He drove Brian and me to the Honda dealership in my parents' late-model Lexus. My parents had owned Contemporary Design Furniture for about twelve years. As a buyer and a seller, my dad was a professional dealmaker.

I think in some ways, my dad's accent and "different" way of doing things as a refugee, a hustler, and a scrapper, served us well. His ignorance of any racism directed toward him was either an armor against the bigotry or a free pass to do things that non-immigrants would never do.

He went right up to the Honda salesman, chatted him up for a few minutes, and then offered him $12,000 for a $16,000 car. It was a total lowball offer. With a straight face, my dad said, "Heyyyy mannn, I know how much this car cost. I will pay twelve thousand."

The guy was taken aback. "Sir, I can't sell you this car for twelve thousand dollars. I would lose thousands of dollars on it." My dad didn't budge.

Brian raised his eyebrows at me. I shrugged.

"Come onnnn," my dad said, sounding just like a Vietnamese John Stossel from the ABC show *20/20*. "Gimme a break. Do you want to make your quota or what? I know you can sell for twelve thousand. I *know*."

He was certain. He talked like he *knew* this car could go for four thousand below sticker. It was the kind of thing only my dad would do. I was sort of mortified but also curious about how this was going to go down.

Back and forth they went. The guy was trying to explain the numbers, the features, the invoice price, the Kelley Blue Book value.

My dad: "Thirteen thousand. Take it or leave it." He turned to me. "Yến, let's go. This guy isn't serious. He doesn't want to sell the car to us."

The salesman was speechless. Like, how do you reason with someone so unreasonable?

We did eventually leave with the car, a beautiful white manual transmission Honda Civic EX. I don't know exactly how much we paid, but it was not my dad's opening offer of $12,000. I bet that guy never had a customer like my dad.

The fact that I was an American college grad and almost officially of drinking age didn't mean I wouldn't still have awkward moments with my refugee parents.

When I turned twenty-one, Brian threw me a surprise party. He took me to Calistoga for a mud bath and couples' massage. When we got back to my house, our friends were there to greet us and continue the celebration. My parents made all my favorite foods: spring rolls, fried rice, and *bánh tôm*, shredded fried sweet potato clusters with shrimp to wrap with lettuce and dip in *nước mắm*. They were smiling ear to ear, delighted to be part of the festivities. They especially loved joining the all-American experience of hiding and waiting until I walked through the door and yelling, "SURPRISE!" The suspense of gathering

all my friends and cooking the food and waiting for us to come home was as much fun for them as it was for Brian pulling it off without me suspecting a thing.

"So much good food, huh, Yến? Your friends like this better than restaurant. They told us," my dad gloated.

I was not surprised by the generous home-cooked meal. My mom and dad always showed their love by making sure I was well fed. No matter what I craved, they made it, found it, or bought it.

But I *was* surprised when they called me up to my room to give me my present. Má and Ba were so excited. This was the first time they'd ever been part of a surprise party, other than watching me plan Brian's sweet sixteen surprise party years before. My dad almost spoiled that one because he has never been able to keep anything to himself. He asked Brian something about seeing all his friends soon, and I had to give him the evilest eye and redirect the conversation: "Dad, I think I hear something in the backyard. You should go look."

Now they were taking me up to my room. "Surprise!" my parents said. The room still housed the pink and white Formica bed I'd loved as a kid. The ceiling was still painted half blue sky with sun and half night sky with stars, something I'd done with my friend Sasha when I was in junior high.

Taped to my mirrored closet door were twenty-one hundred-dollar bills, positioned to form the number 21.

"It's twenty-one hundred dollars because you're twenty-one!" My dad grinned.

"Happy Birthday, Yến!" my mom said with an excited smile.

"Umm, thank you," I stammered. My friends were surprised, but in an awkward way. They weren't familiar with this "straight cash homie" custom of giving a gift. I was already one of the more well-off friends in our group, living in a nice house in a new development.

"Wow, cool," my friends murmured, but I could tell they thought it was a little odd. And while I should have been grateful, I was embarrassed. My parents were beaming.

"Ohhhkaaaaay, thanks, Mom and Dad," I said briskly, ushering everyone out of my bedroom. "Let's go back downstairs for cake."

Here it was again. My parents, oblivious to the socioeconomic differences between my friends' families and ours, didn't see anything tacky about taping cash to my mirrored closet and giving it to me in front of *everyone*. That blind spot reminded me that even when they meant well, my family was different and so was I.

We wouldn't be rolling in the dough for long.

29

Absolute Rookie

Being high school and college valedictorian doesn't mean squat in the news business. I still had to make a résumé reel.

During my internship with KTVU, I asked the news photographers I worked with if I could record stand-ups when we were out in the field. In the industry, news photographers are the people who shoot and sometimes edit the video to put on a broadcast report. A stand-up is when you are on scene somewhere and say a few sentences to the camera about the news event you're covering.

For example: "The storm knocked down these powerlines, and as you can see—the wind was so powerful it toppled this tree. The branches went through the roof here."

Or "Crime scene tape still surrounds this parking lot eight hours after the stabbing. Police are now out with search dogs to try and find out where the suspect went."

To get a job in TV news, you can't just send in a paper résumé, you have to submit video too, so the news director can see what you look and sound like.

With the help of photographers Sean Drummond and Tony Hodrick at KTVU, I shot stand-ups at a few locations around the Bay Area and bribed an editor with pastries to help me edit video clips for my demo

reel. Then I made twenty VHS tapes and sent them out all over the country. I heard back first from the ABC station in Sioux City, Iowa. They were interested in offering me a general assignment reporting job for the grand salary of $18,500 a year.

My parents were flabbergasted. Their daughter, who had just finished four years of college at a private Jesuit university, who had given the commencement speech as valedictorian, would make less than a fast-food restaurant worker—in a state they'd barely even heard of?

"Eye-oh-ah. Where is Eye-oh-ah? Why they pay so low, Yến?" My dad was alarmed by the salary range. "It snow there. Very cold in winter."

My mom was equally worried, especially about the fact this job was located in the middle of the country near . . . nothing and no one that she knew.

"I don't know, *Con, xa quá.*" Too far.

Brian was about to start his senior year at USF. He was a straight-A student preparing to apply to medical school. One of us made it through all the hard science classes with flying colors!

Before I could make a decision about Iowa, I left for the Asian American Journalists Association convention. It was in New York City in August 2000. News directors and recruiters from all over the country attended these conventions. The gatherings were part boondoggle, part networking and talent searching. I had only been to the conventions as a student journalist. This would be my first AAJA conference as a job seeker.

Imagine an entire hotel teeming with Asian journalists from all over the country. A sea of jet-black hair, newspaper and TV reporters ranging in age from twenty to sixty, mostly female. The TV reporters stood out; we dressed in brightly colored pantsuits and wore a lot of makeup. Everyone carried a complimentary black laptop bag with AAJA embroidered across the front. Laminated name tags around our necks identified us and the publication or TV station we were from.

Mine said, "Vicky Nguyen, University of San Francisco" because I didn't yet have a job. Each day of the conference was scheduled with panels and workshops with titles such as "How to Write for TV," "Pitch-

ing the Perfect Story," "Investigating Government Abuse." I attended the sessions and listened to local and national broadcast reporters who looked and sounded flawless. These were women doing the jobs I wanted! They were sophisticated and put together. They had so much firsthand experience as TV journalists.

The opening night reception was unlike anything I'd ever seen in person, much less attended. We gathered at New York City's famed Tavern on the Green restaurant in Central Park. The entire outdoor dining area was reserved for AAJA. It was magical. Twinkle lights crisscrossed the tree branches above us. The tables were teeming with silver chafing dishes filled to the brim with fancy hors d'oeuvres. Everyone had a champagne glass or cocktail ready to clink and cheer old friendships, new connections, and the shared joy of being alive in New York City on a perfect summer night. I walked around, taking it all in. It didn't just look expensive and fancy, it smelled expensive and fancy. *That's how you know it's real,* I thought. *When it smells like money.*

My good friend from college Toan, the one who introduced me to the possibility of becoming a TV journalist, joined me at this convention. We were bonded for life over our adventures in reporting, the many internships we'd survived, and our searches for our first jobs after graduating. We were also poor, so we shared a hotel room and pooled our money for all the cab rides.

"I can't believe we're here," I marveled, walking around the reception and staring at the twenty-somethings who were only a couple years older than we were but already more self-assured. They were actual reporters, living on their own, earning an honest, though likely low wage for their work. We were so close we could taste it. But first, how to land a job offer?

The highlight of the convention was the job fair. Booth after booth occupied by local TV stations, newspapers large and small, journalism schools. Even the big five broadcast and cable networks were there with their talent recruiters and news executives: ABC News, CBS News, NBC News, Fox News Channel, and CNN. In 2000, there was a collective effort to diversify newsrooms by seeking reporters from backgrounds and cultures who reflected the communities they covered.

Toan, an Asian male reporter, was a unicorn. Asian females over-indexed in broadcast news; it seemed like there were at least one hundred of us to every one Asian male. Toan and I split up to cover more ground: then we'd come back together to see who was sponsoring a "lunch and learn" so we could eat for free and compare notes.

I shook hands with and took business cards from everyone I met. Managers, producers, seasoned reporters, and fresh-out-of-school wannabes like me. I was . . . green. I was stiff on air and still sounded like a teenager with a high-pitched, raspy voice. I signed up for critique sessions to get feedback about my tape: *You need to work on your voice. It sounds very girlish. Try to be more natural when you're on scene. You haven't been doing this long, have you?*

I was persistent. On the second day of the conference, I said hello to a tall guy whose name tag said he was the general manager of Central Florida News 13, a Time Warner station.

"Hi, how are you," I said, quickly introducing myself before he could get away. "I'm Vicky Nguyen, and I'm looking for a reporting job. I'd love for you to see my work and give me some feedback."

He introduced himself and said he'd be happy to check out my tape. "But we don't have a booth here," he said, "so I don't have a way to watch your tape right now at the convention."

I seized my chance. "Actually, I just walked past the CBS News booth. They had a bunch of VCRs, and it didn't look like anyone was there. If you don't mind," I said, willing him in my mind like a Jedi to follow me as I pointed to the booth, fifty feet away.

I made small talk while weaving through the crowded aisles. I kept checking over my shoulder to make sure he was still following me until we finally got to the CBS booth. I had a canvas tote bag stuffed with twelve VHS tapes labeled with my name and email address, plus a manila folder with forty copies of my carefully formatted résumé. I pulled out a tape, commandeered the VCR, and handed him a set of headphones.

He watched for less than a minute, took off the headphones and said, "You know what, we have a gal, Jane Park, who's leaving."

It took me zero seconds to figure out—an Asian for an Asian. Jane

Park was likely a female Korean reporter leaving her job, and here I was, a female Vietnamese reporter who wanted a job. Jackpot!

He didn't say much about my stories or my on-camera presence. He just did the mental calculation and thought that I looked enough like Jane Park that I could probably replace her easily. Maybe he appreciated my tenacity in getting him to see my tape when neither of us had a VCR? I never knew because he didn't say why he liked my work, and I didn't ask.

"My news director will call you tomorrow at ten a.m. What room are you in? I can give her your number. Just be there and I'll tell her to call you."

She called me the next day at the appointed time. We spoke about my experience, which was basically none except from school and internships, and she told me the general manager liked my tape.

Three weeks later I flew to Orlando with two suitcases full of clothes and makeup. It happened that fast. I paid three hundred dollars to have the Honda Civic my parents bought me transported from the Golden State to the Sunshine State on a big flatbed truck. I stuffed that little car full of everything I could. The trunk was jammed with clothes, towels, sheets, and blankets. I wedged nonperishable snacks like cereal and granola bars, books, and some photo albums into the cabin. Not one square inch of that car was empty, and through the windows, it looked like everything was ready to burst out the second I opened a door. My dad had done the research. Stuffing the car was much cheaper than shipping my things in boxes. Between my Civic as a suitcase and my actual suitcases, I brought everything I owned.

I negotiated my salary up to $26,500 a year from the initial offer of $25,000. Plus, I scored a moving bonus of $2,000, which was more than the cost of the plane ticket and transporting my car. The offer was much higher than what ABC was willing to pay for the job in Sioux City. At forty hours a week, this job would pay $13.25 per hour, compared to about $9.00 per hour in Iowa. And Orlando would be a lot warmer.

So much for graduating first in my class. It was a laughable salary compared to what my peers were making fresh out of college at con-

sulting and engineering firms, which was easily twice what I would be making.

But this was my first job, and I knew that journalism was a career where the salary range was wide. A few people at the top were being paid millions of dollars a year. I had to start somewhere. My journalism BFF, Toan, landed his first job in Midland, Texas. There was some solace knowing we were in this together, even though we'd be hundreds of miles apart.

I also chose Orlando because I wanted to follow the advice of my news director at KTVU. Andrew Finlayson told me, "Choose the news market where you would most like to live and where you think most people will see you. News directors travel and you never know when one might be in a city where you work, see you, and give you a call."

The salary was enough to pay for my first apartment, on the third floor of a complex where some of the other CFN 13 reporters had lived when they first started. My rent was $428 a month, and the parking was free. I was amazed the first time I filled up my gas tank and it was only ninety-nine cents a gallon. Having lived in California, I had never filled up while watching the number of gallons increase faster than the dollars. When it came to cost of living, this was reverse sticker shock and a perfect way to start my career as a real reporter.

30

One-Man Band

I sucked. My first assignment as a professional reporter was an easy feature story about a teen girl returning home after spending weeks in the hospital recovering from a bad accident. Every station was there. All I had to do was get some interviews and get the shot of her going into the house and everyone cheering and hugging.

I set up my tripod in a good spot, muddled around, and managed to get all the elements I needed: shots of the girl, shots of the family, shots of the decorations. But when I got back to the station and popped in the tape, most of my video was blue. I hadn't "white-balanced" properly to tell the camera how to shoot in the correct color tones. When I went inside after being outside, my video was tinted blue. On top of that, I was editing a full story for the first time. I had to log my interviews to find the best soundbites, write the piece, and then edit "tape to tape." The only experience I had at that point was a semester of radio class that taught me the basics of editing.

I was slow at everything. Central Florida News 13 was a twenty-four-hour cable news station. We didn't have the traditional newscasts that were only on at five or six in the evening and then again at eleven. We were constantly putting new stories on when they were ready. My goal was to have my story air in the 6:00 p.m. news hour. Four hours would

normally be plenty of time to log, write, and cut a spot. But not for me.
I didn't get that first story on until 10:00 or 11:00 p.m. I remember my
producer, Len, a beleaguered veteran of the industry, checking in with
me every hour and sighing when he realized I was nowhere close to
being ready to file my story. He was patient, but this new reporter was
screwing up the newscast. I was slow as molasses.

I finally put my blue video news package on TV and went home after
a fifteen-hour day. *Well, it can't get worse than this,* I thought.

Reporting solo is hard. Do you know how to get video of yourself
in focus when you're a one-man band, the reporter and the camera per-
son all at once? You zoom in on a leaf or a rock on the ground to mark
where you should stand and to get a focal point. Then, you make a lot
of guesses about how far to widen the shot to make sure your head isn't
cut off or there's not too much headroom. When you've never done it,
there's a lot of opportunity for errors. I made them all.

I lugged thirty pounds of gear all over Central Florida and used a
map book to find addresses. The books had grids with letters and num-
bers that you used to pinpoint your destination. I got lost all the time.
In Orlando, a street starts out named one thing, then it hits a lake and
is named something totally different on the other side. Driving to and
from locations was easily 30 percent of the challenge of my job. The
other 70 percent was dealing with the heat and humidity and smiling
kindly at the strangers who drove by yelling, "Hey, it's Connie Chung."
How original. Connie was the iconic trailblazer and had been on the
news longer, but it would have been nice if they shouted, "Hey, it's Ann
Curry," once in a while.

That first year, I learned how to make the best of a bad situation. I
was eventually promoted to reporting live for the morning news. Pros:
getting to work with a photographer every day to shoot stories. I no
longer had to shoot and edit by myself. Cons: My alarm going off at
3:15 a.m. so I could get to my shift at 4:00 a.m. and be ready for live
shots starting at 5:00. The other major con: working with one of the
grumpiest and most negative people I've ever met, a guy I'll call Fred.

I was twenty-two, and he was in his mid-thirties. Fred was just an

"I'm here for the paycheck" kind of guy. He didn't have a desire to do great or even good work. He just wanted to do the bare minimum. And he was not shy about putting a new reporter in her place.

"Hey, Fred, I was thinking we could do a walk and talk to show where the crash happened and then where the car ended up in this yard."

"Nah. I'm locking down the shot here in front of the yard."

"I think it would be more creative if we show the path of the car."

"I don't care what you *think*. You worry about your job, and I'll worry about mine."

We were supposed to be a dynamite news-gathering team, but Fred wanted to maximize his nap time in the live truck. If we were walking and talking, that meant pulling more cable, which meant taking more time to clean up, which meant less time to sleep. At that predawn hour, it was hard to muster up the energy to build a rapport, but after a few attempts to get to know him, to understand what motivated him, to learn why the hell he was even in news, I learned a valuable lesson. Know when to say when.

I let him nap and did what I could do to make my reports engaging, and I had a lot of work to do. I was insanely nervous before every live shot. I would write out everything I wanted to say on live TV for two to three minutes, then try to memorize it all. Most reporters would just have notes with a few bullet points, then tell the story conversationally.

Not me. That was not smart. Because whenever I forgot the exact wording of my sentence, I went into a death spiral of blanking out, stumbling, and struggling. Fred loved to mutter that I was a real "Stumbelina."

The first live shot I ever did was reporting from the airport tarmac, waiting for Vice President Al Gore to fly in. I was supposed to talk a little about his visit, then step out of the way to show him getting off the plane. The anchor would take over and handle the rest.

Well, Mr. Gore took a long time to get off the plane after it landed, so I had to "tap dance" as they say in news. That means keep talking and talking until you get to the action. I recited as much as I could about Al Gore; his wife, Tipper; and the reason for their trip. I went back and forth with anchor Scott Harris for several minutes. I thought I did a

decent job for someone so green. But when I watched it later, I cringed. I said "Absolutely" at the start of *every* sentence before expanding on my thoughts when Scott tossed back to me.

Scott: "Are they expected off the plane soon?"

Me: "Absolutely. They touched down about fifteen minutes ago . . ."

Scott: "The Gores are in town for the first time since blah blah."

Me: "Absolutely. They're here to visit with blah blah."

Scott: "Vicky, tell us about the time line for this trip. What are they expected to do while they're here in Orlando?"

Me: "Absolutely, Scott, first they're heading to a meeting with XYZ."

I was *absolutely* a beginner, and it showed.

But my worst live shot happened right after a local election. I was going through the results of who won what district and school board race. I got so mixed up with names and numbers, I eventually just looked down at my reporter notebook, figuring it would be best if I simply read the results out loud. But I was so flustered I couldn't even read my own handwriting. After a few "Uh, in the race for District One, it was, um, Dennis, uh, Jones, no Johnson, who, uh, won, um, and secured the seat." Eventually I just sent it back to the anchors in the studio. It's a wonder I stayed employed.

The upside of getting my first job in the twentieth largest television market was that we had real news to cover. Orlando was a very busy and happening city. The downside was I barely knew what I was doing, and every day was a new lesson. I was so lucky to work for Robin Smythe, the news director who would eventually become my News Fairy Godmother and give me advice throughout my career. She didn't fire me for incompetence although she certainly could have. I made many, many mistakes, including the time I set up my tripod but didn't secure it, so my camera crashed to the ground in the middle of a press conference. The woman at the podium jumped and gave a little shriek. People back at the station thought it was hilarious and rewatched it many times, even in slow motion. I think that clip was part of our holiday blooper reel. Robin took mercy on me because she was used to hiring young reporters and nurturing them. She saw that I was trying, and that counted for something.

I tried to never make the same mistake twice. Every day I learned something new and added it to my skill set, improving my shooting and writing and finessing my craft. It was paid training, and I was grateful for the chance to do it.

I did not master live reporting in Orlando, but I was building muscle memory toward my 10,000 hours—that golden number that represents mastery of a skill, according to Malcolm Gladwell in his book *Outliers: The Story of Success.* I think I hit that sometime in Phoenix, two jobs later. I was in my mid-twenties and had five years of on-air experience, I could report live on anything anywhere at the drop of a hat. I could tell you what I knew, what I didn't know, and fill several minutes of time without being crippled by my nerves, I used a minimal number of "ums" and "uhs," and I broke my habit of trying to memorize everything word for word.

31

Distance Makes
the Heart Grow Fonder

In Florida I focused on work and not much else. I was now in a long-distance relationship with Brian. We'd been dating since I was sixteen, our first kiss was on August 11. We had a little string of numbers we'd memorized for every make-out session since that date: 11, 2, 11, 23, 13, 21, 28, 29. A lot of days between that first and second kiss apparently.

But Orlando was tough. Brian was enjoying his last year of college and applying to medical school. I had a Samsung flip phone with an antenna, and I was on the "free minutes after 9:00 p.m." plan, so that was the time we talked every day. With the three-hour time difference, he was usually getting ready for dinner, and I was exhausted after a long day at work.

We felt the distance on so many levels. Guys who started out as my friends inevitably wanted more. Between our schedules and bank accounts, we could only travel to see each other every few months. When we talked on the phone, we were rarely on the same page, and our relationship suffered.

It didn't help my self-esteem that I gained my freshman fifteen in Orlando. I worked odd hours and ate too many Einstein Bros bagel sandwiches. I treated my stress and loneliness with Tostitos and queso dip. I was also coming off my junior and senior years in college, when I

had been rabidly calorie restricting since sophomore year and was under-weight. My rebound from nearly three years of anorexic behavior pushed me from 90 pounds to 115. That's technically a freshman twenty-five. I was not at an unhealthy weight, but I felt sluggish, and all the extra pounds showed up in my cheeks. I was not in a good place with myself.

On top of the weight gain, I was blond and had the most atrocious short haircut with bangs, which made my round face look even rounder. I started tinkering with highlights in my hair. No one told me that you shouldn't just keep getting highlights. Instead, you should add back some lowlights or your hair will just keep getting blonder.

So there I was, a short-haired blond Viet girl with dark brown pointy eyebrows and too-dark lipstick stuffing myself into my pantsuits. My mom, if she even noticed the changes in my weight or hair, didn't offer any advice. She always had beautiful skin and never wore makeup. I was on my own in that department.

And now, my first and only real boyfriend, whom I'd dated from age sixteen to twenty-two, was here for a weekend, and we were . . . not ourselves.

"Hey."

"Hey."

"It's good to see you."

"Yeah, you too."

We struggled for words when normally conversation flowed eas-ily. Both of us knew we were disconnected. We had a few meals and watched some shows together. We made small talk. But even together in person, we felt distant.

When it was time for Brian to go back to San Francisco, I waited with him at the airport. I felt sad. It seemed like things were ending, and neither of us wanted to say it out loud. He was quiet too. We hugged and he got on the plane. I went home and sobbed. We agreed we were going to talk less frequently to see how things went. Would we miss each other? Would we be relieved? So much was unsaid and undecided. No one ever said the b-word, but I worried that's where we were headed. After being with Brian for six formative years, I felt lost and alone.

At the same time, I was getting my butt kicked at work. Even though I was mostly doing live shots in the morning, I still went on assignments to shoot my own stories. For the first year, I didn't have people I hung out with outside of work. My co-workers and I were friendly, but once again, I wasn't in the popular clique. Then a new girl came. Cute, petite, blond Kelly Teague. Like me, she was a one-man band, but unlike me, she was *really good*.

Her shooting was amazing, her editing was full of natural sound pops, and her writing was concise and creative. She made friends easily and quickly established herself in the newsroom.

This Kelly had just come in and rocked my world. I didn't really have a chance to talk to her because we were always going on different stories. So I just watched her reports. I studied them. I made notes on how she opened her story about the U.S. Postal Service getting ready for the holiday shipping season and how to pack your gifts safely. She used the sound of a box slamming onto a table, cut to a tight shot of a roll of tape unspooling across the top of it, *brrrrrt,* and the patting of a label onto the package. She was using "natural sound" in her storytelling, and it was effective.

I listened to how she wrote, saw how she used wide, medium, and tight shots to get unusual angles and visual sequences. Then I straight-up copied what she did. No excuses for me. I was petite, she was petite. I was new, she was new. I didn't know how to get better until I saw up close and personal someone like me who was so much better than I was.

As wise executive producer Sean Reis recently told me, "Talent invents, genius steals." I was no genius, but Kelly Teague was talented, and thanks to her, I put together a great résumé tape and started sending it out to news directors in markets closer to home: Sacramento and San Francisco in California; Portland, Oregon; Seattle, Washington. Then the call came from KOLO-TV.

"We like your tape. Would you be interested in coming to work as a nightside reporter for us?" After a year and nine months reporting at

Central Florida News 13, I was headed back to a place my parents never thought they'd have connections to again: Reno, Nevada.

Brian and I made it through that rough patch in Orlando. The time after his visit, which lasted about three weeks, allowed us both to see what life was like without talking to each other daily. Turned out neither of us liked it. Nothing momentous happened in our "Silent Era." We chose each other, and we chose to stay together. When I imagined life with someone else, I didn't want it. We grew up together and we grew as individuals, together. No one understood me the way he did, and he always made me smarter and stronger and more capable at moving through life the way I wanted to. Getting over that test early in our relationship ultimately strengthened our foundation as a couple.

Brian came out to Orlando to live with me the summer before med school, and that cemented our commitment that we were going to get through the challenges of being apart. The distance was temporary, but we were forever.

We embraced a quote by Roger de Bussy-Rabutin that summarized that phase in our lives perfectly: "Absence is to love what wind is to fire; it extinguishes the small, it inflames the great."

32

Reno Part Deux

In Reno, I took control of my health. I joined a 24 Hour Fitness gym and used turbo kickboxing classes to deal with my stress. I lost weight. I stopped stress eating. I got over the unhealthy drive to be thin. I grew out my bangs and let my hair return to its God-given color. I was a cute, stereotypical-looking Asian American TV reporter, shoulder-padded blazer included. Everyone at work was friendly, and once in a while, we'd grab all-you-can-eat sushi or celebrate someone's birthday at a local casino nightclub.

I made the three-hour drive to visit San Francisco whenever I could, and Brian surprised me plenty in Reno. He was in his second year of medical school, and it wasn't easy to get away. But compared to Orlando, Reno was practically next door. We didn't consider it long distance, and I even used my cell minutes to call him before 9:00 p.m.

Life was infinitely better in Reno. I was in a good rhythm at work, until my nightside photographer, Isaac, developed feelings for me. I didn't know until he started asking questions about Brian but would never mention him by name or ask how he was . . . you know, the way a normal friend would ask you about one of the most important people in your life.

"You're still with that guy?" he'd ask caustically. "Why?"

I answered earnestly in the beginning. "Yeah. We go way back. He makes me better. We work well together."

"*We* work well together," Isaac said, meaning him and me. Awkward. I brushed it off at first and changed the subject. But word got around the station he had a crush on me and wasn't shy about it. Another reporter asked me if I heard what he said about Brian.

"When Brian picked you up the other day, Isaac said, 'That won't last. I'm not worried about him.'"

Here was someone I worked with every night, whom I considered a friend at work, now disrespecting my boyfriend/best friend, and insulting me for being with him. It was starting to creep me out. But how to deal with the snide remarks and the campaign to replace Brian? I was at a loss. We had assignments to complete every night, but Isaac kept at it.

Oh, you didn't go to San Francisco this weekend? Are you guys breaking up?

I don't know why you'd put up with that.

Don't you think he's cheating on you?

After a few weeks, I just told him: "Dude, you need to stop. I don't know what your problem is, but you're being super rude. Brian is my best friend, my boyfriend, and I don't appreciate how you talk about him. Let's just focus on our work."

Then I got the silent treatment. It was clear Isaac did not appreciate me calling him out for his weird and gross way of trying to win me over, so he turned 180 degrees and ignored me. We went from being friends and colleagues to this purgatory. He was also angry. I could see it in the way he gripped the steering wheel or squared his jaw when I spoke with him about our work. If he had to look my way, he glared. He was an unhappy person, and somehow, he thought I betrayed him by bluntly calling him out.

Eventually I was assigned to work with other photographers, and that saved me. My photographer Jeff and I won three hundred dollars on a slot machine while shooting for a story, and we had a blast collecting all our quarters and turning them in for our short stack of fifties. This was my first and only jackpot at a casino, and we split it down the middle.

My high of feeling lucky and enjoying my independence came crashing down. I was just a couple of months into my reporting job when my mom called me.

"Yến, we sold the house," she told me. "We going to live with your uncle."

"What? *Why?*"

My mom took a beat. "Your dad lost the money. We had to sell it."

"What? He lost what money?" The Windsor, our *Miami Vice* house, which I helped decorate when I was ten, the only place that ever felt like home, was already in escrow.

How had we gone from that extravagant cash display on my twenty-first birthday two years earlier to no longer even owning our own house?

"Mom, wait. What happened? How did this happen? What do you mean you sold the house? I don't understand."

The long and short of it is a familiar story for some immigrant families. After establishing a comfortable life, opening the Santa Rosa furniture store and a second furniture store in San Rafael, my dad decided he was ready to get out of furniture and try something new. He pursued a series of business ventures, including a gift shop in downtown Santa Rosa. But what he started to focus on was trading stocks on his home computer.

Day-trading is a little like gambling—a lot like gambling, actually. And if you have a confident, risk-taking personality, you can get in over your head quickly. The same personality traits that helped you and your family flee your birth country are the traits that can be your undoing.

"Your dad refinanced the house, Yến," my mom said. Her voice was strained, halting. "I didn't know. The banks, so stupid, they just give him more money."

I was too angry to speak. This was a betrayal of trust and all too predictable at the same time. I had known my dad was trading stocks, but I had no idea the extent to which he had leveraged my parents' most valuable asset, our family home. And now it was gone. I couldn't even help them. I was making less than $30,000 a year in my second

TV reporting job and had just a few thousand dollars in savings. I was furious with my father and sad for my mother.

My dad was contrite, but confident this was just a momentary blip in his life. "Don't worry too much, Yến. We be fine. I get it back," he told me. His apology was casual. "I'm sorry. I have to do what I have to do for the family. But don't worry. I make it back." He pulled the literal teal rug out from underneath my mom's feet, and his attempt at apologizing made me feel like he wasn't aware of just how badly his actions had damaged the foundation of all our relationships: trust. How could I trust what he was saying? His actions had spoken far louder.

The loss was especially hard on my mom. She loved that home so much. It represented everything they had both worked so hard for. And now that house, with all the nice furniture from the model home, and all the happy memories of my childhood from age eight to twenty-one, was collateral for a loan they couldn't repay.

My mom was the most depressed I've ever seen her. Her usual lightness was gone. Every time we talked, she was sad and angry. She blamed herself.

"I should have pay more attention," she said. "I didn't know what was going on."

She said she felt like a failure for not fighting the bank, for not pushing back on how they allowed my dad to refinance everything.

"Yến, Má tức lắm." "At first, I was so mad." "Má tiếc cái nhà đó." "I regret losing that house."

When our gray Honda Accord was thirteen years old, my parents upgraded to a taupe Lexus ES luxury sedan. It was the second "We have arrived" moment after the house. My mother loved the beige leather seats and how smoothly it drove. It was spacious and comfortable and safe. Everything you could want in a car.

"When we sold that, I was even madder than selling the house," she told me. She knew logically it didn't make sense, but the nadir of the whole experience for her at that point was letting go of the Lexus. Losing the two material symbols of the American dream within a few years of each other made my mom feel like everything was ripped away from her.

My dad was mostly silent. He'd said his piece. He was moving on. This issue was far from being resolved. But I didn't have the tools, the communication skills, or the energy to fix it. Every time they visited, or we talked, the betrayal hummed in my brain and filled the gaps in conversation. I couldn't connect with my dad.

I was working under a new stress. As a journalist, I made a pittance, and now my parents, who had been financially stable and secure with a roof over their heads, had nothing but a pile of debt. I had chosen a risky career path, and now I felt the weight of our circumstances. The pressure to succeed was never more intense.

When I'd gotten my first job, my parents had joked about moving to Orlando with me. "Why not?" my dad said. "We go where you go." But we all knew he was kidding. That was never really the plan. As much as they would miss their only daughter, I was twenty-one, and they had to let me go. Besides, why would my parents leave the comfortable lives they'd established in Santa Rosa? They were semi-retired. They owned the Windsor outright, and they didn't live extravagant lives. They had savings, and they had very few expenses now that I was out of college and making my own salary. I hadn't worried about my parents because they were doing well. They had succeeded in America.

But after this crisis, my parents considered joining me in Reno, for real.

"Well . . . I don't think that's a good idea," I said, pausing to choose my words. "I don't plan to be here a long time. What would you even do here? You still have your gift store." I knew the store in Santa Rosa had been limping along for a while.

I thought about myself. How could I focus on work with my parents moving to the same city, jobless and in debt?

"Yeah, we not moving," my dad said after a heavy silence. "We stay here. We find something."

My mom, now fifty-four, and my dad, forty-eight, moved into a rental home.

I sighed. A respite. I was already distracted enough thinking about my parents' financial situation. I needed to focus on my career. I had to

succeed in Reno and move on quickly to a bigger market, because that meant a bigger salary.

For the eighteen months I was in Reno, my parents kept up appearances. They didn't share many details about how they were doing financially, and I didn't ask. They spent time at their gift store, making enough to cover the rent to keep the shop open. I visited Santa Rosa a couple times, but mostly Brian came to Reno because I never wanted to stay with my parents in a strange house that reminded me of everything that happened.

"Thank you for taking care of Cali, Mom," I said on one visit. Our family dog was getting older, and she was having a lot of accidents. My parents kept her in a pen in the kitchen, and it was depressing to see Cali aging and losing her ability to move around.

Our family dinners were quiet. I couldn't get past all my anger, and seeing my parents dredged up so much guilt. The financial situation hung like a black cloud over our interactions.

The only bright spot during that period was Brian. He knew everything happening in real time. He was there to talk me through it, listen to me vent, and offer support. We never told his parents the details, but surely they noticed my parents no longer lived in the Windsor. They never pried. They just continued to be there for Brian and me.

I didn't have anyone else to talk to about what was happening. But Brian was more than enough. He knew me, he knew my parents, and while neither of us knew what was going to happen, we knew we had each other. It was like when I had struggled as a kid in a new school; all you need is one good person to keep you going.

Fortunately, my time in Reno came to an end when I got a job offer in a top-20 market. I kept my résumé reel up-to-date. In addition to periodically sending it out to all the stations in the San Francisco Bay Area (my dream market), I submitted my tape to a place called Talent Dynamics. It was a video data bank where reporters could send their tapes to be viewed by news directors looking to hire new talent.

One night, a little over a year after I started the gig in Reno, I came home to a voicemail from the news director at KSAZ-TV, the Fox-owned

station in Phoenix. It was midnight, and I saw the red light beeping on my answering machine the second I walked into my apartment. (I saw almost everything in my apartment the second I walked in because it was about 550 square feet.) I hit the button while taking off my coat.

BEEEEEEP. "Hi, this message is for Vicky. This is Doug Bannard with Fox 10. I saw your tape on Talent Dynamics, and I wanted to chat with you about your work and see if you'd be interested in coming out to Phoenix." He left his number and requested a call back.

I called Brian, waking him up, and said, "Where's Phoenix, Arizona?" I knew it was in the Southwest, but what I meant was *How far away is it from San Francisco?* And *Do I really want to move even farther away when I just got back within driving distance of my family and you?*

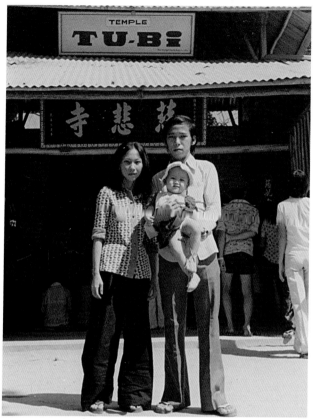

Without these two, there is no boat baby. Huy and Liên in front of a temple at the refugee camp in Pulao Bidong, Malaysia, July 1979.

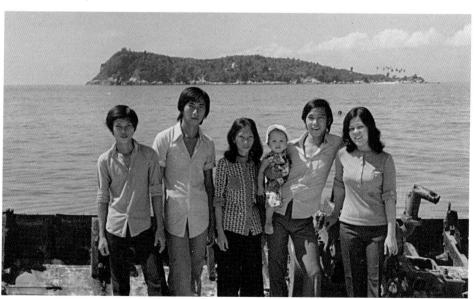

Our family crew in Malaysia, July 1979. Quang, Tam, Liên, me, Huy, and Nga. Even I'm smiling because we made it ashore. To get photos, clandestine photographers from the mainland would sneak into the camp, take the pics, then smuggle them back in.

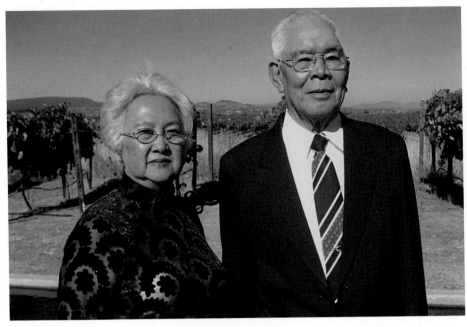

Dì Hai, who was always like a grandma figure to me, and her husband, whom I called Dượng Hai.

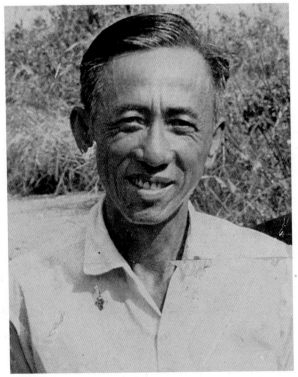

Đo Công Minh, my maternal grandfather.

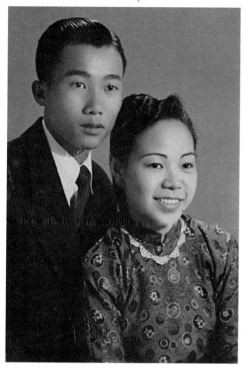

My paternal grandparents, Toàn and Ty.

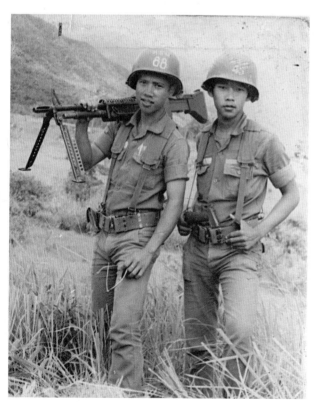

My dad, Huy, eighteen, on
the right with an unidentified
soldier in the South
Vietnamese Army.

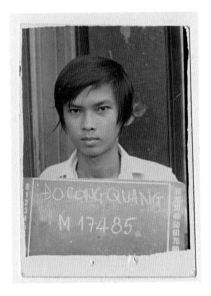
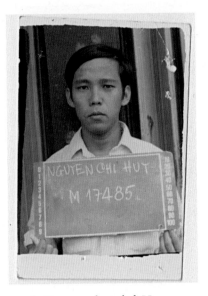

ID photos at the refugee camp of my uncle Quang and my dad, Huy.

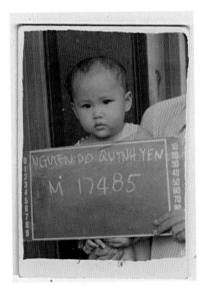

My ID photo when we got to the refugee camp.

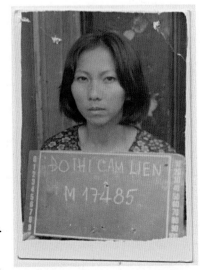

My mom, Liên's, ID photo.

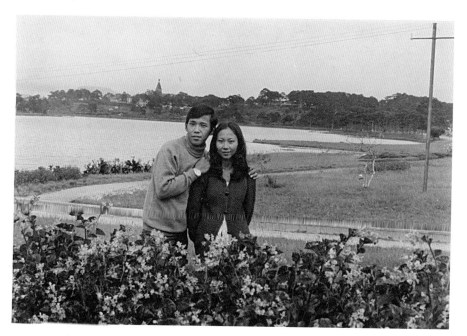

A photo taken shortly after my parents married in Đà Lat, Vietnam, 1976.

My mom, Liên, reviewing applications at adoption organization
Holt International Children's Services, circa 1979.

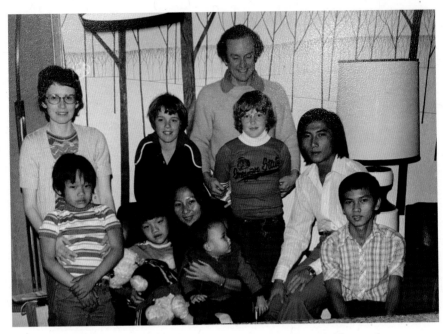

Wannell and Don Ware, far left and center, with their children and my mom, uncles, and me, 1980. To them I will always be grateful.

My handsome uncle Tam somewhere in Oregon, circa 1980.

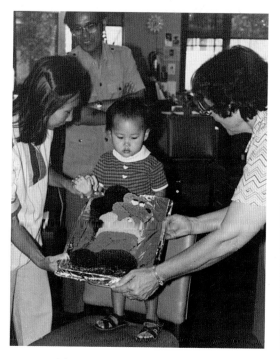

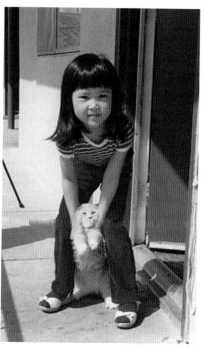

The amazing Mickey Mouse cake made to celebrate my second birthday in Eugene, Oregon.

Me, the kindergartener who begged for a lot of things, including Sugar the kitten.

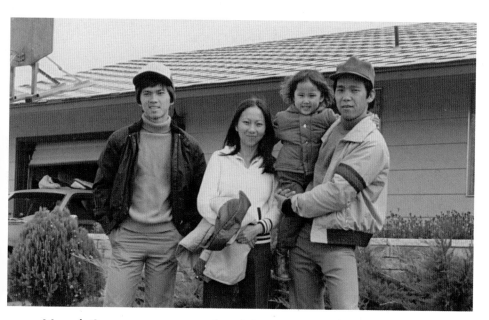

My uncle Quang, my mom, me, and my dad on a visit to Washington, circa 1982.

My first department store portrait, circa 1982. Look at that pose and perm!

Fifth-grade school photo. My amazing haircut that made everyone think I was a boy.

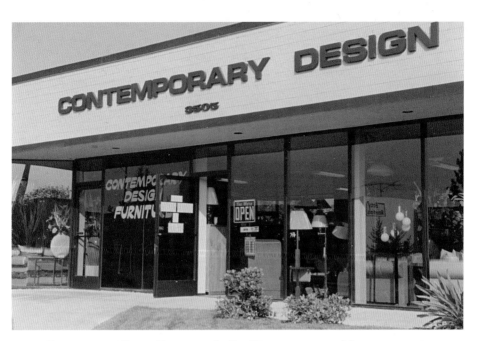

Contemporary Design Furniture, the first Vietnamese-owned furniture store in Santa Rosa, California, opened by my parents in 1987.

Posing on a moped with my maternal grandma on my second trip back to Vietnam at age fourteen.

Brian and me in front of the Windsor taking our homecoming dance photo when I was sixteen.

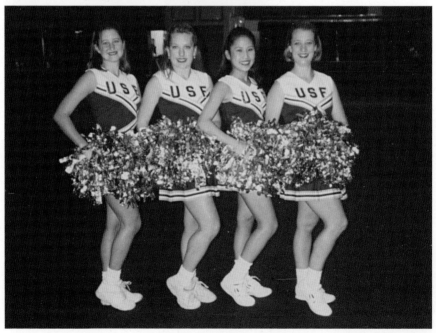

That time the USF cheer squad was asked to dance on set during a *Wheel of Fortune* college tournament in San Francisco, November 1996.

In my first job at Central Florida News 13 where
I shot and edited my own stories, 2000.

NBA superstar Shaquille O'Neal and me at the Tent City jail in Phoenix, Arizona. Shaq loves law enforcement, and he toured the facility and met with Sheriff Joe Arpaio. He's holding a pair of the jail's infamous pink boxers given to inmates. When I shouted a question at him in the scrum, "Shaq would you wear those boxers?" he turned, looked down, and locked eyes with me. "For you," he joked. January 5, 2007. *Jack Kurtz*

Brian and me on our wedding day in 2007 with our dear friends Kiet and TuAnh Do.

Right after my once-in-a-lifetime Blue Angels flight, October 1, 2018.

Accepting the DuPont award at Columbia University with my NBC Bay Area colleagues for our series "Drivers Under Siege." Left to right: Stephanie Adrouny, Michael Horn, Kevin Nious, Jeremy Carroll, and Jodi Hernandez in January 2019.

Anchoring at NBC Bay Area with reporter and anchor Garvin Thomas, March 17, 2019.

First day on air at the *Today* show with Craig Melvin
and Savannah Guthrie, May 16, 2019.

Thanksgiving in New York, 2022.

Holding the Jilly Bing Asian American doll on the *Today* show couch, September 6, 2023. *Jamie Nguyen*

With the legendary Connie Chung at the Millennium Biltmore Hotel in Los Angeles for an interview about her memoir Connie and to serve as the emcee for her Centennial Medal from the Asian Hall of Fame, September 23, 2024.

33

But It's a Dry Heat

When I'd moved to Reno from Orlando, it was a slight upgrade professionally and it put me much closer to Brian. But Phoenix? That meant we'd have to take a flight to see each other. When I called the news director in Phoenix, I asked for all the details in the first conversation. I wanted to know what the hours would be and what the salary range was.

"That's putting the cart a bit before the horse, Vicky," Doug said.

I did my favorite thing to do in a conversation. Something I learned from *The Good Girl's Guide to Negotiating*. The pregnant pause.

Me: "..."

Doug: "..."

Me: "..."

Eventually Doug continued, "If you were to get the job ... the range is in the sixties."

As in, *sixty thousand dollars*? As in, *twice* my current salary? Never mind that I later learned most reporters doing my job at that station were making in the seventies. Sixty grand sounded like a real, grown-up salary—the kind that you could afford to live on and have extra to save.

I called Brian to tell him about the job. I'd be working nightside Wednesday through Sunday, doing a ton of live reporting, and I would make more money. He had the same reaction.

"Twice your current salary? I think you're gonna have to go."

I looked up the flight time between San Francisco and Phoenix. It was two hours, not bad. And with that new salary, we wouldn't have to skimp on visits. It was a no-brainer to accept the job. Plus, I'd never even visited Phoenix, so this would be an adventure. Once again, I stuffed my Honda Civic and paid for someone to transport it out to the desert. Phoenix was going to be my home for at least three years; that was the length of my new contract. I got rid of all my Reno snow gear, got on a plane, and promptly got horribly ill the night before my first day at work.

I had to call my brand-new job and tell them I wasn't coming in because I was sick. Great first impression. I was home alone in a new city on a new couch with a fever, chills, and nonstop nausea. Brian and my parents had flown out to help me settle in, but they were gone. It was Sunday night, and I was so miserable, I just shivered and slept on the couch with my cordless phone.

I learned: never start a job on a Monday. It makes for too long a week. Try to set it up for a Wednesday so you can give yourself time to ease into things. And regardless of what happens in those first few days on that new job, Friday is within sight, and you have the weekend to recuperate and process the new gig.

Once I started work at Fox 10, it was easy to make friends. I was more confident as a reporter, and I could focus on my storytelling and writing because I no longer had to shoot and edit my own stories. Phoenix newscasts were full of live shots and breaking news. I worked nights Wednesday through Friday and days on Saturday and Sunday. My weekends were Mondays and Tuesdays. I didn't complain or worry about my "work-life balance." I was in Phoenix to work, and boy did I. Often the story I was assigned at 1:00 p.m. would change two or three times by 5:00 p.m. and again for the 9:00 or 10:00 p.m. show. Phoenix was where I hit my "10,000 hours."

I felt comfortable live on air describing the details of a breaking news situation, like when stormy weather toppled trees onto homes or kicked up a brutal dust storm called a "haboob." I could even say that without laughing like a fourteen-year-old.

The worst stories were always the ones involving kids. I reported on heartbreaking incidents, like parents losing track of their children, only to find they'd drowned in a backyard pool. Phoenix, being one of the hottest places on earth, was home to thousands of pools. That meant the city had far more child drownings each year than anywhere else I had ever reported. The weekend anchor Linda told me she couldn't cover those stories after she had her own children.

Twice I reported on new parents who had driven to work and left their newborns in the car, where they died. One time it was the mom, who was sleep-deprived, like all new moms. She didn't normally take her baby to daycare; that was her husband's routine. But that day, for whatever reason, she was on drop-off duty. Instead, she drove straight to work with the baby strapped into a car seat in the back, silent and sleeping. No one realized the baby was still in the car until the daycare called a couple hours later. In Phoenix, summer temperatures can hit more than 100 degrees by midmorning. Inside a car in that heat, a baby has no chance.

That mother's anguish when she realized what happened shook me to my core. As journalists, we try to keep a professional distance from the events we cover, but it's not always possible to shield yourself from the secondhand trauma, particularly when you can relate on a human level. People can say, "I would never do that. How could anyone forget their baby in a car?" But all it takes is one morning, a tired mind, a change in routine, to make a fatal mistake.

I also did a series of reports on a serial killer and rapist who was terrorizing the city at the same time two other psychopaths were committing deadly drive-by shootings and arsons. Their heinous crimes sent the news cycle into overdrive every time another killing happened. Phoenix was on edge because authorities were still piecing the shootings together, posting sketches, and eventually offering rewards to solve these violent crimes. I sometimes did live reports for the national Fox News Network because they didn't have as many correspondents on the weekend. It was a "run and gun" market, where we covered hard news like border and immigration issues, but we also did feature reporting for the "Only on Fox" franchise.

Our managers were very smart. They knew that we would get burned out reporting on only death and crime, so they allowed us to work on lighter stories to give us a break. One of my more random stories featured Neuticles, fake testicles designed for neutered dogs so they wouldn't feel insecure. It wasn't highbrow, but it sure was promotable.

I also attended my first concert in Phoenix. My friend Yetta got us into the Fox suite for Gwen Stefani and the Black Eyed Peas. The Harajuku Lovers tour was Gwen's first solo concert tour, and BEP was the opening act. Can you imagine how entirely off the chain that was? I wore a mesh heart-print yellow shirt I bought at a boutique in Los Angeles, sparkly purple eye shadow, and skintight white jeans. Everyone knows white jeans mean you're ready for a good time. I danced my buns off that night. Brian was in town and he was starting to see the perks of being my plus-one. A night with Gwen and Fergie and Will.I.Am. for free? That s--- was bananas, b-a-n-a-n-a-s.

But the greatest concert moment came when I took my mom to see Madonna. It was my Vietnamese mother's first and only American concert. I had to make it count. Madonna was on her Confessions tour, and I bought tickets for us to see her in Glendale, Arizona.

Being frugal, I paid for "upper-level" seats. I didn't really know that "upper level" meant "dizzyingly high, look down and get vertigo" seats. We got there, climbed up what seemed like a thousand flights of stairs, and waited for Ms. M to start the show. She was more than an hour late, normal for a diva of her status.

While my mom and I waited and tried not to get nosebleeds from the altitude, a lady dressed in casual clothes climbed the stairs toward our section. I saw her holding a three-inch stack of what looked like tickets, the rectangular kind with perforated stubs. I watched her lean over and talk to some people and they shook their heads. She approached another group, and they waved her off.

She made her way over to my mom and me and said, "Would you like to sit down there?" pointing way down in the general direction of the seats in front of the stage. I was intensely regretting bringing my mom all the way to this Madonna concert only to sit so far above Madonna

she could have been any blonde dancing around on a stage the size of a postage stamp. So when this lady with the tickets asked me if I wanted better seats, I nodded, ready to pay the price.

"How much?"

She said it wouldn't cost anything. But we needed to get down there, right now.

I said, "It's free?" And she nodded—handing me two tickets that said FLOOR and our seat assignments. She wasn't wearing a uniform, but the tickets looked like the real thing, and she was urging us to go "You need to make your way down there now if you want these tickets, the show is about to start."

I looked at my mom and said, "Mom, she's saying we can move closer. Do you want to?" My mom raised her eyebrows, figuring any seats would be better than our current ones. "Okay, Yến, where do we go?"

I wasn't sure, but we took the tickets, and walked down down down down down toward where the lady had pointed until we got to the seats about forty rows back from the middle of the stage. What good fortune! We showed our tickets to the usher, who shined his flashlight onto the paper and shook his head.

"No, no, no. You're not here."

My heart sank. Did I just get scammed? And now I've walked my mom all the way down a gazillion steps and the concert is about to start and we have no seats? I should have followed those other people and refused that lady's offer, *damn it*! He went on, "You're down *there*," pointing to seats that were only twelve rows in front of the stage. *Even closer and better.*

I couldn't believe it. My mom and I went from last class to first class all because we took the risk of listening to a lady and going for it.

"Mom, can you believe this?"

"Wow, Yến, this is much better than seats you buy."

"I know, right? What about those people who shook their heads at that lady?" We thought of all those other people before us who didn't take the time to let her explain she was giving away free tickets to fill

the seats in front of the stage so it would look like a healthy, sold-out show right in front of Madonna.

"This is so close, *Con*." My mom was looking up at the stage, which was now so near we would be able to *smell* Madonna.

I felt like a conquistador. Who knew being so cheap could pay off so big? Twenty-eight thousand people were there that night, including my colleague and friend Joe, a photographer from Fox 10. Joe was a mega Madonna fan who had seen her in concert several times. He had spent big bucks to get great seats close to the front. I texted him to say we got upgraded from the cheapskate section to the front. I looked back, scanning the seats behind us until I spotted him. I grinned and gave him a big wave.

He flipped me the double bird.

I laughed and turned around, put my arm around my mom, and we partied like it was 1999. For her, it was *almost* as good as a Paris by Night Vietnamese music concert.

34

The Hot Intern

Often in a newsroom, there are only so many "slots." You have an un-spoken quota for how many Black, Latino, or Asian American reporters can be on air. TV being a visual medium, you can literally size up your competition on the most superficial level.

The situation has improved greatly with the awareness that diverse newsrooms better reflect and cover their communities, but this is an industry where there will always be more supply than demand. On top of covering the who, what, when, where, and why of news events, broadcast TV newsrooms create a hyperawareness of who's doing what, when, where, and why. It can lead to brutal rivalries.

People trash-talk, gossip, and make nasty comments behind others' backs. You're far more likely to hear something negative about someone than anything positive. TV journalism brings out the cardinal sins of lust, envy, pride, and a slew of other unsavory personality defects.

People are constantly comparing themselves to one another, and it can be an endless mind game, feeding off questions like *Why did so-and-so get that and not me?*

I got off that mental merry-go-round relatively early in my career. I inherited the Zen philosophy from Mom and Dad, "Don't fret about what you can't control. Focus on what you can." I'm never going to

know who my next boss is or who will get the next promotion or why someone else won the award and not me. What I can control is how hard I work, and what I put out in the world. If I want good things, let me put out good things. Never complain, never explain.

In Phoenix, I started learning how to tame my jealous tendencies. That is not easy to do nowadays with curated social media feeds shoveling everyone's best life moments into your face. But like any habit, the more you focus on yourself and on being the best version of you, the easier it is to avoid comparing and despairing.

It took a while to figure that out, but it started with the Hot Intern.

From time to time, we had interns who'd come through for a few months. They were there to learn, shadow us on shoots, and make their own demo tapes, the way I had five years earlier. Hot Intern was a knockout. Five-foot-eight, bright blue eyes, blond, very Barbie-like in her features and body type. She was assigned to follow me on a few stories.

With previous interns, I was friendly and helpful. I suggested they shoot stand-ups. I helped them think of what to say. I gave them feedback and coached them to relax in front of the camera. I looked out for my interns, and even when we were busy on tight deadlines, I made sure they got something shot for their reel during my shift. It was what Thuy Vu, Robert Handa, Manny Ramos, Roz Plater, and so many others had taught me, and I was paying it forward.

But with Hot Intern, I was guarded and quiet, irritated. She was gorgeous, nice, and seemed genuinely dedicated to learning how to report. I suggested she shoot stand-ups, but I stayed in the truck and worked on my story or played on my phone. I was jealous and indignant. Did I really need to help this person who already had all these advantages?

The only time my curiosity got the better of me, I asked her a question about her schooling, and we got onto the topic of hobbies. Hot Intern was *literally* a Miss Arizona or Miss County Something, and she was a personal fitness model. She was putting herself through school with a job that paid her to work out and maintain her physical appearance. That didn't stop me from begrudging her honest living. She told me how she trained, what she lifted, how she ate. There was a whole protocol

for restricting water in the days leading up to a competition. That way you could look super "cut," and your muscles would gleam and glisten under the fake tan and body oils when you posed onstage.

It was fascinating. But I was still cold to her. Eventually her internship ended, and she left. I felt awful. I realized I was jealous and insecure. I felt threatened. This was not a *her* problem, this was a *me* problem. Hot Intern should not have been punished for existing in my space. She was there to learn, and I was there to help. I regretted how I'd treated her and how I didn't extend myself the same way I had with all the other interns that had come my way.

How did I let those negative feelings overcome my naturally positive personality? For no reason other than my pride and ego, I had cheated Hot Intern out of the best experience she could have had at Fox 10. I felt guilty, and I felt wrong. This was not how I wanted to move through life, as a petty person who would wield whatever little power I had to make someone's life harder. It was an ugly moment and a wake-up call. Do better, be better. Someone else's excellence should not threaten you. Let it motivate you.

Now I tell my interns and mentees, "There's always going to be someone prettier, more pedigreed, better connected than you are. But there is never going to be another *you* better than you. So focus your energy on being the best *you* possible. That's the secret to moving through life without getting bogged down in whys and what-about-mes."

Also, I've never treated another intern, no matter how hot, badly again. Sorry, Hot Intern.

35

April Fools'

In Phoenix, I decided I needed a dog. My very own dog I would look after as an adult. I landed on miniature pinschers. I had learned my lesson about the disruptive habits of basenjis from our family dog, Cali. I needed a small dog that wouldn't mind living in an apartment and could come with me easily on flights back to the Bay Area. A miniature pinscher sounded perfect. Short haired and clean, "min pins" are high energy and love to walk, but they are happy to snuggle on the couch and chill too. They don't need any type of special grooming, and I did not want a dog that had to go to the salon more often than I did. Keep the poodle doodles. Mama can't be getting fewer haircuts than her dogs.

After a careful search, I landed on a breeder who happened to have *one* puppy left. They sent me a photo of the little guy, his ears wrapped in stiff white tape from being recently cropped. He was reddish brown with a worried facial expression, his forehead wrinkled between his propped-up ears. He was staring right into the camera, and he looked anxious. It should have been a red flag to me that he was the last one left of the litter, already four months old with no one who wanted him.

But he was available, and I was ready for a dog. I drove to a mobile

home park thirty minutes outside of Phoenix. Three hundred and fifty dollars later, I had myself a little red miniature pinscher I promptly named Romeo, as in Lil' Romeo, after the teenage rapper and son of Master P. The year was 2004, and one of my news photographers, Eric Corrales, suggested the name as a joke, but it stuck.

Romeo was the exact opposite of a confident, debonair rapper. He shivered on the ride home, peering out through the holes in his plastic crate, his ears trembling. When we got home, I opened the door to the crate, and he darted out. He sniffed everything and circled me, warily. Every time I reached out to pet my puppy, he scooted back, just out of my reach. After ten minutes of this, I called Brian.

"I have the dog. He's so cute, but he won't let me touch him. Like, every time he comes close, I try to pet his head and he runs away."

"Do you have any treats?" Brian asked. "Just hold one in your hand and wait for him to come closer and then try to pet him."

Sure enough, the food worked. I was finally able to pet him. We spent the weekend bonding over herky-jerky walks around the neighborhood. He was slowly learning to trust me. I set up an elaborate pen for Romeo with a comfy bed, some pee pads, food, and water so that when I went back to work, he'd be comfortable.

After my first day leaving him home alone, I got back from work to see the blinking red light on my answering machine. In 2004, I had a cell phone for work, but I still had a landline too. I hadn't told my apartment manager I was bringing home a new puppy because I didn't want to pay an additional hundred dollars in rent per month and put down a bigger security deposit. I went with an "ask forgiveness not permission" approach and thought they might not notice since he was under ten pounds.

I hit play on my answering machine.

"Hello, this is Jennifer with the main office. This message is for Victoria. Someone reported hearing noisy barking coming from your apartment all day. We don't have you listed as a pet owner on your lease. Not sure what's going on but if you have an unauthorized dog, you will need to call the office immediately."

I panicked. The message was so aggressive, and I had *just* gotten this puppy. I was already busted?

I called Brian in a panic. I was teary, stressed that my new little buddy was about to get super expensive. *$100 x 12=$1,200 a year!*

"Brian, they know about the dog! I just got a nasty message from the office. Someone said he was barking. A lot. All day."

"Oh no, Vicky. That's bad. You just got him."

"I know. I know. I know. Crap."

On and on this went for several minutes. I was totally coming undone. Like now I have to pay for this dog deposit and monthly rent, and it's going to be so expensive and damn, how did I get caught after having him for like three days?

Finally, Brian burst out laughing. "April Fools'!"

It was, in fact, April 1st. My boyfriend thought it would be hilarious to have his friend Erica leave me this message about my new dog, knowing full well I was already paranoid about sneaking him into my apartment complex.

I was relieved, of course, but also furious. Who does that? I vowed revenge but, in that moment, I was happy Lil' Romeo was still an undocumented puppy and I didn't have to increase my rent payment for my new companion.

It took a lot of coaxing and snacks, but eventually Romeo became my BFF. He was so spunky and always just a little bit off. If a dog could be on the spectrum, he was. He was not social with other humans or animals. He only let immediate family touch him, and that was only after multiple meetings involving a lot of snacks. He was never aggressive, but he was easily spooked by anything that was out of order. On a walk, if there was a box or branch on the sidewalk where it normally wasn't, he'd give it an extra-wide berth or bark loudly at it before racing past the offending object.

Romeo wasn't particularly affectionate but was agreeable to snuggling for warmth. I spoiled him and let him sleep in the bed with me, something I had always wanted to do as a kid with Cali, but my parents didn't let me. They insisted she sleep in a pen downstairs. On

the nights I snuck Cali into my room, she paced around and wouldn't settle down.

Since I lived alone in Phoenix, I loved having Li'l Romey Chomey as a bed warmer, and he quickly adjusted to the routine. He flew with me and went on all my car trips. We hiked and did our outdoor shopping together. Romeo helped take the edge off being alone in Phoenix.

But I wouldn't be alone for long.

36

Dutiful Daughter

"Should we come out there and help you?" my dad asked one day just a few months after I landed in Phoenix.

I knew what he was asking. And I knew my parents *would* be a big help to me whenever I needed it.

"Well, I know I'm going to be here for three years, so if you want to move here, sure."

I sighed. I thought this was the right decision. I accepted the fact my parents were coming out to Phoenix. They could be closer, they could help with Romeo, and we would be a family unit in the same city once again.

After their gift shop shuttered, things were going nowhere for them in Santa Rosa. The store sold international trinkets, and my dad found other small business owners and artists to sublease parts of the space to display their work. But it wasn't enough to bring in a sustainable income. My parents wanted a fresh start, and I figured a new climate wouldn't hurt. They rented a condo near me. My dad worked a number of jobs. I helped him make a résumé: "Many years of self-initiated and self-managed entrepreneurial ventures, proven self-starter." I edited his cover letters and follow-up emails.

He sold cars. He sold furniture. He sold art. He had a printing busi-

ness on the side. He didn't have trouble getting hired and getting trained. Staying on the job was a different story. I guess once you've been a successful entrepreneur, working for someone else feels like a colonoscopy every day. Why work for The Man when you *were* The Man?

These guy don't know what they're doing. Real jerk.

Yến, you không hiểu. *You don't understand. They don't listen.*

I can't make much money doing this.

I tried to encourage him to stay with the various jobs, to at least get a steady paycheck. But ultimately, my dad always did what he was gonna do.

"Don't worry about me, Yến. I tell you, I did it before, I can do it again. Trust me."

So began the most stressful decade of my life. As I was beginning to launch into adulthood, my dad was on a different, almost opposite trajectory. I was making money; he needed money to fund his new projects and ideas. He had already achieved so much, lost so much, and now he wanted to be successful again. He had big dreams and big plans: to launch a college superstore, an online grocery business (ahead of his time!). You name it, he'd already thought about it. He was certain with a little capital and some time, he'd be back on top of the world.

For all his self-confidence, I was the opposite. Uncertain and untrusting, I was not in a place to take chances. The man who got us out of Vietnam on a rickety boat, started several businesses, paid for everything I ever wanted or needed, drove me to work, and even helped me set up tables at the coffee shop at 5:00 a.m., was still my father. I respected him. But trusting in his plans for the future? I couldn't put my eggs in that basket.

We were never a lovey-dovey father-daughter pair. Culturally that's not how either of my parents was raised or how they raised me. But my dad was always there for me, helping me whenever I needed it, and always when I asked. I knew I owed him for so many of the best things that have ever happened to me, including my actual life and freedom.

But isn't that what kids are—little debtors who aren't expected to make good on their lifetime loans? They're supposed to pay it forward to

their kids. Well, that's American culture, not Asian culture. As comedian Jimmy O. Yang put it in his 2018 book, *How to American: An Immigrant's Guide to Disappointing Your Parents*. "Asian parents' retirement plans are their kids." Asian parents expect a lot of their children, and part of that expectation is that we will support our parents in whatever way they need us to, including financially.

Now my dad needed capital, and I was President of the Bank of Dutiful Daughter.

37

All Together Now

By my second year at Fox, Brian had some breaking news of his own. He could apply for his internship (first year of residency) anywhere in the country, including a hospital in Phoenix!

"So, this means you can come here for a year? And live with me? In Phoenix?"

"If I'm accepted to the program, yes."

We would live in the same zip code? In the same apartment even? This was the best news ever. I fist-pumped and jumped and screamed into the phone, "YES! DO IT!!!"

Brian landed his internship in anesthesia at St. Joseph's Hospital in Phoenix. In his mind, living together would be a romp. It would be the first time we could be alone for long periods of time, get romantic anywhere we felt like, and sleep in on the weekends. He was excited that we would finally enjoy each other with no interruptions.

That fantasy crashed into Real Life Circumstances.

"*They're* getting the big bedroom?" Brian asked, trying not to sound disappointed that his giant self wouldn't be able to have a king-size bed because we'd be in one of the smaller rooms.

"Yes, Brian. They're my *parents*. I can't have us take the big bedroom. That wouldn't feel right."

Now that I was purchasing my first home, a brand-new three-bedroom-plus-den model called the Durango in South Phoenix, it only made sense, financially and culturally, that my parents would move in. Ever wonder why immigrant families manage to get ahead after moving to the United States with no money? We all live squished together for years while everyone saves money, and then boom, the kids move out and right into a house with a down payment. There's no stigma in Asian culture about living with your parents if everyone's saving money, and bonus, you're eating the best home cooking daily.

The Durango was in one of the many subdivisions popping up all over Phoenix during the huge development boom before the 2009 mortgage crisis. It was 2005. I was twenty-six-years old. I was halfway through my three-year contract in Phoenix, now making $64,000 a year. The house was $195,775 brand-new. I needed 10 percent for a down payment. With my salary and my ability to stick to a tight budget, it was totally doable. *Why pay rent?* I was channeling my parents' sensibilities about money and savings and how they first secured the Windsor. It didn't make sense for Brian and me to live alone in that big house while my mom and dad paid rent on a condo fifteen minutes away.

Brian sighed. Being the respectful boyfriend of a dutiful Asian daughter, he accepted that we would be sleeping in one of the small rooms, while my parents would get the biggest bedroom in the house.

I tried to sugarcoat the situation.

"At least our room is on the other side of the house, and we'll have some privacy!"

"Why does he have to make so much noise?" Brian grumbled the first morning we were all one big happy family.

I opened one sleepy eye and peered at my nightstand. The clock read 6:45. It was Saturday. My dad was up, making his usual elaborate savory breakfast. It could be fried eggs with Maggi seasoning sauce and toasted *bánh mì*. Or maybe it was ramen with pork and vegetables. It could be *cơm tấm,* broken rice with a pork chop, pickled leeks, and *nước mắm* fish

sauce. Sometimes he sizzled up *lạp xưởng,* juicy sweet Chinese sausage and ate that on top of *xôi,* a mix of steamed sticky rice and mung beans.

He finished every morning with breakfast dessert. *Cà phê sữa đá,* iced coffee with thick condensed milk, wasn't enough to satisfy his sweet tooth after all the spicy Sambal oelek sauce he added to every dish, so he always had a tiny scoop of ice cream with his coffee. The Huy Nguyễn affogato was part of his daily ritual. This entire meal? Always consumed between 6:30 and 7:15 a.m.

When we all moved into the Durango, Brian and I were not yet engaged, but we had been in a relationship since we were sixteen, and friends since fourteen. Now that we were in our twenties, my parents and Brian were closer than most future in-laws, but living together was testing everyone's patience.

"I don't understand. He's *so* loud." Brian sighed. Unlike me, he was a light sleeper, and once he woke up, he was up.

Our room was right down the hall from the open kitchen.

Clang, a frying pan on the stove.

Ting ting ting, the metal spoon stirring in the milk for coffee.

Jooomp, a drawer closing.

The crack under our bedroom door, and the vent above it, let in every single noise from my dad's breakfast routine. Every morning.

It wasn't a problem during the week, because I could sleep through it, and Brian was already gone for his early mornings at the hospital. But on our two days of rest, there was no escaping Dad. Just like on our family vacations, when he was up, so were we.

"Let's try this," Brian said. He stuffed some pillows at the base of our door and into the vent. We woke up the next morning not to the sounds of my dad's cooking but to the stifling heat of an unventilated room that's been slept in for eight hours.

"I'm so hot." I lay there, sheets kicked to the floor, sweat dampening my lower back. Annoying noises or suffocating heat? Pick your poison.

I wasn't keen on this whole Jeffersons setup, but this was my version of a deluxe apartment in the sky, and I was proud of my ability to provide and give back to my parents. I was going to be able to keep a

closer eye on their financial situation, and I thought that would help us all deal with the losses. It had to get better, right?

My mom wanted to go back to work. She wanted to help. She didn't want to live in the Durango house in Phoenix and sit idly by, waiting for my dad to recalibrate.

"No. Mom doesn't need to work. I will take care of her," my dad said when I tried to lobby for her new independence.

"Mom says she wants to go to barber school and learn how to cut hair," I said.

"No. No need."

My mother and I took matters into our own hands. I helped her buy a car. This time, I was funding the new Honda Civic, a gray one, for my mom. She enrolled in a barber school because it was the quickest way to get a license. After one thousand hours, she graduated and took her new skills and sharp shears to work at Great Clips, the national chain where you could walk in and get a haircut for twelve dollars. They specialized in no-frills haircuts, and most of the clients were men who wanted a fade or simple trim.

My mom, in her mid-fifties, was starting a new career in Phoenix. Another life twist. We had relatives in California who were nail technicians and even one who had her own hair salon. But my mom never thought she'd end up in the hair business too.

"I am so proud of you, Mom. You're going to do great," I said when she left to drive herself to work that first day.

"Okay, Yến, thanks, babe. See you later."

I had never felt this way toward my mother. I was awed by her quiet confidence. She was my mom, who always took care of me. Now she was taking care of herself. Even when my dad did not support the idea of her going to work and having to stand for long hours and make minimum wage and tips, she did it anyway. I don't know if he thought it was beneath her or it further cemented reality. But she didn't have time to wait around while he looked for the Next Big Thing.

My mom worked alongside all kinds of people. She made friends easily at the salon. Just like her days in Sài Gòn when she was a salesperson in the American PX, she chatted up her customers and quickly established regular clients, who came back to see Miss Liên.

I think the people who got haircuts from her appreciated her easy smile and the meticulous attention she gave to their hair. She asked questions about her clients' jobs and families. She teased the men with shaggy hair, "Why you wait so long for a haircut?" She perfected her fade cuts and never hesitated to share an opinion "Number one? Why so short? That too short." All of this brought people back and prompted generous tips. She genuinely loved what she was doing.

My father did have an "I told you so" moment early on. My mom was at the front counter of the barber school, where they sold a few brushes and hair products, when some guy walked in and demanded money from the register.

"He walk in, and I was in the front. He point the gun at me," Mom told us during dinner. She hadn't bothered to call anyone because in her mind, nothing bad had happened and she had a busy day at school.

"Mom, *what*? Are you okay?" I was stunned and worried.

"Yes, I'm okay," she said, shrugging. "I'm okay."

"What happened?"

"This guy walk in. Older guy. I said, 'May I help you?' and he take out a gun and say, 'Open the register.'"

"Oh my gosh, Mom! What did you do?"

"I just turn around and walk to the back. I say, 'I'm not the owner.'"

"Did you call the police?"

"Yes, they came. They ask us what happen."

My dad tempered his reaction. Standard Vietnamese language of love: get mad at the person who got hurt because you love them.

"Tsk, tsk. Very bad."

True to form, my mom went right back to barber school. She figured that something like that wouldn't happen again.

In a way, my mom's reaction to that attempted armed robbery is how

she has maneuvered through all of life. If you don't like what's happening, turn around and go in a different direction. Calmly.

After that, her classmates became her guardians. Oscar and P.J. walked "Miss Liên" to her car every day after they finished lessons. God bless those guys. I didn't know about that until years later, when I asked her to recount the story, which she now laughs about. "The robber, he just left because I turn around and walk away."

When I see my mom outside of our family, she's a different person. When she meets new people, or when she's with friends she hasn't seen in a while, there's a lightness in her interactions. She's a great listener and she connects with people easily. She's interested in what they have to say, she's curious and she asks questions, and most of all, she laughs. My mom is always laughing when she listens to someone tell a story. She's never the one talking too much. (That's my dad.)

I wrapped up exactly three years in Phoenix. At the end of my contract, I knew it was time to move back to the Bay Area. Brian was now in his anesthesia residency at UCSF. We were ready to move into the next phase of our lives after establishing our careers: marriage. He proposed to me in Hawaii during a surprise trip. We were on a deserted beach. He got down on one knee, said the customary and requisite words, I said yes, and we called our families. It wasn't until a few minutes after the celebration that I saw a giant dead sea turtle on the sand a few feet away from where we had pledged to love each other forever. I guess it was good luck. We've been married since 2007.

Brian flew back to Phoenix to help me drive my stuff to the Bay Area. I packed my clothes, my Prius, and my little dog Romeo. We moved to San Mateo, a city between San Francisco and San Jose. Brian would commute north to San Francisco General Hospital, and I would go south to San Jose, where I would start a new job as a freelance general assignment reporter for KNTV, also known as NBC Bay Area.

My parents stayed behind in the Durango house. My mom was still cutting hair at Great Clips. My dad was hustling, working at one

or another job, making enough to cover day-to-day expenses but not enough to save for his next big venture.

"Ready, Vicky?" Brian asked.

"All right, well, good luck, Mom and Dad," I said, feeling relieved that at least my parents were in a nice house, together, and healthy.

"Bye, *Con*," my mom said, giving me a hug. "Love you. Drive safe, Brian."

"Bye." My dad waved.

A lot had changed in our dynamic. My mom and I grew closer after she became a barber and began to forge her own path. I was not just the daughter she always took care of. I was taking care of her a little bit now too by supporting her decisions and encouraging her to be independent.

My dad and I still had a lot of unresolved issues. We didn't see eye to eye on what was best for my mom, or the family. But now we were going to have some distance. Perhaps that would help us heal our relationship. Maybe I could get past the loss of the Windsor house I grew up in and the end of my parents' financial independence.

38

No Pain, No Gain

When I first got pregnant, in 2007, we were elated. It was easy. We didn't have any fertility issues. Sex without birth control? Bam. Positive pregnancy test right away! I always thought I would want to "enjoy being married" for a while before adding a baby to the equation, but on the first night of our honeymoon, I set down my copy of *Harry Potter and the Deathly Hallows,* and said, "I think we should make a baby."

Brian's eyes widened. "Really?"

"Yeah. What are we waiting for? We're married. We know we want to have kids. Let'sssss do disssss!"

I surprised myself. But somehow being married gave me permission to lean into the next stage of our relationship: creating a family. I knew Brian would be an amazing dad. He'd thought about being a dad since he was a young boy shooting hoops in his yard.

"I always wanted to teach my kids how to play basketball," he told me at one point in our twenties. "I remember being twelve years old on our driveway thinking, 'It will be cool to have a kid and teach them things.'"

As an only child, I was not as confident or enthusiastic about the idea of becoming a parent, but with Brian as my partner, my attitude was "Why wait?" I was twenty-nine, and there would never be a "perfect

time" in the news business to get pregnant. I would have to bend the world to my will, or at least try.

I had just been offered a full-time reporting job at NBC Bay Area, so I had a stable job with maternity leave. Have the baby, figure out the rest. I knew too many women in their late thirties or early forties who were trying to have babies and going through heartbreaking unsuccessful IVF cycles, the stress making it even harder to conceive. I had seen how broadcast journalism could be a career that takes, takes, takes. If I didn't prioritize my prime baby-making time, no one else would.

When we got the double blue line on the pregnancy test, we ignored the general cautionary advice about waiting for three months before telling anyone. We wanted to share the news with all our loved ones right away.

"Mom, Dad, are you sitting?"

My parents were still in Phoenix, so we told them over the phone.

"We're pregnant!"

"Wow, breaking new," my dad said, sans *s*. He enjoyed sprinkling journalism terms into our conversations now.

My parents and Brian's parents were thrilled. His brother, Mike, and his wife, Jessica, sent baby gifts. My aunts and cousins were so happy. "Congratulations, Yến!"

Brian got the morning off to come with me to the eight-week appointment, where we were scheduled to get my first ultrasound.

"Let me see," the ultrasound technician said, swiping the wand over my gel-covered belly to scan for the baby's heartbeat.

"Hang on." She squirted more gel onto my skin. "Hmm." After a minute or so she said, "I'll be right back. I want to get the doctor in here."

The doctor couldn't find the heartbeat either. There was no rapid thump . . . thump . . . thump . . .

"I'm so sorry, Vicky," our doctor said. "Please don't be too sad. Miscarriages are very common. Especially with the first pregnancy."

Miscarriage. Did she say miscarriage?

Brian, by then a resident at UCSF, had already done his rotation

through obstetrics. He understood what the doctor was saying even if he didn't want to believe it.

I didn't say anything. I didn't want to start crying in front of everyone.

"Take as long as you need in the room," the technician said. "I'm so sorry, guys."

We sat, quiet. I wiped some leftover goop off my stomach and put my shirt on. Brian wrapped me in his arms. Then the tears came. We had a good long cry.

The miscarriage hit us hard, like when you see a bird fly straight into a sliding glass door. We didn't see that one coming. No one we knew had ever had a miscarriage. Or so we thought.

Once the news got around, it seemed like everyone had a miscarriage story. Friends, colleagues, cousins. A close friend told me, "It happened to us last year, and then we got pregnant with our baby six months later. Don't give up."

I was grateful for all the women in my life who shared their experience. It certainly made us feel less alone. Our families were devastated. Brian's parents gave us space to be sad, but they offered encouragement.

"Try again, guys," Marilou said. "It's hard, but you'll have a healthy baby. Take your time."

"No heartbeat?" My mom had had no problems getting pregnant and carrying me to term. She had been so excited for us, and she didn't know how we could go from such happy news to such sad news.

The doctor listed my options.

"Vicky, we can wait for your body to expel the fetal tissue naturally," she said, "or we can give you mifepristone to help it along. But if everything doesn't come out in the next week or so, you'll have to come back for a D and C procedure."

"What's that?" I asked.

"It stands for dilation and curettage," the doctor said. "Some women have a womb that will completely expel the fetal tissue. That's that, and she moves on. But other women need medical assistance, or they risk infection and potentially deadly complications." I fell into that second category.

A D and C is essentially the same procedure as an abortion. The only good thing about having it was the Valium. "They gave you ten milligrams?" Brian was incredulous. "Did they get your weight right? That seems strong."

"I don't know," I said, holding the tiny white pill. "Can I take this?"

"I mean, it's fine, but it's a lot for you."

I tilted my head back and gulped it down. "Well, this is what they prescribed."

By the time I got to the doctor's office fifteen minutes later, I was in a happy place.

"Vicky, sit up, babe," Brian said.

"I *am* sitting up."

"No, here, sit up." Brian tried to help lift me into the waiting room chair.

"Ishhh fine, I'm fiiiine," I slurred. I felt perfectly straight.

"You're almost lying on the ground, Vicky."

"Yesshhh." I stared at the ceiling. I felt so relaxed. I had never been this relaxed. I was floating. What were those things on the ceiling, dots? Why were they moving on a conveyor belt above me?

"Victoria?" the nurse called out.

"Yes, this is Victoria." Brian moved to help me stand. "Here we go."

"I got thish, Briiiiian."

I walked smoothly toward the exam room, just holding Brian's hand for a little support. At least I thought I did. Brian later told me I was shuffling like a little old lady, or LOL in medical parlance. The original LOL, before it became "laugh out loud," was shorthand between doctors. *There's an LOL in room 7, be careful, she's cranky.*

"You were not walking, Vicky. You were taking teeny shuffling steps, and you were bent over looking at the floor the whole time."

The Valium apparently took the edge off, a lot.

I had another miscarriage a couple months after that. Another D and C. This time, I sobbed through the procedure. Under the sterile, blinding lights, listening to the sound of the machine sucking up whatever was in my uterus, I was literally being hollowed out. The drugs made

me feel numb, but the sadness felt bottomless. I could barely process it mentally. How did we have another pregnancy that didn't take?

This time, at least we didn't tell everyone.

Before trying to get pregnant a third time, we went to the doctor for extensive testing. Was it Brian's sperm? Was it my eggs? Was this going to be our lot in life? Easily pregnant but never able to create a tiny human? It was so easy for Brian's brother, Mike, and his wife. They got pregnant and had their first baby, Jason, no problem, no miscarriages. Jessica was my maid of honor, and she was pregnant at my wedding. We were going to have our first babies so close together, maybe even have overlapping pregnancies! But now I was two miscarriages in. Brian and I were worried but tried not to spiral. We were taking it one recommendation at a time.

"We're going to have to draw ten vials of blood for this, okay, Vicky? So just lie down and relax and we'll let you know when we're done."

"Okay."

"And that's the last one," the phlebotomist said, taking the tourniquet off my arm and removing the needle. "You can go ahead and sit up now."

I sat up.

"Oh no. We must have missed that vial. I'm so sorry."

One of the tubes had rolled underneath me while they were extracting all that blood. I could not catch a break.

Brian gasped. "Oh, babe, so sorry," he mouthed. Just watching me get my blood drawn made him woozy, which I found endlessly funny. The Good Doctor used needles all day long as an anesthesiologist in training, but it pained him to see his wife getting poked.

They stuck a needle in me again for one last vial.

A week later we got all the results back. Both of our reproductive systems were normal. The doctors didn't see any cause for alarm. I was about to turn thirty, and in good health. They said we should keep trying to have a baby.

It was emotionally draining. I didn't want to think about going through another failed pregnancy. I confided in my dear friends Kiet and TuAnh.

"Vicky, you need to go see my herbalist," TuAnh said. "They have this Chinese medicine tea. It tastes horrible, but it's supposed to help with miscarriages."

The herbal tea tasted like death in a cup. It consisted of a mixture of bark and mushrooms and herbs and what appeared to be dirt and sticks foraged from a damp forest floor. It smelled bad when it was dry. But when it was brewed up with boiling water, the smell alone made me gag, and I have a strong stomach.

"Idso bidder," I complained to Brian, plugging my nose while trying to chug it, swallowing it a second time when my gag reflex pushed the warm liquid back into my mouth. "I cad still tazed it."

Each mug took about four big gulps, multiplied by two because each time I took a swallow, it came back up and I'd have to force it back down.

I drank that tea daily for two weeks.

39

Me Too?

As we soldiered on through the miscarriages, waiting the requisite amount of time before trying to get pregnant again, I continued working mostly nights at KNTV. When you're a local news reporter, your "office" for most of your shift is a live van. It's outfitted with all kinds of TV equipment in the back and a mast with a coil of cables on top so that wherever you travel, you can quickly stop, throw up the mast, and dial in a live shot. For most of your nine-plus-hour shift, it's just you and the photographer, who is also the van driver, usually male. Over the course of my career, I have worked with incredibly talented, funny, thoughtful, creative, hardworking photographers. They carry the heavy gear, respond quickly to breaking news, and do the challenging and sometimes thankless work of capturing the video and sound to keep us informed and connected.

I have also worked with the "meat and potatoes" photographers, like Fred in Orlando. The photogs who don't offer creative ideas or take ownership of a story, the ones who decline to use a tripod because they can "shoot just fine off the shoulder." Basically, the photogs who do the least and say "Let's just get what we can" to put together ninety seconds of TV. All this to say, like in any job, you have teammates you'll go to the moon with and those you just want to get to the end of a shift with.

I was working with one of those in the latter category. Let's call him Pierre. On one of our night shifts, as I leaned over and reached into the back of the live truck to grab my bag, Pierre put his hand on my lower back and got too close to my backside, just too damn close.

"CAN YOU PLEASE NOT TOUCH ME EVER AGAIN?" I blurted out.

This was not the first time Pierre had invaded my personal space. Over months of working with him, I had noticed he would get closer than necessary, put a hand on my shoulder or waist, lean over me, or reach his hand across my body. I still remember when it happened the first time. When I was brand new, and still a freelance reporter, I asked where the bathroom was. He grabbed my hand and led me down the hall. I should have said something or pulled away, but I didn't. Still, his way of needlessly touching me raised my hackles. I started to casually ask around about Pierre. Other female news staffers and reporters confirmed my suspicion.

"Yeah, he's creepy," one said.

"He touched my thigh, and I pulled away," another woman told me.

I knew I'd be working with him more frequently because there were fewer photographers who worked the swing shift, so I had preemptively reached out to the chief photographer to ask for guidance, letting him know I hadn't spoken to Pierre about it and that I "didn't want to make a big deal" since we'd now be together more often.

But that night, I'd had enough. I'd already resolved to say something the next time he touched me. I'm sure I surprised him with such a strong reaction, because I surprised me. His response was telling. "Don't flatter yourself," he snapped. I thought that was such a weird thing to say. Not a "Whoa, sorry" or even a "What are you talking about?"

That was it for me. I was done working with this creepy guy who told misogynistic stories about various women in his life and called his twelve-year-old daughter a "bitch." I wrote a note about the incident and explained what happened to the chief photographer. He didn't respond other than "I'm sorry to hear that. I'll talk to Pierre."

He also told me I could talk to Human Resources if I thought it was

serious enough. I didn't hesitate. It was very simple to me. I requested that I not be assigned to work with Pierre anymore. I wasn't asking for anyone to be fired or disciplined. I was not naïve about HR. I'd reported on a few whistleblower stories in my career and knew that the role of HR was to run interference, to listen to all the sides of the story and find the best solution for the company. It wasn't necessarily beneficial to the employee reporting the problem. Sometimes that employee got reassigned or unofficially deemed a troublemaker for complaining.

Still, I was determined to report the situation, and present my solution.

I greeted the HR person with a smile.

"I'm sorry to be here, but I think this is important for you to know," I continued. "This isn't the first time Pierre has touched me in weird ways or made me uncomfortable. We spend many hours alone together, and I'd like to avoid future shifts with him."

HR said, "Vicky, we understand. That must've been uncomfortable." I nodded, waiting for more.

"But we can't guarantee you won't be scheduled with him. The holidays are coming up, and we don't have a lot of staff to move around."

I don't know why I wasn't nervous or scared, but I stuck with my gut. I'd already talked about this creepy Pierre with Brian, and practiced with him for this meeting.

"Just be firm and say your piece, Vicky," Brian counseled.

My response was calm, cool, and collected. I didn't even think before responding. I just said what I honestly felt.

"Okay, I totally understand we have a skeleton crew. You may schedule me however you need to, but I won't be working with him again."

And then I employed a technique that works in a lot of difficult conversations. The pregnant pause. It's when you just stop talking. Silence. You say your piece and . . . Stop. Talking. The other person is then forced to fill the silence because it's awkward.

And it *was* awkward. I don't remember exactly what the HR rep said after that, but I left the office knowing I would never work with Pierre again. Whatever the schedule said, I made a choice, and I com-

municated my choice to the people in charge. I couldn't control what they would do, but I could control what I would do. Fortunately, they never put us together again, and I avoided Pierre whenever I saw him in the newsroom.

Was he a "predator"? I won't go that far. But his behavior was not okay. I think about women in similar situations who have to weigh whether or not to speak up and whether I would have had the confidence to do so earlier in my career. I've always gone with my gut, and while it sometimes gets me in trouble, most of the time, listening to my intuition gets me the results I need.

Even after the public downfall of Harvey Weinstein, the birth of the #MeToo movement, and the normalization of discussions about sexual harassment across every industry, it is still incredibly difficult to know if you should speak up when someone says or does something inappropriate. Are they from another generation and totally out of touch? Is it a joke in poor taste, or is it an egregious violation? Is someone just handsy when they talk? If you pose those questions to ten different people, you'll get ten different answers. These situations are nuanced, but more workplaces are taking sexual harassment seriously.

At that time, I trusted myself and it worked out. Even if it hadn't, I am glad I didn't compromise. When you know, you know. Don't doubt yourself.

40

Heartbeats

The third time I peed on a stick and saw the double lines, it was 2008. Brian and I were guarded. We wanted to feel hopeful, but inside, we prepared for another heartbreak at the eight-week appointment. I lifted my shirt and lay down, ready for the cold gel on my stomach.

I didn't let my hopes get too high. *"Boomp boomp boomp."* The sound was rhythmic.

"Do you hear that?" the ultrasound tech asked us, moving the wand on my belly and pushing harder.

"BOOMP BOOMP BOOMP."

"That's the heartbeat," she said.

Brian and I looked at each other, happy tears in our eyes this time. Yes, we heard it.

Our baby had a heartbeat!

That was the joyful, wondrous part. But soon after the ultrasound, the nausea started to rage, nonstop. My commute at that time required me to cross the San Mateo Bridge to get from our townhouse to Oakland, where I covered the news from 3:00 p.m. to midnight daily.

The San Mateo Bridge is seven miles long. Once you're on it, you're not allowed to stop. Even if I wanted to pull over to barf, it wasn't safe or legal. On the way to work, driving fifty miles an hour, I clutched a

plastic container to catch my vomit. For some reason, the bathroom we shared in the Oakland news bureau had a black toilet. Thanks, Black Toilet. You swallowed a lot of my bile.

After my 11:00 p.m. live shots and the commute, I was usually home by 12:30 a.m. Brian would be waiting at the front door of our bright yellow townhome, ready to take my barf bucket to dump and clean. Not all heroes wear capes.

Morning sickness was a misnomer. I was sick morning, noon, and night. It was an all-day, nondiscriminatory nausea. I was both hungry and sick at any given moment. This was our nightly ritual in the first trimester.

We had one major scare during my pregnancy with Emerson.

"She has a bright spot on her heart and on her bowel," the doctor pointed out. "Do you see that? We call it echogenic bowel. Could be nothing. Could be something. We should probably do an amniocentesis to check."

I was sixteen weeks pregnant. The doctor wanted to insert a long needle into my belly, and extract some of my baby's amniotic fluid. This procedure can result in the spontaneous combustion of your pregnancy. That's not the medical term, but it's scary and it's serious and it comes with the risk of losing your baby.

"The odds of pregnancy loss are about one in five hundred," the doctor told us.

An amnio can diagnose a range of conditions, including genetic and chromosomal issues. Now they can do that with blood tests. And amnios aren't even recommended anymore. But in 2008 the doctor advised us to get one, so we scheduled the procedure.

"Ready?" the doctor asked.

I took a deep breath. Brian squeezed my hand as the needle went in. We watched it on a big monitor in front of us. We could see the black-

and-white image in real time, the long sharp needle poking into my skin first, then through the membrane of the amniotic sac. I held my breath. The doctor sucked up some fluid, then pulled the needle straight out.

The results came back the next day. "Everything looks normal."

We could breathe again.

The last hiccup before Emerson's birth was when I went outside to let our dog pee on the grass. Tofu, my sweet little white Chihuahua and Romeo's little "sister," ran back in the house after doing her business. I turned to step back inside and tripped over a sprinkler

I fell straight forward.

Emmy, in my ginormous belly, broke my fall.

"Vicky, what happened? Why is your belly all wet?"

"I just fell outside, right onto my stomach, on the grass."

Brian was not taking any chances. We went to the ER, where they hooked me up to a machine and attached some sensors to my belly.

"Well, that was a scare, wasn't it?" the doctor noted. "But everything looks fine. Baby's heartbeat is normal. Just please try to stay on your feet, okay?"

"Yeah, stay on your feet, Vicky." Brian nudged me.

41

Baby Time

I told Brian I was going for a natural birth, no epidural, with as little medical intervention possible.

"Okay," he said, smiling. "We should definitely keep an open mind though." As an anesthesiologist in training, he had a lot more experience with epidurals than I did. But as my husband, he knew better than to mansplain to his pregnant wife that I was probably going to beg for that shot.

I didn't beg. But I did ask politely about eighteen hours into labor.

It wasn't the pain that was overwhelming, it was the ongoing waves and the exhaustion of being uncomfortable and not getting a break.

I was three days overdue when we went to the hospital. Because the baby didn't seem eager to exit, the hospital admitted me and nurses started me on Pitocin, a drug that induces labor.

After I'd been in labor for hours, the contractions were coming every fifteen or twenty minutes. I dreaded the wave of nausea and discomfort that slowly took hold of me with each contraction.

"It feels like I have to poop, but I don't," I wailed.

"Just breathe, deep breaths," Brian said, his thin smile betraying the fact he knew what was coming.

"I think I need the epidural, babe."

"You want me to call the doctor?" Brian patted my arm and hit the call button. He didn't even say, "I told you so."

The anesthesiologist who showed up recognized Brian. He had been a couple years ahead of him in residency.

"Oh, hey, man! This your wife? Nice to meet you!"

"Okay, Vicky, I'm gonna have you sit on the edge of the bed. Bend forward as far as you can," he said. "Try to be really still, okay?" He slid the long needle into my back and pushed the sweet epidural juice into my system.

I was so happy that I would finally get some relief. But an hour later, nothing much had changed. "Brian, I can still feel the contractions. Is that normal? Like my whole side and back—it feels the same."

"Can you feel this?" Brian pushed on my lower back.

"Yes."

"What about here?"

"Yes. Oooh ohhh another wave is coming, another poopy wave!"

I could handle each contraction. It was like a six out of ten on the pain scale. But the contractions. Kept. Coming. I was exhausted and hungry. They wouldn't let me eat anything except ice.

After several hours of poop waves, I wanted this epidural to kick in so I could get comfortable and nap until it was Baby Time. But something was off.

"Hmm. Can you feel this?"

"Yes, I can feel when you push on my thigh."

"I don't think he got the epidural in the right space, Vicky. They're gonna have to do it again." Brian frowned.

It was my first time needing an epidural, and I had to get two. Fortunately, the second anesthesiologist got everything in the right spot and properly numbed up my bottom half.

When it was finally time to push, the baby had other ideas.

"I think we're going to have to do a C-section, Brian," our obstetrician said.

"The baby is faceup and you're not fully dilated. You've been pushing for a while now, but there's a little part of your cervix that's blocking the baby's head from coming out."

We'd been in a holding pattern for hours now, and the doctor was worried about the baby's health.

"Hang on, Doctor," Nurse Christa said. She was one of the many labor and delivery nurses who'd cycled in and out of my room over the past umpteen hours.

This was not in the birth plan. Not that I had one. I don't love planning. I'm more go with the flow. Besides, how can you plan for a momentous life event like this? I trusted that nature and my doctor husband would cover the big bases. My job was to be the vessel.

But this vessel was not down with being cut open.

"Let me try something before we do the section, okay?" Nurse Christa asked the doctor.

The doctor obliged and left the room.

Nurse Christa turned to me. "Vicky, can you get on all fours? Do you think you can do that for me?"

By now, my epidural was in full effect, which meant I couldn't feel or move my lower body.

"Let me try. My legs kind of feel like sandbags," I said. "I feel like I'm wearing leather pants. Tight ones. I can't feel my legs, but I know they're there. Brian, help me here."

Brian and Nurse Christa helped me get on my hands and knees, belly down.

"Now I want you to rock forward and back and side to side," Christa said. "Just try to move that baby so it turns facedown."

After a few minutes of my swaying my belly back and forth, the doctor came back in to check.

"Hey, it looks like the baby turned! And you're ten centimeters dilated. You can start to push again, Vicky!"

Just like that, I went from almost having an emergency C-section to pushing my baby out without any surgical intervention. Nurse Christa's

experience and willingness to try something before the doctor whipped out the scalpel made all the difference. I'm deeply grateful she spoke up. Her patience and expertise altered the course of my first birth experience, which would allow me to have two more daughters without C-sections.

"Thank you so much, Christa! You saved me from having surgery." I was relieved, dead tired, and staring at my newborn in wonderment. I made a mental note to write a letter to the hospital president and post a Yelp review about Nurse Christa. Five stars.

Kiet Do, my dear friend since college and a fellow Bay Area TV reporter, came to visit our brand-new family of three in the hospital.

"She looks like a tiny Chinese man," Kiet said.

She really did.

Kiet brought his fancy Nikon and took Emmy's first professional photos.

"Here, turn her more toward the light," he said. *Chk chk chk.* "She is soooo cute and tiny! I forget how little they are when they first come out."

"Kiet, this is bananas," I said, my face still puffy from all the fluids and Pitocin they'd pumped into me. "I can't believe we made a human, and we're leaving tomorrow with this human."

Brian was beaming. "So good of you to come visit, man. I still can't believe it either."

Motherhood did not come as naturally to me as it seemed to for other people. Everything about my tiny baby was alien to me. Maybe because I was an only child? I had held maybe three babies at that point in my life. One of them was Kiet's daughter Liv.

"Can you swaddle her again, Brian?"

I felt most confident holding Emmy when she was safely wrapped up into a tight little burrito, her arms and legs tucked into a gauzy blanket so her wild hands wouldn't flail and scratch her face.

I always said I would do ten births for one pregnancy. The pregnancy is forty weeks, that's ten months, not nine, of all kinds of ups and downs. A birth generally takes twenty-four to forty-eight hours, sometimes a lot less, and you walk away with a teeny tiny little human. It doesn't get more gratifying than that.

42

Breastfeeding Barracuda

I didn't have enough hands to feed my baby. Emmy was like a little sucker fish who did a great job latching on but wouldn't open her mouth wide enough to take in the whole areola for successful breastfeeding. Because she would chomp down too soon and only get my nipple in her mouth, breastfeeding was excruciatingly painful.

The lactation nurse showed Brian and me how to use our thumbs to push down on her little chin to get her to open her mouth wider and then quickly shove as much of my boob into her mouth as possible. Once she attached, her tiny mouth had so much suction power that detaching her would bring tears to my eyes from the sheer pain. She had the Shark vacuum of baby mouths.

"Okay, let me hold her on the Boppy," I said to Brian, positioning Emmy on the pink U-shaped nursing pillow. I held the back of her head with one hand and my boob with the other. "You get her chin."

It was all hands on deck in that first month.

"I'm sorry, Vicky." Brian sat next to me for moral support, watching me grimace as Emmy Hoovered away at my breast. His eyes widened. "Is that your skin?"

"Yes."

He was staring at the flap of my nursing bra. Sticky bits of my nipple

had detached from my body and were now lodged in the fabric. My skin was raw from being vigorously sucked on every two hours. Neither of us recognized my once familiar body part.

"Are you using the lanolin?"

I inhaled deeply and closed my eyes. "Yes. It's not really helping much, and it hurts almost as much to apply it as it does to leave it alone so . . ."

I focused on my breathing during each nursing session. The pain was so distinct and immediate it made my eyes water instantly. But after a few minutes, the hurt subsided and I could zone out, breathing in and breathing out until she was done.

After the first month, my tender boobs started to toughen up. We had a life to sustain, damnit! I had read all about how breastfeeding helped the baby's immune system. It also helped me shed baby weight because my body had to produce all that milk. While it hurt like nothing I'd ever experienced, it was also free food. No expensive formula to buy or mix. Just my body, making everything my baby needed.

Breastfeeding was far more grueling than childbirth. No one tells you that part. When I got mastitis, an infection of my mammary glands, there was no epidural to numb the pain. My left boob swelled into a hard lump that felt like it was on fire. Just lightly brushing a finger against my skin sent shooting pain into my brain. I could only try to massage my clogged milk ducts and soothe them with a warm compress. When Emmy nursed, my breast softened, but the relief was overshadowed by the burning sensation of milk flowing like molten lava through my inflamed ducts.

I had two bouts of mastitis, but mercifully my boobs acclimated after that, and we kept it going for almost a year. I saved and froze enough milk from pumping that Emmy had enough to make it to her first birthday.

Breastfeeding mission accomplished.

Shortly after Emmy was born, my mom moved back to San Mateo to live with Brian and me in the two-bedroom townhouse we were

renting. Once again, she was a lifesaver. She helped us take care of our newborn, cooked delicious meals, and became the number one caretaker of our baby when I went back to work after a four-month maternity leave. Brian returned to his eighty-hour workweek as a resident after just a couple weeks of leave, so having my mom with us 24/7 was a game changer.

She was the reason I could go back to work and not worry one iota about what was happening with my baby. I didn't hesitate when colleagues asked me what it was like to leave Emmy at home.

"Is it hard to be back at work, Vicky?"

"Nope," I said. "It's really nice. I can sit here, read news articles without being distracted, and do something I feel like I'm good at (my job), versus doing something I'm not good at (being a new mom)." I went on, "My mom is amazing with Emmy, and honestly, I feel safer when she's with the baby than when I am. She's gentle, patient, and she loves Emmy so much." Not everyone can live with their mother, but I thanked God every day for mine.

Financially it was a boon too: affordable, high-quality childcare. I transferred a small amount of money to my mom each month, but it was nowhere near as much as we would have had to pay a nanny or daycare provider.

My dad stayed behind in the Durango house in Phoenix. He came out to visit us and the baby, but he was still working various jobs, and despite my urging him to stop, he was still buying and selling stocks. It wasn't ideal to split my parents up geographically. But my mom loved Emmy, and taking care of her new granddaughter gave her some space from my dad.

I asked her how she felt, not having my dad there every day. She was very Zen about the situation. I still harbored a lot of anger toward him over the sale of the Windsor. My parents were now floating without a place to call home, financially uncertain, and in their fifties.

But my mother found a way to move forward.

"For years, I was so angry, Yến, *Má tức lắm,* but then I let go," she told me. "I don't want to live like that. *Đau bụng,* that anger hurts you.

It give you stomachache. Now I just go with the flow. I don't need any-
thing. I feel light. I have you. I have Brian, and now Emmy. That's all I
need. I don't need house or things, *Con*."

She taught me how to let things go, by modeling this practice in her
own life. Why hold on to resentment and anger? You can take time to
acknowledge the hurt, but you don't have to live in that space. It has no
long-term purpose. It's like the famous saying "Holding a grudge is like
drinking poison and expecting the other person to get sick."

Still, I had a hard time channeling my mom's Zen.

"Dad, I'm getting calls from Capital One Visa. What is going on?"
I was pushing Emmy in the stroller. She was two months old, and I
was getting the hang of our napping, feeding, walking routine. But I
was distracted and stressed because suddenly creditors had my phone
number, and they were calling at all hours about my dad's accounts.

"They have no right to contact by calling you whatsoever. You have
a right to file a complaint or even sue them, Yến!"

"I don't have the time or energy to sue a credit card company, Dad,"
I said. "And that's not the point. The point is why are you still opening
credit cards and buying stocks? You're not going to come out ahead.
You need to stop."

My dad always defended his decisions.

"The reason I want to open an account to buy stock is because after
a few months watching the market, there was several stocks so cheap,
and it will have to come back up. I started in September, and I made
some gains. I did not want to do this again for many, many year, but
after a lot of thinking, I know that I can do this. It may take several
years slowly and patient to gain back some of the money I lost before."

I listened, staring into the middle distance, hearing all the same
rationales I'd heard in some form or fashion over the past several years.

My dad continued, "I can understand that you and Mom may not
agree with me. But please let me do what I *need* to do. Again, *I am
really sorry*. I will have to live with the consequent. I will apologize to
Mom, too."

I sat down on a bench overlooking the little lagoon in our apartment complex. There was nothing I could say to convince him to change his mind or his plans.

"Well, Emmy is doing good. Let me know when you're planning to come out next. Bye."

43

Sysco Not Cisco

We had another miscarriage after Emmy was born.

"I have a hostile womb," I joked, because laughing about it was better than crying. I did what I often do when something bad happens. I looked for the reason and the good that could come of it. I think I get that optimism from my parents, who are big believers in fate. *Things happen for a reason.*

In the miscarriage department, I rationalized it. This was nature's way of telling me things didn't come together properly to form a human being. Creating a healthy baby is a miracle. Cells must divide correctly, chromosomes have to line up just right, all the alchemy has to happen in a certain amount of time, in the proper order. Each person who has walked on this earth is truly astonishing. Let alone the ones who look like Lucy Liu or Daniel Dae Kim. That's another level of human perfection.

But I digress. We dealt with the third miscarriage and moved on. When I got pregnant again and we heard the baby's heartbeat, we were grateful. Emmy would have a sibling.

As my clothes got tighter and it became obvious I was pregnant with my second child, we were under new management at work, and big changes were under way. Our head honchos brought in Matt Goldberg, who had huge aspirations for KNTV. He wanted to build the biggest

local investigative reporting team in the nation. Our managers wanted us to make a name for ourselves with local investigative journalism that had national impact. And they were going to hire multiple experienced reporters and producers to make it a success.

Where was I going to fit in this mix? I wondered.

"Vicky, we're going to bring you into the Unit," Matt said.

It was 2011. With my mom managing baby care and meals at home, Brian and I were able to focus on our careers. He was working in his first job with a real anesthesia group, and I was being assigned to the new investigative unit.

"We Investigate" would become the station's new brand. Our team consisted of five producers, five on-air reporters, and three dedicated photographers, who shot, edited, and even produced graphics. We were a massive investigative unit by local news standards.

"Okay, wow, this sounds . . . amazing," I told Matt. "But I really haven't done any investigative reporting."

"Don't worry," he said. "That's why you have me." Matt was a confident leader with decades of investigative producing experience, and the national awards to prove it.

I was enthusiastic. "Fantastic, yes, of course, I want to do this. This is exciting." Inside, I was nervous. This was a serious career move, and I was surrounded by several new reporters who had fifty years of combined investigative reporting experience. Each one, especially Tony Kovaleski, our chief investigative reporter, offered a lot for me to learn from.

When he came for his interview, I was candid with him about joining the team. "Tony, this is a great place to work. The culture is amazing, and our photographers are talented. But I've never done 'investigative reporting' the way you do, so I have a *lot* to learn."

"I believe our success as a team means we all help each other," Tony said. "I've been doing this for twenty-five years. If you have any questions, you come to me. I'll always be there for you." It felt sincere.

Tony walked the talk. He started uncovering all kinds of stories

about misuse of taxpayer dollars at the local water district, rodents overrunning a grain facility, and complaints of sexual harassment, racism, and retaliation at the National Guard. It was hard-hitting, splashy, and confrontational. Tony loved to "catch up" with officials who were dodging his interview requests and fire a bunch of questions at them while they tried to rush away from his microphone and camera.

He explained his philosophy on those interviews.

"It's not 'ambush' reporting, Vicky," he told me. "Look up the word *ambush*. It means 'a surprise attack.' This isn't a surprise! I've asked multiple times for a professional sit-down interview at an agreed upon time and place. If they refuse, I always tell them, 'Okay, but please expect me to find you and ask the questions.' That is *not* an ambush. I told them I was coming."

I took his point. The subjects of our investigations were often public figures who owed the public answers. Or they were scammers or other people who needed to be held accountable for their scummy actions. Still, I had a steep learning curve. It didn't help that right after I met all the new reporters and producers, I went out on maternity leave. Out of sight, out of mind. By the time I got back to work, the team had a five-month head start. They were gelling, producing stories. I was on the fringe, catching up.

It was competitive. There's a reason you don't often see a big local investigative team at a TV station. The egos and attitudes can be so enormous there isn't enough oxygen for everyone. You're fighting for producers, for stories, for resources. As they say, there's no "I" in "team" but there is in "I-team."

Lucky for me, I had a secret weapon: Kevin Nious. Kevin was a young guy with investigative reporting instincts that were not to be trifled with. He's one of the hardest working people I've ever met in this business, supremely trustworthy, honest, and kind. He also drives me crazy with his contrarian viewpoints, and we spar like siblings. In short, Kevin is one of my closest confidants in work and life, and I was especially lucky to have him in my professional corner when the Sysco tipster called.

"Vicky, yo, I just got the tip of a lifetime—if it's true." Kevin was standing over my desk. As usual, he was dressed in a shirt and tie with

slacks, his black hair dippin' in waves close to his scalp that he styled meticulously. He was our best dressed producer. He felt he couldn't risk the laid-back casual Friday look so many other producers wore because he was young and Black.

I raised my eyebrows, looking up from a script I was working on for another story. "Continue?"

Kevin was not one to exaggerate. He was jacked, whispering at the pace of a rodeo auctioneer even though no one was close enough to overhear us.

"This person called and left a really cryptic message, but I could just tell by the voice, something is up." He leaned in. "They said Sysco—the food storage company, not Cisco the software people—is doing all kinds of unsafe things with food all across the Bay Area."

"Like what?" I asked.

"Like putting it in storage lockers outside."

"Is... that a problem?" I was not yet a food safety expert and unaware this was an absolute no-no in the food delivery industry.

"Hell yeah. It's not kosher, Vicky. This is meat, dairy, seafood, stuff that's supposed to be kept at a certain temperature and in refrigerators. It's *food*," he rushed on.

"Okay, so how do we see if this is actually happening?"

"I'm gonna check out one of the locations they told me about," Kevin said. "It's in San Jose. I'm going tonight, and I'm bringing a camera to see if the Sysco truck shows up like they said it will."

Sounded like a good plan. I trusted Kevin. It was exciting to be in this new investigative reporting world. I always thought I-team reporters were the pinnacle of our industry. Of course, you need daily general assignment reporters to cover breaking news by telling you the who, what, when, and where of events that happen in real time. But investigative journalists often uncover the why and how. They are tasked with working on impactful long-form reporting that gets results: Bad guys go to jail, laws are passed, corruption is exposed.

The next morning, Kevin rushed over to my desk.

"I got super bored and impatient last night and started driving around looking for the Sysco truck on random streets. I didn't see anything."

"Oh man, that's a bummer, Kev. So, it was a bust?"

Usually when you get an anonymous tip, it's overblown, or worse, bogus. Someone says people are being trafficked to build a new theme park, but you dig and surveil and follow vans and none of the clues add up. You always have to follow up on the tips, but often, they end up being a colossal waste of time. Was this Sysco tip too good to be true?

"Actually," Kevin said, drawing out the suspense because he knew he was about to drop a bombshell on me, "*I* didn't see anything. But that doesn't mean we didn't get anything."

"Kevin, ugh, what are you saying?"

He was enjoying this.

"I'm *saying,* I didn't see anything. But the GoPro did."

I sighed, waiting for him to further illuminate, at his own pace, what happened on his ten-hour stakeout.

Revved up, Kevin spilled. "So I set up the GoPro camera on the sidewalk. It was rolling the whole time. While I was driving around, the camera recorded a huge shiny silver Sysco semitruck drive right through the gates! Then a couple minutes later the video shows me driving by. I literally missed the truck with my eyes, but it was there all right."

Then, he said the golden words you love to hear in TV: "We got the video."

The Sysco tipster was solid! Us? Not so much. We had never done something like this before.

We made a plan. We went back to the source, who told us instead of using a big, refrigerated truck to make a bunch of little stops with items here and there for small restaurants, Sysco was using storage facilities all over the country as temporary places to leave perishable food like meat, milk, and produce. It was more cost effective to have their salespeople go to the storage sheds, pick up the food they needed, and make the small deliveries in their personal cars.

Our source said it was a nationwide practice, but we only had a

list of the Bay Area locations. We focused our resources and enlisted all our photographers—Jeremy Carroll, Felipe Escamilla, and Mark Villarreal—and another investigative producer we trusted, David Paredes.

"You guys, this could be insane," I said. "We have to work overnights and long hours. We need everyone to be laser-focused because this is a multibillion-dollar company, and they might be cutting serious corners."

Everyone was all in, but no one knew exactly what to do or how it would play out. We brainstormed the different ways we could approach the story and decided on the first order of business: try to rent a storage locker near one of Sysco's lockers and rig it with cameras so we could see what was happening once that semi drove into the San Jose facility.

Kevin and I went to scope it out.

"What are you planning to store in the unit?" the salesperson asked.

"Some boxes, some gear," Kevin said. As journalists, we couldn't lie, but we weren't required to tell her we were planning to install hidden cameras either.

"No food or water, right?"

"No," I said. "Are we allowed to store food or water here?"

"That's against the rules. No food, not even water, because that attracts rats and mice. They chew through the plastic. We don't allow anything like that."

She showed us a locker way on the other side of the facility from Sysco's.

"Um, no, not this one," Kevin said. "How about something larger?"

Then she went to a different locker, even farther away.

"How about this one?"

"Not this one either," Kevin said, glancing back toward the entrance near the Sysco shed.

Eventually, we threw subtlety out the window and walked directly to the shed with the best view, directly across from Sysco's.

I pointed to it. "How about this one? This one would be perfect."

The salesperson looked warily at me, then Kevin, and shrugged. "Okay, if this is what you want. It's more expensive though."

"That's fine," Kevin and I said in unison.

We wanted our cameras to have the best chance of capturing whatever happened every time the semitrucks rolled up that door.

Kevin piped up, "Can we get it? We're kind of in a hurry. Here's our credit card."

Kevin and David immediately brought in some gear and rigged our storage locker with cameras pointed right at Sysco's locker. We looked so suspicious I couldn't believe that no one ever asked us what the hell we were doing.

After a few days, we had video evidence. Our hidden cameras recorded multiple Sysco employees coming to the locker, opening it, and taking out food products to put into their personal cars. This was irrefutable proof.

Now the conundrum. We needed enough time to gather the facts for our reporting. But we knew we also had to contact the California Department of Public Health as soon as possible. We were witnessing risky food practices that could endanger the public.

BEEP BEEP BEEP BEEP BEEP

2:00 a.m. I hit the button on my alarm. Go time. I pulled on my stakeout outfit, stretchy jeans and a navy T-shirt with proper shoes. I needed to be comfortable for the next six hours. If this morning was like the others, I'd be sitting in the station's Toyota RAV4, camcorder in my hand, ready to shoot video of anyone coming to or leaving the shed in Concord, a city about thirty miles northeast of San Francisco.

Now that we had a few video clips showing multiple Sysco employees taking food out of these sheds, we were going to try to follow them and see where they delivered that food. I yawned. I knew a life of spycraft and surveillance would never be my full-time calling. Anyone who has been in the investigation business knows it's nothing like the movies.

Most stakeouts are long, and boring, and you always have to pee. You spend hours waiting for ten seconds of something to happen.

We had figured out a pattern at this point: usually the Sysco semi-truck delivered the food to the shed around 3:00 or 4:00 in the morning. Around 8:00 or 9:00 a.m., Sysco employees arrived, sometimes running into each other and saying their hellos before picking up their parcels, tossing them in the trunks of their cars, and zipping off.

"Kevin, what is that? Zoom in," I said.

"Chicken, it's chicken. I can see it on the box."

Chicken is not one of those meats you want to mess around with. It can be a host to salmonella, which is a nasty bacteria that can cause diarrhea, vomiting, even full-blown food poisoning that has killed people. Babies, the elderly, and those with weakened immune systems are especially susceptible.

"Damn. Chicken? They're leaving chicken in there?"

Three hours later, someone finally came to pick up that chicken.

"She's got it," Kevin narrated as he recorded. "Chicken going into the trunk."

Kevin and I decided I would drive and he would shoot. I was in the driver's seat, ready to pursue.

Had I ever pursued someone in a car before? No. I was going to try to stay as close as possible without looking like a stalker. Funny thing is, most people are really oblivious. They are not paying attention to who's paying attention to them. These stakeouts taught me to be much more situationally aware in my own life.

"Ready? Put on your seat belt, Kevin. We about to go on a riiiide."

I was wide awake now.

"I'm good. Let's go. She's turning right."

I floored it through an almost red light to keep up with the black Nissan.

"Where is she going?" I muttered.

"This isn't a restaurant. Wait, is this a neighborhood? Hang back," Kevin said. I slowed the car and hugged the curb. Kevin, holding the camera, kept it steady.

"Looks like she's carpooling. That lady is getting in the car."

We pulled out slowly.

"Oh, snap. Are they delivering to Starbucks?" I asked. "No wait, does Starbucks even serve chicken?"

We parked a few spots away, watching as the Sysco worker and her carpool buddy walked into Starbucks.

"Dude, I think they're just getting coffee."

I was proud of my driving skills; two stops and I was still on her as she pulled away with her morning joe.

"Vicky, she's getting on the freeway, pull up, pull up, pull up." Kevin didn't want us to lose her at this point.

Freeway pursuits are not easy. Cars kept getting between us in traffic. Every time she changed lanes, I changed lanes. I wasn't even trying to be subtle at this point. I just needed to keep up with her. If I lost her, we'd never know where that damn chicken was headed!

"Yo yo yo, this is Lockheed Martin," Kevin said.

"Uhhh, we can't go in there. There's security." Our mark drove through the gates at a giant military aviation company.

"Maybe the chicken is for their cafeteria?" Kevin guessed.

We hung back, annoyed that we wouldn't get to see her unloading the chicken from her trunk. That would be a great money shot, but there was no way we could get past security.

While we sat trying to figure out where to head next, Kevin looked up and spotted the black sedan.

"Hold up. Is that her? Is that her?" he said, squinting through the windshield.

"Yes, yes. She's by herself, but that's the license plate."

I flipped a U-turn and got back on her tail.

Finally, after fifteen minutes of following her through city streets, we stopped at a kids' swim center.

"Are you rolling?" I asked. "There she goes!"

"Yep, I'm seeing it."

She popped the trunk and took out a box.

"Get a shot of the sign so we remember where this is."

The woman took all the remaining chicken out of her car, dropped it off, and left.

"Holy crap," Kevin said. "She straight up delivered chicken that was sitting in that shed for three hours, plus however long we've been driving this morning, to this little rec center snack bar?"

We staked out four different outdoor storage units across the Bay Area. In all, we observed Sysco truck drivers dropping off food in Concord, San Jose, San Francisco, and Greenbrae. We surveilled these sheds starting before dawn, recording video of pork and shrimp, milk and bread left inside dirty storage sheds, sometimes for hours, in summer temperatures.

"We gotta go to the restaurants to get their reactions too," Kevin said.

Our first stop was that swim center where we saw the chicken delivery.

"So you don't get chicken from Sysco? But we saw a lady delivering things here from Sysco."

"Yeah, we have a deal with them, but we only get our paper products from Sysco, no food," the manager told us.

Crap.

We hadn't gotten close enough to see what she took out of her trunk, and apparently we stopped our pursuit prematurely. We were massively disappointed.

That raw chicken had been left in a storage shed for three hours and driven around Santa Clara County for an hour. We never found out where that shed chicken finally ended up.

I told you: surveillance is hard. Fortunately, our producer, David, had better luck with the "five-hour pork." On one of his stakeouts, David recorded video of pork tenderloins left at a shed in Concord. Five hours later, he excitedly hit record again when a Sysco employee loaded the pork boxes into his trunk.

"There goes the pork, there goes the pork," he said, making sure to narrate the video so we could keep track of all the different undercover shots.

Temperatures that day hit the mid-eighties in Concord, and we knew it got even hotter in those metal and concrete sheds.

David scored big.

"I got it, you guys. The pork went to this restaurant in Concord. I got the guy taking it out clear as day from his trunk and bringing it inside."

"So that pork went from the back of his car to the back of that restaurant?" I asked.

"You bet," David said.

"Let's go and talk to the owner." I was so happy David's hard work had paid off.

Kevin and I loaded the video onto an iPad so we could show it to the restaurant owner.

"Hi, we're with NBC Bay Area, is the owner here?" I asked the host at the bistro.

"No, but our manager is here. Do you want to speak with him?"

Yes, please.

"Hi, I'm Vicky Nguyen. I'm an investigative reporter with NBC Bay Area. Sorry to bother you, but do you have a minute? We wanted to show you some video."

I quickly explained the situation and how we'd recorded video of pork that went to his restaurant. His eyes opened so wide we could see the whites; his chin dropped, and he gasped. "That's horrible! We definitely don't practice that here." His genuine shocked reaction was more TV gold.

Eventually it was time to confront the sales employees coming and going from these sheds to ask what was going on. Unlike interviews holding public officials accountable, these were ambushes. Gentle ones. I wasn't planning to take a mean, accusatory approach. I never did. I wanted to keep my tone neutral and get our subjects to talk as much as possible. Photographer Jeremy and I went over the plan.

"As soon as we see them pull up to the shed, just start rolling." I had the handheld "stick mic," and I was wearing a lavalier mic, the tiny kind that clips on, as backup. "Obviously if it gets hectic, we back off."

Jeremy was used to these confrontations; he'd done several with Tony. It's not easy for the photographers. They have to keep everything in focus, make sure the video and audio are recording, and be ready in case people get pissed and want to fight.

"Yep. Got it." He nodded, checking his battery.

Jeremy had his camera in his lap ready to go. I sat in the passenger's seat and rehearsed what I planned to say. I calmed my nerves by putting myself in the viewer's shoes. *I'm asking what people at home want to know.*

"Heads up, looks like this guy is stopping at the Sysco shed."

Jeremy and I hopped out of the car and walked up to a middle-aged guy with silvery hair and wearing sunglasses.

"Hi. I'm Vicky Nguyen with NBC Bay Area." I handed him my business card.

He was surprised to see me. He took one look at Jeremy and the camera and turned to walk right back to his car. This was not how he expected his morning to go.

"Are you storing food in these sheds?"

He pulled a classic response when you're caught doing something you shouldn't be. He answered the question with a question.

"Are we?" he said nervously and then quickly closed the shed. "Oh, I'm not allowed to talk, sorry." He climbed into his car and drove off.

"We got that," Jeremy said.

Kevin was about ninety minutes north of me, doing the same thing at just about the same time. He approached a Sysco sales associate in Concord.

"Hi, I'm Kevin Nious, I'm a producer with NBC Bay Area. Did you know you guys had pork sitting out here for five hours the other day?"

"Well, sure, five hours is a problem, yeah," the man acknowledged, continuing, "It's a common thing, though, you know, because it's food distribution." He shrugged, walked back to his car, and drove off.

We had the evidence we needed to go to the California Department of Public Health. We asked for an interview with health inspectors to show them what we had documented. They immediately launched an investigation, sending inspectors to all fourteen sheds we'd identified.

I learned so much from that series of reports. Our execution wasn't perfect. We failed to track the chicken, and we didn't realize that when we called the health department to request an interview and explain what we'd found, they would head out immediately to see it for themselves.

We were caught flat-footed on that, with no video of inspectors going to the sheds to gather evidence that would shut this operation down.

Fortunately, we had more than enough to put together a series of reports that garnered a lot of attention and ultimately improved food safety practices across the country. Sysco Corporation was the biggest food distribution company in North America, with revenues of $44 billion in 2014. They operated 193 distribution centers serving 425,000 customers, including schools, hospitals, and restaurants.

Once our reporting broke, people working at several other food companies called to say storing food in temporary sheds without temperature control was a common practice across the industry. But their companies, overnight, changed their practices. They didn't want to be next in the NBC Bay Area spotlight.

By the following summer, our undercover investigation had resulted in Sysco having to pay $19.4 million in penalties and restitution to the state of California. It was the highest consumer settlement in state history.

The Sysco reports, I would learn years later, put my team and me on the map for the executives in charge of investigations at NBC News. They loved the hustle, grit, undercover reporting, and results from our series. At the time, I was just relieved our early mornings, overtime, and our source's trust had triggered major changes in food safety for millions of people across North America.

44

Torn

During those years when my dad was working off and on, still day trading, trying to find something *big* that would propel him back into financial security, I was constantly struggling to be a Good Daughter. A Good Daughter respects her parents. A Good Daughter supports her parents. A Good Daughter obeys her parents.

Those things proved impossible for me to do as I gained financial independence, moved into adulthood, and wanted to ensure my own family had security. I was not going to lose the Durango the way we lost the Windsor.

I started to say no to my father. Not because I didn't want to support him but because I didn't want to depend on anyone but myself. I trusted only myself to make money, to save money, and to carefully spend money on what we needed.

It was hard. How do you say no to your dad when he has only ever said yes to you? I wanted to believe in him, and I wanted him to be successful again, whatever "successful" meant for him. I listened to his ideas, I offered support and suggestions, and I felt guilty. Guilty for not investing in the latest idea, guilty for not writing a check, guilty for not believing in him the way I had when I was a kid.

The balance was off. Parents provide and care for their children. As

a new mom, that was how I felt. You bring kids into this world to step onto your shoulders and get that much further in life. But as an Asian daughter, I felt the boomerang. My parents sacrificed so much for me that when it was my turn, I had to give back to them too.

I listened to my dad's suggestions about success and money. He was supportive of my career, but he didn't see why I would continue in a line of work if it wasn't maximizing my earning power. Every day I spent making less money than my peers in law firms or at tech companies didn't make sense to him. Especially because he thought we could make more money together if we just bought a small business.

"Yến, look at this franchise. You put in 150K and find the right location, you make 300K a year. Turnkey operation. Can't lose money."

Many times I considered leaving journalism. I was reporting and working mornings, nights, weekends. It was a demanding job with little stability. Would I be able to earn enough to support myself and my parents? The question nagged at me constantly.

"Okay, Dad, let me see those papers."

We looked at the profitability of laundromats, gas stations, Asian fusion fast-food chains. I even investigated what it would take to open a Chick-fil-A. We would never make the cut. It wasn't just about money and spicy chicken sandos, Chick-fil-A wanted a "holistic commitment." The website explained the corporate purpose: "To glorify God by being a faithful steward of all that is entrusted to us and to have a positive influence on all who come in contact with Chick-fil-A."

"Can you imagine my dad going to six weeks of training and talking about his commitment to Jesus?" I asked Brian as I looked over the glossy online prospectus with its colorful photos of smiling, diverse franchisers.

Brian raised his eyebrows, "Yeah, no."

I researched what it would take to open a fast-casual Vietnamese *bánh mì* chain like Chipotle, but with sandwiches. You'd start with freshly baked baguettes and add ham with pate and *đồ chua*. No cilantro on your *bánh mì*? No problem. We would serve *cà phê sữa đá* and fun sides like seasoned waffle fries. I pictured myself on the cover of

Entrepreneur or *Fast Company,* "Queen of Sandwiches" with stacks of *bánh mì* piled around me.

I interviewed the gracious owners of Pizza My Heart and Papalote, two very successful fast-casual restaurant chains in the Bay Area. I wanted to know the ins and outs of running a restaurant and how to do it successfully. I have always admired entrepreneurship and small business owners. They work hard, but they're masters of their own destiny. They create jobs, they vitalize communities, they make something where nothing was before.

"Which one of us will make a million dollars first?" my dad liked to ask, because he believed in himself. Fully confident he was going to get back on top, he didn't see the stress and anxiety I was feeling. I wasn't ready to quit my career so I could make it big as my own boss. I also didn't want to go into business with my dad. We would never be compatible as co-owners. We are far too much alike. My dad and I were both born in the Lunar Zodiac year of the horse. Horses like to travel, they're wild and free. They're enthusiastic, cheerful, full of optimism. But they can also be self-centered and reckless. We would not make good cofounders.

Knowing that—but not saying it out of respect—fed my guilt daily.

45

Show Me the Money

While I continued to struggle with guilt for refusing to invest in my dad's dreams, by 2015 the negotiating skills I had learned from him would serve me well and help me secure a salary that justified following my own career dreams.

I was coming off a big year. I won a national Emmy award, which is a big deal when you're a local reporter. You only get to the national Emmys in two categories: breaking news and investigations. To even get a nomination, you must first win the local Emmy. Then you're judged against all the winners of that category throughout the country. Four to six are nominated for the national Emmy, and usually only one award is given.

I had also been doing other impactful investigative reporting for the station. I learned a lot in a short time from my talented colleagues, including producers Liza Meak and Liz Wagner. Our assigned photographers—Jeremy, Felipe, Mark, and Michael Horn—helped us shoot and edit those stories and make them come alive.

At the time, our station's entire branding campaign was built around this team, and our motto was "We Investigate: Holding the Powerful Accountable." I was one of five on-air reporters who made up the "We." We were regional celebrities. The station invested in giant posters of us and

plastered them on city buses and at BART stations, the Bay Area Rapid Transit train system that carried hundreds of thousands of riders daily.

I was angling for a bump in pay and title. Senior investigative reporter. *Why not?* I had the highest story count quantitatively, and the quality of those stories had been recognized by outside awards and viewer feedback. I wanted to make the case for a promotion, and I knew there was room to grow my salary. I just didn't know how much.

Until this reporter, let's call him Angel, up and told me.

"You should ask for the sun, moon, and stars. You're killing it. I'm so proud of you," Angel said. "Remember when you were doing stories about vampire facials? Look at what you're doing now!"

I was in a quandary. I no longer had an agent representing me. My previous agent had helped me get the job at NBC Bay Area, but after a few years, we agreed to end our deal because I was happy and didn't need her to find other gigs.

In early 2015, I was ready to at least *see* what else was out there. Could I get a job as a network correspondent and report for a national audience?

I found an agent willing to take on an unorthodox deal. He agreed to take my résumé and clip reel and represent me in a search with the big three networks: ABC, CBS, and NBC, as well as CNN and FOX News. If he got me an offer, and I accepted, he would receive a 10 percent commission on my salary for the duration of my contract. Contracts are usually three-year deals.

But if I stayed at KNTV, I would negotiate for myself and pay zero commission. I had strong relationships with my news director and general manager and felt comfortable representing myself with them. It was unusual, but we both thought it was fair.

I was talking to my colleague Angel about how much it sucks to go through a contract negotiation. All the stress and game playing and back and forth.

"I'm not sure what to ask for," I said with a sigh, perching on the chair across from him.

"Well, what are you making now?" Angel asked.

I was a little hesitant to talk about the exact number, but I trusted him, so I came straight out with it. "I'm at $145,000."

"What? That's ridiculous. I make way more."

"Like how much more, Angel?" I asked, sitting up. "If you're not comfortable saying, I totally understand, but can you give me a ballpark?"

"Let me see. I have my contract right here. I can tell you exactly how much." He reached into a file cabinet and pulled out our boilerplate contract. I couldn't believe it. I was surprised for multiple reasons:

1. It's one thing to tell someone how much you're making, but to show them?
2. Who has their contract with them at all times in their office?
3. When does anyone just casually whip out their paperwork to show a co-worker all those personal details?
4. He was making *what*?

Angel was totally nonchalant about showing me his exact salary *in writing*. It was one of the most surprising and life-changing things anyone has ever done for me. And he did it because he just thought it was the right thing to do to help a friend know her value and give her the ammunition to fight for it. There it was in black and white. Angel was making nearly $200,000 in the final year of his three-year contract.

Make no mistake, Angel was an amazing reporter and deserved every penny of the $200,000 and more. But that $55,000 difference slapped me right across the face. I later learned that the chief investigative reporter was reportedly making more than $300,000.

So I asked the chief what he thought I should negotiate for in my next deal.

"You're playing in the deep end. You've had the best two years of anyone in this unit, and you should be rewarded for that," he told me, which gave me confidence. Another generous gesture from a second colleague who was rooting for me to be fairly compensated.

Their openness about pay gave me the confidence and righteous indignation needed to advocate for myself. These two men were making

significantly more than I was, for measurably similar output and work product. And I wasn't too far behind in terms of experience and seniority.

The negotiations started out in the standard fashion, friendly enough. My news director's first offer for my new deal started at $155,000 for the first year and increased to $165,000 by the third. I knew that was just an opening offer and that they expected a counteroffer. It's ridiculous, but this is how the world works. Why offer the best number and wrap things up when you can enter a protracted negotiation and make the employee second-guess themselves and lose sleep and be anxious for weeks on end?

At home, I only talked with Brian about the negotiations. I didn't want to stress my mom, and I didn't need the extra pressure from my dad about how to talk to my bosses.

On our evening walks, I hashed out the different numbers and scenarios.

"Angel is making fifty K more than I am!" I huffed.

"It's generous he actually told you," Brian said. "Now you have a data point, and you can build from there. But, Vicky, be prepared for pushback. You're shifting the whole paradigm by trying to reset the conversation in the twos considering what they offered," Brian advised.

My first meeting with the news director was cordial.

"We love the work you're doing Vicky," he said. "We want you to stay. We feel this is a very fair offer. We know you are a model citizen. We are lucky to have you, and your colleagues all love working with you." The news director smiled, unaware I was about to get Real World real with my counteroffer. I needed to be clear and get the attention of those in the back row too.

I laid out my case.

"Based on the work I've been producing, not only in quality and quantity, but also the national recognition my reporting has brought to NBC Bay Area"—I listed off my Emmy, National Press Club, Murrow, and Society of Professional Journalists Awards—"and the salaries of others in the newsroom who are comparable to me, I think the deal should look more like $225-$235-$250."

It was not even in the same zip code as what they had offered. It was

a statement counteroffer in bold italics. With my numbers, I was saying, *You've given me a slight bump in salary on a salary that's far lower than my market value. Allow me to reintroduce myself and the new numbers we should be talking about.*

My news director scoffed in my face. Literal scoff. He couldn't even hide his reaction in real time.

"That's not realistic, Vicky. Where are you getting those numbers? That's more than the anchors make."

While that was true for some anchors, I also knew that several an chors made plenty more than that, and I also knew two reporters who told me they were in that range.

Thus began the protracted negotiation. What managers want to wrap up generally in a month with maybe one offer and one counteroffer took five long months. It was enough time for me to travel to New York and meet with executives at CNN including Jeff Zucker, the president of CNN Worldwide.

After a series of interviews, CNN offered me a correspondent position based in New York or L.A. And guess what they were offering? $215K-$225K-$235K. That sounds like a lot, and it is. But the cost of living in NYC and L.A., plus the expense of relocating from the Bay Area, minus the agent's 10 percent, meant the offer wasn't "make me move" money.

The pros of CNN: working at a network, having my reports seen by millions, and representing Vietnamese Americans at a national level.

The cons: no promises of investigative reporting, which I had proven I could do and actually loved.

Holding people accountable and seeing the impact of our in-depth reporting was addictive, and I felt like I had much more room to grow into that role at NBC Bay Area.

And being a general assignment correspondent at the network level was not the lifestyle I wanted at this point in my career with two young daughters at home. Emmy was six, and my second daughter, Odessa, was three. If I took that CNN job, I would be living out of a suitcase, missing my precious girls and Brian.

"Brian, what about this CNN offer?" We were on spring break vacation with our good friends the Teng family. It was Decision Time. CNN was pushing for an answer. I tried to limit my hand-wringing conversations to the evenings, when I could pace the room and lob my career questions at Brian without annoying everyone else, because we were there to enjoy the San Diego sunshine.

"What if I never get another network offer? I'm thirty-six. This might never happen again."

"No. First of all, the money is not enough to move our whole family," Brian said. "And second, the job is GA. Do you really want to go from being an investigative reporter to general assignment correspondent?"

He reasoned with me. "Right now, you have so much autonomy. You work normal Monday through Friday hours. Do you want to fly around the country at the drop of a hat and cover disasters and shootings? We will never see you."

He was right, of course. We went back and forth, part of me romanticizing the idea of a correspondent lifestyle and picturing myself on a national network. I would be representing all the Nguyens and Phams and Trans and Dos out there! But in my gut, I knew the answer was ultimately no. It took a week of talking it out to let myself down easy. My ego was excited by the offer, but it wasn't an offer that would be worth upending our lives. Personally, and thanks especially to my mom, I had that elusive "work-life balance" that's near impossible to achieve for a woman in TV news. Professionally, I still had more to learn and a longer runway at NBC Bay Area.

Having the offer from CNN gave me some leverage at NBC Bay Area. My current boss, the news director, was not happy to hear that there was a possibility I would leave. And apparently, neither was my station's general manager.

The head honcho of the whole operation sent a meeting request, which was unusual; few of these reporter-level contracts go up to the front office. But clearly things were taking too long, and conversations with my news director were at a stalemate.

When I arrived for the meeting, it was not only the general manager

but also the news director and our brand-new assistant news director. They had pulled her into this meeting for good measure. We had a laugh about it years later. She said, "I didn't even know why I was in there."

Looking back, I can see that she was there to beef up their presence. Three of my bosses on one side of the negotiating table and just me, myself, and I on the other.

I had already spent many sleepless nights rehearsing all the lines in my head.

"I'm like a stock that you bought for a great low price per share. Now my value has grown like Apple stock and I'm paying dividends!"

"It's like when the Warriors got Steph Curry and he was small, and people weren't sure about his ankle. And now look! He's the MVP changing the entire game."

I was an analogy machine. But when you're in a negotiation, you only get one shot. I'd always made my best arguments using analogies, and I didn't choke, because I'd practiced saying these things out loud. I repeated them in my head. The only time I ever suffered from insomnia was during contract negotiations, because I'd lie awake running the dialogue through my mind, anticipating what they'd say and planning my response.

I had nothing to lose. They weren't going to take away the offers they'd made just because I was taking my time and building my case. They set deadlines, but those dates seemed arbitrary. Were they really going to rescind their offer and risk me walking away? I read Mika Brzezinski's book, *Knowing Your Value*. I knew my value.

I also tried not to take any of their responses personally. *This is just business, Vicky,* I told myself. Once we got to a deal, all of this would be in the wind.

Often, we're rushed into signing a deal. "You need to sign by Friday, or this might go away." "No one else is making this much." "This is just what the job pays." "The Big Boss wants to know why you haven't signed yet."

It's not to say these things companies tell you aren't true, but you have to fact-check. Never take anything at face value. You'll know the absolute truth if you have another offer to leverage or if you're really

willing to walk away. That's not always possible, but it's how you find out how much your company is willing to pay you. As Robin Smythe, my News Fairy Godmother, told me when I tried to get CNN to offer more, "If CNN doesn't meet the number you need to make this move, it doesn't mean they don't want you enough. It means they don't pay what you want for this position. It's not about you. It's about CNN's pay structure."

For whatever reason, we're all conditioned not to want to go too high on the chain of command, especially when it comes to contracts and money, which is silly if you think about it. Welcome that opportunity. If your immediate boss can't make things happen for you, and you think you have a strong case, go for it. As Wayne Gretzky said, "You miss 100 percent of the shots you don't take."

After I fired off way too many analogies and rehashed all my "exceeds expectations" employee reviews, my general manager was actually somewhat amused. Years later he told me, "I was thinking about my daughter when you were in there, making your case. I hope she has that same moxie. You were a firecracker."

A few days later, they made me an offer I couldn't refuse. $190-$210-$225. That was a big jump from $145,000, and it made me feel valued. And as difficult as it was to turn down CNN, I still felt I had more to learn at KNTV as an investigative reporter. As fate would have it, three years later, I was in the right place at the right time to have a shot at one of the best investigative correspondent jobs in existence.

46

Stars Align

My bosses would agree: the station got its money's worth. Over the course of my contract, I led investigations involving federal whistle-blowers at the Occupational Safety and Health Administration. My reporting exposed an outdated rule prohibiting workers from calling 911 at the United States Postal Service and resulted in a national policy change to make it safer for more than half a million workers. Perhaps the most personally upsetting investigative reporting I ever did involved an extensive history of sexual abuse allegations that had been covered up at a prominent girls' Catholic high school. Ultimately, my reporting with producer Michael Bott led to the resignation of the school's president.

My Sysco partner and star producer Kevin Nious and I put together a series of reports called Drivers Under Siege. We revealed that brutal attacks against AC Transit bus drivers were on the rise, contradicting official statements that those assaults were declining.

Our investigation involved extensive research, interviews with former and current bus drivers, and a meticulous examination of surveillance videos. These videos were crucial in providing visual evidence of the mistreatment the drivers endured, from verbal abuse to physical assaults.

They served as undeniable proof of the unsafe working conditions plaguing the AC Transit system and became a powerful tool to convey the urgency of the situation to our viewers.

When the reports aired, the impact was immediate and far-reaching. The public was shocked to learn about the mistreatment these essential workers faced daily. The reports sparked a wave of empathy and outrage, and the community demanded action.

AC Transit, under the weight of the evidence we presented, had no choice but to respond. The agency installed protective barriers on buses and implemented better training programs to help drivers deescalate conflicts. Beyond raising awareness, Drivers Under Siege resulted in tangible changes and safety improvements for the bus drivers.

In 2018, I learned our team had won Columbia University's 2019 duPont Award. It's considered the Pulitzer Prize of TV news. It's not easy to earn one, and it was especially meaningful because of the subject matter. Just after learning about our team's big win, I was sitting at my desk when my phone vibrated. It was December 6, 2018, and I was looking forward to the holidays and winter break.

The text read, "You see Rossen leaving? You applying to do it? You should!"

I had spoken to Jonathan Dienst only a couple times. He was the chief investigative reporter at WNBC in New York and a contributing correspondent at NBC News.

I responded, "What? Wow, thank you for even suggesting that."

Jeff Rossen had developed the brand "Rossen Reports," and he was a well-known national investigative consumer correspondent for the *Today* show. I had never considered vying for his job, and I certainly didn't have any clue he was leaving.

Besides, I had never pictured myself on the *Today* show. Some people in this business know right away what they're aiming for and how high they want to climb. I loved the *Today* show. I watched the *Today* show. I treasured my photo with Ann Curry from when I met her at an AAJA conference while I was still a college student. But me, *on* the *Today*

show? Never even dreamt of it. It seemed like something other people did. I had gotten to the San Francisco Bay Area, a major news market. I loved local news and my colleagues. I was content.

Still, I googled Jeff Rossen. Sure enough, several articles popped up, published a week earlier. Jeff was, in fact, leaving NBC News.

Pfffft, I figured I was way late to the party. A week in TV is like a decade. Sometimes companies already have your replacement waiting in the wings in case you get hit by a bus.

I texted Dienst. "Thank you for the vote of confidence—truly! I will look into it ASAP." But in my head, I thought it was done and dusted. No way was the *Today* show's big consumer franchise correspondent gone with no one ready to take his place. And even if they didn't have someone or *several* someones in mind, hungry TV agents were probably clamoring to get their clients hired.

But I was intrigued. And if Dienst hadn't told me about the job, I never would have known it was open. *Things happen for a reason.* My dad's philosophy surfaced again.

Brian and I had three daughters now. If I had been trying to establish myself as a national correspondent and traveling all over the country with the CNN job that I was offered a few years prior, I don't think we would have expanded our family. It would have been too chaotic. But staying at KNTV allowed me to be present to raise my girls and consider having a third baby. In 2016, we welcomed our youngest daughter, Renley.

She was now two, and I was the Sunday evening anchor and a senior investigative reporter at NBC Bay Area. Brian was six months into his dream anesthesia job. He was working with his basketball-playing anesthesiologist buddies in an amazing group. He saw himself working there through retirement, for the next twenty-plus years; that's how much he already loved his new job.

I didn't really think anything would come of Dienst's tip. But as a person who strives to make the most of every bit of my life, I thought I should at least reach out about the gig. I contacted the two men in

charge of the investigative unit at NBC News, Richard Greenberg and Robert Dembo, to say I'd heard about the job and wanted to learn more—if it was still open.

It just so happened that the duPont awards ceremony would be held at Columbia in late January. I let Dembo and Greenberg know I'd be in New York in a few weeks if they wanted to meet in person and discuss the job further.

"Perfect," Dembo said. "Congratulations on the duPont. We'll set something up for after the holidays when you're here."

Brian stayed home with the girls. I arrived in New York, my parents in tow, to accept the biggest national award of my reporting career. They didn't know duPont from Dolittle. I told them it was exciting, so they were excited. My dad found an old suit that still fit and asked Brian to preknot a necktie so all he'd have to do was slip it on and tighten it when it was time for the awards dinner. I took my mom shopping at Nordstrom to find the right dress—classic and comfortable, along with size 4.5 Mary Jane shoes that were not the flip-flops or Keens water shoes that she was now fond of wearing everywhere except on the river walks they were intended for. "They're so comfortable, and they stay on!" she would say.

When we landed at JFK, it was one of the coldest days of that year, the windchill bringing the "feels like" temperature down to minus 11 degrees.

"Can you imagine living here . . . in *this*?" I asked as we dragged our luggage from the street toward the Marriott lobby. I was testing my parents in case the NBC gig worked out and we'd have to move to New York.

"We do what we have to do," my dad said, the ear flaps of his Elmer Fudd hat whipping his face. He was already thinking of the future. My parents knew I had some meetings at NBC News, but I didn't want to get too far ahead of myself by revealing too much about the possibility. Besides, I was still skeptical that anything would come of the NBC talks, so I tried to keep the focus on our quick trip to NYC to collect the silver duPont baton.

After a memorable night on the Columbia University campus, where I met fellow honorees including *60 Minutes* correspondent Bill Whitaker and PBS documentarian Ken Burns, we went back to the hotel so I could get some rest. The celebration was over. Now it was time for my interviews.

47

Tsunami

When I had first called Brian to tell him about the potential job open-
ing, he was leaving the gym, happy to be back into a workout routine
now that he had a flexible job. With every detail I gave him about the
job and what it would entail, his dread grew. Outwardly, he was calm
and encouraging. Inquisitive even. We'd always known there was a tiny
possibility some sort of job offer might come along that would disrupt
our lives. That's why he chose anesthesia. It's one of the most portable
medical professions. As much as I wanted him to become a dermatologist
to take care of my face forever, he was the one who suggested anesthesia
because he wouldn't have to leave behind a practice if I ever hit it big
and we had to move.

"Vicky, what's the number that makes sense for us to move our
entire family—the girls, your parents—to the most expensive city in
America?" he asked me early in the process, when we knew the NBC
managers were interested but hadn't made any plans to formally in-
terview me.

"It has to be double what I'm making," I said breezily. Easy-peasy.
That number, huge by local news reporter standards, seemed reasonable
given the rumored salary for the role.

"Okay"—Brian nodded—"let's see what happens." He was secretly

happy I had tossed out such a big number because he thought an offer that high was unlikely.

It didn't happen. I did get the job offer after slaying the interviews, but my euphoria was short-lived when the first offer was nowhere near a number that would convince Brian this was a worthwhile decision. He was on pace to earn a healthy salary in his new anesthesia group, so when the first offer came, he was Mr. Logic and Mathematics.

"Vicky, do you remember what you said about 'the number' when this all started? You said, 'Double what I'm making.'" Brian tossed my words back at me matter-of-factly.

"Yes . . . But that was a hypothetical. I'm sure once I get my foot in the door, my next contract will be much better." I backpedaled, knowing this was not my most convincing argument.

"This offer doesn't make any sense," Brian said. "It's not much more than you make here." He was firm. "Plus, I've been asking around. New York anesthesia groups work way more hours, and they make way less than my group."

Ugh. That wasn't happy news. Still, I was encouraged he'd made some inquiries about working in New York. That meant he thought it was at least plausible! But the first NBC offer was a nonstarter, and I'm glad he held his ground to prevent me from caving.

I channeled his resolve when talking to my agent.

"It's not gonna work. My husband is relieved by this offer because it means we definitely aren't moving my whole family to New York."

I paced as I talked to her, remembering another tip I had learned about having hard conversations. Stand up, puff out your chest, square your shoulders, and draw upon your inner Wonder Woman.

"I hear you," my agent reassured me. "I'll go back to them."

"Thank you. I really want this job, but we need a better deal."

In a way, Brian pinning me to my first number made me that much more determined in the negotiations. I knew we weren't budging unless we got a lot closer to my initial estimate. It didn't make sense to uproot everyone and move from one crazy expensive place to another crazy expensive place where the weather was infinitely worse.

He was cool as usual, but inside, Brian already felt the change com-ing. It was a tsunami that looked tiny in the distance but loomed larger with each email exchange and phone call between me and the honchos at NBC News. That wave was coming, ready to sweep up our little California family and take us to the East Coast.

He knew that the opening offer would get competitive enough to force a serious conversation about our lives and our futures. Brian thought that taking a hard stance now and saying it wasn't worth the risk would break my spirit. He didn't want to put the cork back in the genie bottle just as I was floating out, high on the belief I was about to grant some wishes, starting with my own.

The Blow Up Before the Glow Up

"Enough! You scold me enough, Yěn!" My dad stormed out of the kitchen. "Your friend lie to me, I tell you," he snapped over his shoulder as he walked into the garage, the door slamming behind him.

"Where is he going?" I asked no one in particular, hearing the garage door lift and his car back out.

It was an hour before I was supposed to leave our house in California, forever. Brian would stay behind while the girls finished school. He and my parents would pack up all their things and move to New York in the summer.

I chose the latest flight available, a Saturday red-eye from San Jose to JFK, landing on Sunday morning. My first day at NBC News was Monday, April 22. After several rounds of negotiating, we'd reached a deal. I didn't have Brian's happy blessing but I did have his supportive acceptance, and that was enough for now.

I defied my own advice from the Phoenix debacle to start a new job midweek. I picked that crazy red-eye because I wanted to spend as much time with my family as possible before heading to the opposite coast.

That morning we hosted our closest friends and neighbors in California for an Easter egg hunt/goodbye party. For years since our kids were little, we had carried on Grandma Mary's tradition of hiding eggs

in the backyard. We extended the eggstravaganza to all the families in the neighborhood, hosting a massive hunt complete with a Golden Egg prize winner. It became an annual brunch, and everyone brought dishes to share.

A core group of us, seven families, had all moved into this new subdivision within days of one another. We had grown exceptionally close because our kids had spent the past seven years growing up together, celebrating birthdays, biking to school, toasting marshmallows at impromptu backyard s'mores nights. It was as idyllic a life as I could have hoped for: Brian, me, and our three girls living together in a suburb of San Francisco with friends we trusted and adored.

My parents were renting a home nearby with random roommates. They were still struggling financially, and my mom said it was "good for your dad to have some people in the house with him." They were all single men, engineers or coders who worked in Silicon Valley and just needed a room to sleep in because most of the day they were at work, where their meals were provided. Sometimes the renters stayed only a few months.

I worried about my parents' safety, but my dad brushed off my concerns. "It fine. We know if they good or bad. We can tell," he said, every time he screened another potential roommate. It was a three-bedroom house, and at any given time there were two to three other men living there with my parents, including two Russian brothers who shared a small room.

"Well, Dave is nice. He like Dad's cooking. He love *thịt kho*." There was my mom again, looking for gems in whatever less than ideal situation they were living in. As far as I could gather, Dave was a divorced dad who rode a bike to work. He had a daughter a couple hours away whom he saw from time to time.

As much as I didn't want Mom and Dad living like that, I didn't have a good alternative. And I wasn't the only one struggling with my dad's actions over the past decade. Brian had witnessed it all, and it affected his dynamic with my father too.

Still, family is family, and everyone tried to make it work. My mom

THE BLOW UP BEFORE THE GLOW UP 273

stayed with us Sunday through Thursday, in a bedroom suite down-stairs. Monday, she was up making school breakfasts and lunches and getting the girls off to class while I got ready to leave for work. Brian was already gone by the time we started our mornings because his days began at 6:00 a.m.

My dad would leave and go back to their rental house and return Thursday evening to pick up my mom. Because I worked Sunday through Thursday, she was "off" for three nights. When we worked extra, she worked extra.

When Brian and I moved into that dream home in Mountain View, Emmy was three and Odessa was two months old. Shortly after I turned down the CNN correspondent job, we debated whether we should "go for a boy." I never thought I'd have three kids; it seemed like a lot. Naturally I interrogated all my friends and colleagues who had three kids. Everyone said, "Go for it." "You'll never regret it." "More is more when it comes to kids." "The third one is the family's baby."

Just one person offered a counterpoint. He was a dad who told me, "Well, it's kind of a pain having three. When you travel, all the packages are geared toward families of four. And small stuff is annoying, like eating in a booth at a restaurant because you have to have three on one side. When you go on rides and it's two people per car on the roller coaster, someone always gets left out."

He wasn't wrong, but we decided to give it a go because we loved our first two big-headed, adorable girls so much. Getting pregnant an-other time was easy, but producing the baby was yet again a challenge. In between having Emerson and Odessa, I'd had another miscarriage. The same thing happened after Odessa was born. By the time we were blessed with our third daughter, Renley, I had been pregnant seven times.

Who would have imagined, I, an only child, was now a mother of three precious children.

Caring for them was a family affair. A nanny was out of the ques-tion. My mom was a better mom to my daughters than I was in those early years. She still is far more careful and patient with the girls. Odessa would always tell me, "Grandma never gets mad. She's so nice. I have

never seen her get mad, Mommy." My mother has endured so much in her lifetime and asks nothing of anyone.

"Mom, are you sure this is okay?" was a question I asked of my mother early and often. "We can get help if you're too tired. I don't want you to do this if it's too much."

My mother scoffed. "Of course, I do this. I love the girls so much. What else I do? They are my granddaughters!"

Part of me believes it keeps my parents young, having a purpose and being such an integral part of our family unit. I could always focus fully on work because I knew at home, Emmy, Odessa, and Ren were getting the best care and most love possible.

My dad contributed plenty. His specialties were always driving and cooking. It is somewhat unusual in Vietnamese culture that my dad is as active in the kitchen as my mother, but because he's so particular about his own food, he is an amazing cook. He has made many signature dishes that have fed everyone in our family for years, from *bún bò Huế*, rice noodles with beef and pork in a spicy, tangy broth, to *bò kho*, beef stew, to vegetarian *cà ri*, curry.

But still, with Dad, it was different. He never hesitated to remind me, especially if we were in a bitter argument about something, how he couldn't go anywhere because "Mom has to stay and help you. I can't do my own things. I could go to Vietnam, start a business. But I can't leave when Mom here."

Even in 2019, as I was getting ready to fly across the country and take the biggest risk of my career, he was plotting his comeback. Being in Silicon Valley, surrounded by unicorn start-ups and angel investors and billions of dollars available for investment, he never gave up on his idea of creating a retail college superstore. His business plan read as follows:

Business Concept Summary:

A chain of retail superstores selling products to college students, their families and faculty (A "Dream Team of retail executives" from Costco/Target/Fry's Electronics and myself will manage this company.)

If you ask any college student, they will tell you that <u>they WANT/ NEED a store to help them save money/time and provide part-time jobs</u>. A portion of the profit will be used to develop grant and scholarship programs. We strongly believe the support by parents, faculty and alumni will be very significant, too (A college with 50000 students=250000 potential shoppers!) <u>It's a win-win situation!</u>

In California, from 2008 to 2013, the tuition & fee increased 72–104 %! (4 and 2 years public College & University)

Please help college students. They really, really need our help!

My dad spoke to one of my friends, a senior lawyer at a well-known tech company in Silicon Valley, to ask her for help. He sent her emails with his plans. All of this was unbeknownst to me. It was not the first time. A year or so before, another friend had told me, "Hey, your dad is asking me to invest in his business, and I just don't really have the time or funding..."

I was livid. It was one thing to hound me to believe in him and invest in his plans. But again, he was going behind my back, talking to my friends, whose politeness he mistook for interest. So when my lawyer friend texted to let me know she was happy to offer legal advice but she wasn't interested in funding his idea, I blew up at my dad, just hours before flying to New York.

"I can't believe you did this AGAIN." I raised my voice. "This is not okay. Don't talk to my friends, and don't ask them for money!"

"I did not ask for one cent," my dad raged back. "She said she was interest. She told me to email her. Why she say to email her if she not interest? She waste my time. And now she tell you I ask for money? I never ask for one penny I tell you!"

"That is not the point! You don't understand. People are just being nice. They don't want to tell you they're not going to invest in your ideas. She forwarded me your email. I read it myself!"

Now it was my dad's turn to be furious. He was insulted that my friend had dared to share his email with me. In his mind, she betrayed him!

He wrote her an email admonishing her for getting him in trouble,

which she also shared with me. I wanted to crawl under a rock. This was a very good friend. I was seething.

"Why are you even talking to my friends about investing, Dad?"

And that's how he ended up storming out of the house, accusing my friend of being a liar, and blaming her for telling me about his imposition.

This last-minute confrontation was not what I needed. I was already emotional about leaving the West Coast. Instead of joining my mom, Brian, and the girls to take me to the airport, my dad drove off and disappeared.

"Big hug for Mommy." I squeezed each of my daughters tight.

"Love you, babe," my mom said, hugging me. "Forget all that with Dad."

I fought to keep all the tears inside so the girls wouldn't see me crying.

"Bye, Brian." I kissed him. "Love you so much. Take good care of everyone."

He was upset. "This is not right, Vicky."

I shook my head.

"Not now. Let's talk later, I don't want to start crying," I said quietly.

He reached down to give me another hug. "I'm so sorry. I love you. It's not your fault."

"Okay, guys, Mommy has to go. I love you *so* much. Be good for Daddy. I will call you tomorrow from New York, okay?"

I turned and pulled my suitcase through the automatic glass doors. "Mwah mwah love youuuuu!" I said in an overly cheerful voice to mask the deep anger, sadness, and guilt I felt after another blow up with my dad. I didn't say goodbye to him or talk to him for weeks. Our relationship was damaged, and every time it seemed like we patched it up enough to keep moving forward, something else would rupture and leave it even more fraught and fragile than before.

As soon as I turned my back on my family, the tears fell. My emotions erupted and came out in uncontrollable sobs. All I wanted was for my parents to be healthy and happy. I didn't need my dad to "make it all back" or start a superstore. I wanted to take care of them. I wanted him to chill so I could financially protect them. He had done enough. We had enough. Don't try to add anything, I wanted to tell him. Just stop subtracting.

Even though it had been eighteen years since my parents sold the Windsor, I was still walking the tightrope between being a respectful daughter to my parents and a responsible provider, not only for them but for my three daughters. I was the Dutiful Daughter. I didn't have the right to tell my dad what to do. He is his own person with his own ideas, dreams, and priorities. But it didn't absolve me of feeling angry. Once again, I was the bad guy because I had confronted my dad. Alone on the plane, I turned toward the window and cried.

In April 2019, four months after surviving the NBC interview process, I was alone in a midtown Manhattan apartment, where I would live until the girls finished school. The unit was on the top floor, forty-three stories up. My ears popped in the elevator. In the morning, I would start work at NBC News, home to the iconic *Today* show and *Nightly News*.

My first FaceTime call was to Brian and the girls. "Hi, guys—check it out. It's nice. Good size, and someone comes to clean it once a week."

"I wanna see!"

"I can't see!"

"Let me see!"

The girls were curious about New York, and this was their first glimpse of our family's new adventure.

I held my phone up and panned around the room.

"I wish you were here! Let me take you over to the window. Can you see? I think that's the Statue of Liberty. Love you so much and miss you already."

As much as I wanted to show my mom the new apartment, it had been less than twenty-four hours since my argument with my dad, and I was not ready to face him. Instead, I texted my mom: "I'm at the apartment and everything looks great. Unpacking and will call you later this week." I knew she'd understand. This wasn't the first family rodeo where my dad and I had locked horns, and it wouldn't be the last.

49

30 Rock

I compartmentalized the family drama. I had to focus on my first day at 30 Rockefeller Plaza. My new bosses and team of producers deserved my undivided attention.

If there was a meter to measure the pressure I felt, it would have been pulsing close to the "red terror alert" level.

Even so, I was elated to be at the network. It felt like putting on the glass slipper and having my heel click into place. I fit in, and I was ready to represent. My last name, the most common among Vietnamese, would now be on TV almost daily, a cue to all my people that another one of us was making good on our opportunities.

"Hi, it is amazing to finally get here and join this team," I said to Jamie Nguyen. How serendipitous that another Vietnamese American woman, a rarity in this business and especially at the network, would be the coordinating producer of the consumer team. And while we weren't related, we would quickly develop an efficient workflow and easy professional compatibility.

"We are so excited you're here!" Jamie welcomed me and introduced me to the rest of the team, producers Joe Enoch, Conor Ferguson, and Lindsey Bomnin, and our associate producer, Michelle Tak. They were the Navy SEALs of TV producers. Every single one brought a level of

enthusiasm and competence to the job that exemplified what I expected at the network level.

Inhale.

 Exhale.

 Be present. You're about to do it . . . the Today *show . . . America's number one morning news program. How many millions of viewers? Forget that. You're good. You got this. You—*

"Vicky? Hi, right over here is where you get miked."

I snapped out of my mental pep talk and followed the stage manager to get my microphone clipped onto my dress.

There's someone here to do this? I thought. In local news, I always put on my own equipment.

"Okay, just wait here, and we'll come get you," another person said.

I stood in the narrow hall, peeking into the set. This was the famed Studio 1A. I could see a crowd of people standing behind anchors Savannah Guthrie and Craig Melvin on the other side of the giant glass windows, holding signs and waving at the cameras. It looked just like it did on my living room TV. But now I was here—in real life.

Started from the bottom now we here. Drake floated through my brain, an internal soundtrack for this moment.

My heart was beating faster than normal because of the adrenaline and excitement, but I felt weirdly calm. *This is not your first rodeo. Forget that it's a national audience of millions. Just remember your boss: it's the viewer. Tell them the story like you'd tell it to your mom. Go slow. Be conversational. Smile.*

I half hopped into the tall white leather chair on wheels and *zip*— someone scooted me forward to my mark on the news desk. *They have people to push my chair in?*

I sat down across from Savannah and Craig, they turned and smiled; their warmth steadied my nerves and helped me relax.

"Welcome to *Today,* Vicky!" Savannah said brightly. "How are you liking it here in New York?"

"Vicky, great to have you." Craig nodded. He was filling in for Hoda Kotb while she was on parental leave.

We made small talk, my mind switching gears between being star-struck by these journalists and being professional. I didn't have to do that tango for too long. The commercial break ended, and it was time for my first live report. *FOR THE* TODAY *SHOW!*

President Trump had proposed a new round of tariffs on goods from China. The *Today* producers wanted me to deliver a report about what the tariffs would mean for American consumers.

"We're back in ten . . . nine . . . eight . . ." the stage manager called out.

I sat up in my chair, focused on Savannah and Craig, and let my reporting muscle memory take over.

"This morning on In Depth *Today,* the escalating trade war with China." Craig introduced the segment out of the commercial break, the camera slowly pushing into a two-shot of him together with Savannah at the news desk.

"That's right, American consumers could be hit the hardest"—Savannah picked up the rest of the introduction—"paying more for everything from everyday items to big-ticket purchases. Our new investigative and consumer correspondent is Vicky Nguyen, who's here with more on this important story. Good morning, Vicky, welcome to NBC." She teed me up with another encouraging smile.

The director cut to a three-shot on a different camera. There I was, in my fuchsia Ted Baker dress, screen left.

"Thank you so much. Yes, it is. It affects all of us." I turned to my main camera, the single shot. "This tit for tat over tariffs is putting consumers right in the middle of a trade war . . ."

In just over three minutes I was done. It was a no-frills news report delivered smoothly. A producer and I had shot the piece in New York City the day before—gathering video of coffee and groceries, kids' clothing, and electronics. I shot stand-ups talking about how these items could see price hikes if the tariffs were put in place.

This story wasn't the original plan. I was *supposed* to come on *Today* for the first time with a much a splashier piece we'd shot in Costa Rica

investigating the growing trend of women traveling solo. But in true news fashion, current events derailed us.

I took a deep breath as I left the set, smiling at the camera operators, grips, and stage managers, whose names I would try to learn quickly. Each new segment or commercial break prompted a whirling dervish of activity. Anchors stood up to move to their next spots in the studio. Props managers rushed in with pedestals full of products and food. Others maneuvered the furniture, carrying in giant sofas and placing coffee tables in position. People with headsets directed the next group of guests into their chairs. There were so many people in this space, and they all moved with purpose. Everything was on wheels, nothing was permanent. An appropriate metaphor for TV journalism.

As I waited for the audio guys to remove my microphone and IFB, the little box that connected to my earpiece and allowed me to hear the producers in the control room, I allowed myself to have a moment and absorb what just happened.

I had appeared for the first time on the iconic *Today* show. Me, Vicky Nguyen, a Vietnamese refugee, fresh off the boat as a baby. A kid who grew up in California thinking she'd be a veterinarian like every other little girl who loved animals. I never thought to aspire to "network correspondent."

In that headspace, my heartbeat slowing back to normal, I realized I didn't have those "new kid," first day of school jitters. I was buzzing from meeting Savannah and Craig and walking onto the storied *Today* show set. Was I really going to be coming here a few times a week to report on consumer issues to a national audience? I felt like a spoonful of instant coffee sprinkled into a cup of water. I dissolved right into the flow of the show and marveled at how friendly and comfortable it felt.

Yes, it was totally bananas that I was at the *Today* show. If lightning struck me in that moment, at least I would have died knowing I tried my hardest. Nineteen years of grinding through the ups and downs of local news had gotten me a spot on the network at NBC News.

50

Pura Vida

A few weeks into the job, our producer Lindsey Bonnin sent me a text.

What size shoe are you, Vicky?

We had a few days before we had to leave for a shoot in Costa Rica. Lindsey and I were going to shoot the feature piece on women traveling solo that was to have been my first story on the show, and that meant taking off for an international shoot. We wanted to take as little as possible and document the experience of women traveling on their own. Lindsey would do all the shooting using a combination of our phone cameras and GoPros.

"I'm going to REI, and I'm going to get us some water shoes," her text said. "Make sure you get a bathing suit and some comfortable clothes for the waterfall hike."

When I moved out to New York, I'd shipped out a couple boxes of dresses, suits, skirts, and shoes to wear on air. But I didn't have any of the gear needed for a trip to the jungles of Costa Rica, and I certainly didn't have a bathing suit to wear on air.

"Put it on the corporate card," the senior producer, Jamie, told me. "You need this for the shoot."

I was definitely not used to this environment. We had a comfortable budget for every network story, and we were encouraged to get the sup-

plies we needed—including water shoes—to ensure the shoot looked professional. I responded to Lindsey, "Thank you so much for getting me some shoes. I'm a size six."

Thanks to my team's capable and thorough initiation into the ways of the network, I got up to speed quickly. I had never met so many twenty- and thirty-somethings who were savvy travelers and sophisticated professionals. They had TSA PreCheck. They were members of CLEAR. They had current passports that contained many stamps from both their personal and their professional travels.

Many of them had never worked in local news, so they were used to having resources and huge crews and multicamera shoots. I was a local yokel, marveling at the way we shot stories for *Today* and *Nightly News*. I had worked with incredibly talented producers before, but we were generally on much leaner budgets with different production standards.

"Act like you've been there" has never been my motto. I always wear my awe and wonder openly. "Wow, I've never been here."

My exhilaration about being at the network intensified when I was back on set to deliver the Costa Rica story. It was my second *Today* show report, and it was more than six minutes of network TV time. This time, Savannah and Craig were joined at the big round table by Jenna Bush Hager, Dylan Dreyer, and Al Roker.

"When does your family come to New York?" Savannah asked me. "She has three girls, Craig!" she went on.

"Aww, how old are they?" Craig asked.

"They're ten, seven, and three," I answered. "They're all coming at the end of summer break in August."

"Good! Enjoy the city while you're here without the kiddos!" Savannah winked, giving me advice I took fully to heart.

"We're back in ten, nine, eight . . ." The stage manager counted us out of the commercial.

I introduced my piece and sat as everyone watched me living the

Pura Vida in Costa Rica, giving tips about which hotel floors women should stay on, how to protect your drink from being spiked, and places to stash your ID and valuables.

The report ended and the cameras came back to our table. We talked about times we'd traveled solo ourselves, and Savannah gave me one little ribbing. "You know, not all of your assignments will be like that, Vicky."

We all laughed. I was unsure exactly which camera to turn to or how to get off my white leather chair when I caught the stage manager's eye and he motioned for me to stay put. We were going to a commercial, but first Savannah had to read a tease about the next segment, featuring Tim McGraw and Samuel L. Jackson.

I glanced over to where they were standing and realized they were casually walking toward us. Suddenly, I felt a hand on my shoulder. It was handsome Tim McGraw! The country singer nodded and smiled at me like we were old buddies. My brain was not quite computing quickly enough, and I wanted to look around like *I like it! I love it! I want some more of it!* McGraw lyrics aside, my professional brain knew we were live on air and kept me calm, as though I'd been touched on the shoulder by the country legend a million times.

That was the *Today* show in a nutshell. Live TV, where anything can happen.

Those first couple months transitioning to the way we operated at the network level were heady and thrilling. I was in my zone working with people who taught me and inspired me. Months later, when *Today* invited me to the show's annual Christmas party, I asked for a photo with Savannah and Hoda, my gift to myself.

"Heyyyyyyyyy, Vic! Best. NBC. Hire. Ever," Hoda proclaimed, using my nickname like we were old pals. I literally fell to the ground dramatically. I was never more sure that I had made the right career move.

During those early months when I was in Manhattan alone, Brian was holding down the fort with my mom, dad, and the girls. He was enjoying the last few weeks of his Dream Job and dreading the move.

"How are you feeling, Brian? You okay? This is really happening." I checked in often from my corporate apartment, trying to gauge the level of his grief over this life change. Everything was perfect and exciting for me, and he was about to be ripped out of the only state he'd ever lived in, not counting his residency year in Arizona. More important, we'd no longer be just a ninety-minute drive from his parents and his brother, Mike.

"I mean, it's gonna have to work. It's fine." His voice was neutral.

I gave him space, figuring once he got to New York, and we were all together again, it would be a Family Adventure to Remember.

For Brian, it was more like being on the *Titanic,* sailing slowly toward the iceberg. Making matters even worse, he was enjoying the best working life he'd ever known. He was only a few months into his dream job, where new partners eased their way onto the schedule. He had plenty of time to work out at the gym and pick up his favorite foods: falafel, poke bowls, burritos. Life in California had never been better, and he was in a rip current pulling him east to New York, where he would have to make connections and find a new job quickly.

He had flown out a couple months after I started work to go apartment hunting with me.

"This is going to be an awesome weekend," I said as he lifted me off the ground in a big bear hug. I was in shorts and a T-shirt, still dressing like a California girl in the big city, except I had on Uggs. No open-toed shoes to walk around New York—ever. It was a glorious June day, and we had several apartments lined up to visit.

"Welcome to New York, it's been waitin' for you." I sang my Taylor Swift anthem to him as we waited for the Uber from JFK Airport.

"I can't believe I'm here." He sighed, taking in the traffic and the thick stream of people leaving the airport, headed in all different directions.

"You ain't seen nothing yet, Bri."

We toured apartments in Tribeca and on the Upper West Side. But when the broker took us to a nineteenth-story apartment on the Upper East Side, we knew it was the place.

It was a combo unit—someone had knocked down the walls between two adjoining apartments and turned one of the kitchens into a bathroom-bedroom suite. It was ginormous, especially by New York standards: 1,900 square feet with five bedrooms.

"Wow, look at this view, Brian," I said, stepping onto the balcony. To the west we could see Central Park, to the east we could see the East River. The apartment had two main bedroom suites with bathrooms, and they were on opposite sides of the building.

My parents would live with us once again. But this time, unlike in Phoenix, we would take the bigger room, because it had a walk-in closet that could accommodate most of my TV wardrobe, and another big closet I could share with Brian. The timing was tricky though. It was still June, and we didn't need to start renting a place until August, when the girls would be coming out.

"How long has this unit been on the market?" I asked the broker.

"A few months. It's a big one, and not everyone needs all this space."

"Okay, well, we don't need to start paying rent until everyone gets here in a couple months," I said. "So let's keep in touch as we get closer." I wanted to have some leverage to negotiate the rent down a bit.

"I can't promise you it will still be available . . ."

"We understand," I said.

By August, it was time to pack up our dream home in California. While I was working and living the solo life in Manhattan, Brian was in charge of overseeing the entire move.

"We need to sell the living room stuff, couch, two chairs. What about the coffee table?" he asked.

"Keep that. We can put it in our room," I answered. We were on a video call walking through the house deciding what to put on Craigslist and what to bring.

"What about the kids' stuff? We're selling Emmy's and Odessa's beds, right?"

"Yep," I said.

Our eldest daughter, Emmy, was going to have a new desk–loft bed combo to maximize the space in her new apartment bedroom. Much to Renley's delight, the baby of the family was going to share a bunk bed with her big sister Odessa, who had agreed to the arrangement because she was getting the top bunk. My intrepid girls were ready to embrace their new lives.

We signed a rental agreement for the Upper East side combo apartment.

"I never thought I live in New York City," my dad mused. "I thought I live in California till I die."

Before accepting the job at NBC News and the farewell blowout with my dad, I'd talked to my parents about the move. They'd been all in from the beginning.

"If you get this job, we all moving?" my dad asked.

"Well, that's up to you," I replied. "Of course, I want you and Mom to come and keep helping us with the girls, but if you want to stay in California, we'll make it work."

"Yeah, right," he chuffed.

"Mom"—I turned to her—"I'm serious. What do you think? You have the rental here. You can come visit, and we will come back to California to visit, of course. How would you feel about living in New York City?"

"I go," she said simply.

There it was again. "You go, we go" was my parents' motto, even though it caused friction because my dad felt beholden to my career. And now my career was moving us thousands of miles away from Silicon Valley, away from the Vietnamese community in San Jose, where he played chess with his friends and did his weekly grocery runs.

But ultimately, there was no debate. We were doing this together.

They say time heals all wounds. In my case, time and the practical de-
mands of moving three children, a husband, and two Asian grandparents
to New York simply meant my dad and I were back on speaking terms.
Never complain, never explain. We didn't address what had happened
the day I flew to New York, and there was no need to. It was in the past,
and now we were faced with the matter at hand: unwrapping couches,
beds, chairs, and tables, and unpacking hundreds of cardboard boxes
labeled KITCHEN and DON'T OPEN UNTIL VICKY HAS OFFICE.

"How many more boxes?" I panted.

It was August in New York, and my parents and the girls were finally
all in our deluxe apartment in the sky. While I had escaped the tough
work of packing in California, I didn't escape the equally, some might
say more difficult, job of unpacking everything in New York.

Brian was supposed to help, but the moving truck was delayed by
several days. By the time it arrived, my husband was already back in
California, living in a casita in our friends' backyard. He still had a few
weeks of work before he could join us for good in New York City. That
left my mom, dad, the girls, and me, nineteen floors up in a new apart-
ment. My mom was in charge of watching Renley and making sure none
of the girls got squashed by the movers, who kept bringing boxes in.

"We have to find kitchen stuff first," my dad said, wanting to be sure
he would have everything we needed to cook dinner. He surveyed the
growing numbers of boxes piled nearly to the ceiling. We couldn't see
each other over the mountain of cardboard.

"Sounds good," I called back, willing to let him take the lead. My
dad and mom were here, the three of us unpacking and starting fresh
like we had so many times before.

51

The Viruses

Our entire family was finally together in October 2019, when Brian joined us. We'd sold our cars in California, figuring we'd be riding subways and discovering the city on weekends. But between the winter snow and the arrival of Covid-19, our plans for exploring New York were put on an indefinite and alarming hold.

On Friday the thirteenth of March 2020, management at NBC News sent out a message instructing us to work from home until further notice. My producer, Jamie Nguyen, and I got the email when we were at lunch at a Chinese restaurant. We wanted to support businesses that were already seeing a drop in revenue as fears about the new virus from China spread. Our kids had also been told to stay home. The public schools in Manhattan were cautiously optimistic they'd be able to return to class soon, but no one knew when.

For the first several weeks of the lockdowns, I was the only correspondent coming into 30 Rock to deliver my live reports. Only essential businesses were allowed to remain open, and in New York, the media was included in that classification.

Hoda anchored *Today* from the studio while Savannah coanchored from a makeshift news desk installed in her home. Al Roker did the weather reports from his kitchen. The NBC News engineers were

incredible, "MacGyvering" temporary teleprompters, cameras, lights, and studio backgrounds. Every day it seemed we were trying something new. Gone were the audio technicians who gracefully put on my mic and IFB pack. Only one camera operator remained. Hair and makeup artists were sent home. The famed *Today* show plaza was a ghost town.

I came in early in the morning, got myself camera-ready, clipped on my audio equipment, and delivered my reports. It was just Hoda, our camera operator, and me in the studio. The initial days were somber. We reported on the rising numbers of Covid cases and deaths. My job was to keep up with the CDC recommendations and warnings from health experts. Our team was constantly researching and talking to doctors and epidemiologists. We explained all the new terms this disease had spawned: "social distancing," "pandemic pods," "six-foot rule."

We reported on what we were all living through in real time. We tried to answer the questions we were all asking ourselves: How should people mask? Where can we find masks? How can we avoid being scammed by unscrupulous sellers of gloves and antibacterial wipes? Are air purifiers worth buying? What the heck is a face shield? Do we need to wipe down our groceries and packages before bringing them inside? We tried to give people useful information without paralyzing them with fear about stepping outside.

Two mornings we were so strapped for on-air talent that the executive producer asked if I could sit in with Hoda to cohost the first block of her show at 10:00 a.m.

"How long have you been here?" she asked me as we were waiting to go on air.

"Since April," I replied, understanding that I wasn't the only one mystified by the situation. I was briefly filling in as an anchor on the *Today* show. It was surreal on so many levels; this would never have happened under normal circumstances.

Meanwhile, Brian was at Lenox Hill Hospital, where they had to park refrigerated trailers outside to serve as temporary morgues. Initially he was sent home because so many surgeries were canceled, but then as the pandemic intensified, the hospital became a Covid care center. It

was all hands on deck. Nearly every room was turned into an intensive care unit—crowded with infected patients. The hours were grueling, and anesthesiologists were at high risk of contracting Covid because of the nature of their work—intubating patients and dealing with respiratory issues. This was not the New York experience I had envisioned for my husband.

Despite the repeated warnings about only going out when absolutely necessary and limiting contact with others, my dad was at the Morton Williams grocery store at least three times a week. He would forget onions that he "needed" for his meal, or he had to get some other fresh vegetables that simply couldn't wait.

"I have my mask. I wash hands. Calm down," he said. He insisted he was taking precautions.

It was a constant source of tension in the apartment. Brian, my mom, and I thought of Covid as life-threatening. We heeded the public health warnings that were on TV daily from Governor Cuomo. But to my dad, Covid was mainly inconvenient.

I had concerns about my dad leaving the apartment that stretched beyond the potentially deadly virus. By April 2020, Asian Americans were not only suffering from the coronavirus but also being targeted by what I called the "racism virus." Xenophobic rhetoric fueled a wave of unprovoked verbal and physical attacks against anyone who looked Asian.

In just one week in March 2020, the nonprofit Stop AAPI (Asian American Pacific Islander) Hate received more than 650 reports of racist attacks against Asian Americans. Founders of the organization launched this new online forum to give Asian Americans a place to report harassment and abuse. Stop AAPI Hate grew into the nation's largest reporting center tracking the hate acts.

I started to see fellow Asian American journalists like Lisa Ling, CeFaan Kim, Dion Lim, Janelle Wang, and Betty Yu posting on social media and writing op-eds, particularly in the Bay Area, where I grew up,

and where hate crimes against Asians were already in the news before the pandemic.

CBS News White House correspondent Weijia Jiang reported that an administration official called Covid-19 the "Kung Flu" to her face, sparking a Twitter flurry. Some supported her. Others called her a liar because she wouldn't identify the person. I had no doubt she was telling the truth.

Until the pandemic, I abided by one of journalism's golden rules: cover the story, don't become the story. But when I kept seeing videos of Asian elders who looked just like my parents being pushed to the ground and beaten, sometimes attacked so violently that they died from their injuries, it instilled a new fear in me. I'd never worried about my safety before in this way, and I certainly had never been fearful that my parents would be targeted simply for walking while Asian.

It was hard to compartmentalize the reporting from my personal life.

I started to think about all the times people put me in a category or judged me because of how I looked. Usually no one can even figure out "which type of Asian" I am. Thai? Chinese? Korean? "Ohhhhh Vietnamese, but you look more Filipina." "But where are you *really* from?" It's a conversation I've had more than once.

I never forgot the neighborhood boys singing, "We are Siamese if you please," while pulling their eyelids up and making faces at me. Many times I was reminded of my race when I was trekking around Orlando shooting my own stories and people would drive by and yell, "Hey, it's Connie Chung!" When I anchored the news in Reno, several viewers emailed the station saying, "Why can't she speak English?" I knew I spoke fast when I was on air, but it was definitely English.

Although these incidents were embedded in my memory, at the time they happened, I shrugged them off. Growing up, I ignored what my race did or didn't do for me. It was simply a part of me, immutable. If someone treated me differently for my skin color, gender, or refugee background, I found ways around them. My philosophy for most of life was just like my parents': Don't stress about the things I can't change. Spend energy on the things I can.

But the communities I reported on didn't have the same luxury to shrug off these attacks. As a journalist, I knew it was my duty to spotlight this disturbing trend for people who didn't have the same platform or armor to speak up.

I filed stories for *Nightly News* and *Today* about the rise in anti-Asian racism. I reported on the FBI warning about hate crimes against Asian Americans. As the weeks went by, there were so many heartrending and powerful personal accounts. My dear friend Lisa Sun, a Yale graduate and CEO of the clothing company Gravitas, was spit on while walking in Manhattan and told to "go back to China." Her mostly Chinese staff of seamstresses was afraid to come to work because they were harassed on the subway. Dr. Chen Fu, who went to work daily to save lives during the height of the pandemic, was attacked on his commute with racist slurs—"You dirty Chinese, you damn Chinese"—until bystanders stepped in to defend him

That gave me hope. We had allies.

I reported on the Black and Gold movement, a long-standing group of Black Americans and Asian Americans working together to combat racism, especially the kind that pits people of color against one another. I hosted an hour-long special called *The Racism Virus* that streamed to one of the largest live audiences in *NBC News Now* history and hit a million YouTube views shortly after it was posted.

Developed and executive produced by Jamie Nguyen and a diverse staff at *News Now,* the show featured NBA player Jeremy Lin, groundbreaking comedian Margaret Cho, *Survivor* winner Yul Kwon, and actors Daniel Dae Kim and Olivia Munn. These influential Asians talked about their experiences breaking through the controversial "bamboo ceiling" in Hollywood and the NBA as well as the painful experiences of Asian hate they endured growing up.

Nobel Prize nominee and founder of the civil rights organization Rise, Amanda Nguyen, spoke about leveraging social media to launch the #StopAsianHate movement and call attention to the vicious racist attacks that weren't getting the same media coverage as other news events.

Russell Jeung from Stop AAPI Hate spoke about how important it

was to collect data on what was happening. You can't manage what you don't measure. Asian Americans were speaking out.

As much as I tried to just focus on the facts, there was one moment that nearly broke me on air. The night of March 16, 2021, I picked up my phone for one last check of the news before going to bed because I had a story on *Today* the next morning. That's when I saw the headlines about a mass shooting in the Atlanta area.

A deranged man deliberately traveled to three different spas, shooting and killing eight people, six of them Asian women. I went to bed furious and deeply sad.

By the next morning, as more details emerged, I couldn't get the victims out of my mind. It was another nightmare mass shooting, but this one targeted Asian women at their places of work. Meanwhile, I was tucked away inside Studio 1A, alive and safe, and it all seemed so unfair. Why had this happened? Was this a hate crime? How much more could the Asian American community take?

When I walked into the waiting area ahead of my live shot, our stage manager Zach gave me a friendly smile and said, "Hey, how ya doing?" But instead of my usual cheerful reply, I just gave him the "so-so" gesture with my hand. I bit my tongue and turned away, knowing that if I said aloud "I'm not doing so hot," I'd lose it.

But I couldn't avoid Hoda. She looked right into my eyes when I walked on set. There was no masking the sadness I had from the accumulation of seeing and reporting on dozens of violent acts against Asian Americans for the past thirteen months in the middle of a worldwide pandemic. All the stress and emotion I thought I'd been managing was no longer controllable.

She saw it in my crumpled face when I didn't smile back or say, "Good morning." I just kept my eyes focused on the camera and teleprompter, still biting my tongue to prevent any tears from escaping. In my peripheral vision, I could see Hoda waving to the other anchors and letting them know I wasn't myself. She locked in and just knew that I wasn't okay because of what was in the news that morning, and she instinctively protected me. I didn't make eye contact or speak to

anyone. As soon as my segment on family travel deals was done, I rushed off the set into the bathroom and sobbed. I was still wearing all my TV equipment. I had a long cry.

Over the following weeks, I heard from so many colleagues at *Today* and throughout our newsroom. People checked in and offered their genuine concern and support. I hated to be vulnerable in this way because I didn't want to appear overly emotional.

But eventually, I understood that accepting support didn't signify weakness. I was so inspired by the activism in our community. The hashtag #StopAsianHate was all over my social media feeds. The Asian American Foundation (TAAF) formed to raise money and awareness for groups working on Asian American social issues and to harness the collective power of our diverse community. Organizations like Gold House and Asian Americans Advancing Justice gained momentum and rallied to keep the spotlight on representation. I felt like we were being seen and heard in a new way in mainstream media.

Asian Americans are stereotyped for being "model minorities." We try to "go with the flow," as my parents taught me. Refugees don't have the privilege of protesting or demonstrating because they are too busy working and surviving.

Because of that, many in my generation grew up not knowing much about our rich history of activism, which Helen Zia writes about beautifully in her book *Asian American Dreams*. Filipino American Larry Itliong came to the United States when he was a teen. He later advocated for laborers in Alaska, Washington, and California, where he met fellow activist Cesar Chavez. Racial justice and human rights activist Yuri Kochiyama, a Japanese American woman, was a political ally and friend of Malcolm X.

As I shared these stories on various platforms, I leaned more into my own identity. I gave myself permission to bring my entire self to work. People began to understand the gravity of the situation and the urgency of addressing anti-Asian hate.

We all have a sphere of influence. Whether it's your family and friends, people you work with, or millions of social media followers,

you can choose to foster empathy and understanding in your everyday actions. As journalists, we have a responsibility to use our platforms to combat misinformation and amplify marginalized voices. Sometimes adding our own voices and personal stories can make the message even more powerful.

52

The Dream Team

Groggy, Brian checked the time on his phone. 5:01 a.m. Still another forty-four minutes until his alarm for work. My mom was knocking on our door. She came in and said in a low voice, "Brian, Huy hit his head. Huy . . . he fell."

I, being a heavy sleeper, didn't quite catch on until Brian was sitting up in bed, stepping into his slippers. I could hear him talking to my mom as I slowly opened my eyes.

"Liên, what's going on? Where is he?"

"In the room, Brian," my mom said. "I don't know what happen. He hit his head."

That snapped me awake. I went from 0 to 100. "Brian, my dad hit his head!" I panicked as I processed what my mom had said, except I was two steps behind.

Brian and my mom raced toward my parents' room at the far end of the apartment, talking in hushed tones because the girls were still asleep. I slid into my Ugg slippers and hustled to catch up.

"Huy, what happened?" Brian asked my dad, who was sitting slumped on the floor, his back against the bed. In the lamplight I could see blood all over his face from a gash on his forehead.

"Dad, oh my God, what happened?" I was in full freak-out mode.

"Brian, he's bleeding!" I was Captain Obvious, reporting live on the scene that Brian could clearly see in front of him. "There's . . . so much . . . blood!"

"Liên, call 911," Brian calmly instructed my mom. He knelt in front of my dad, examining his face. Dad gazed off into the middle distance.

I tried to talk to him. "Dad, are you okay?"

Suddenly, the blood drained from my head. Seeing my dad limp on the floor, blood streaming out of his head, was too much. My legs detached from my body.

Brian looked over his shoulder when he heard something bump the wall. It was me, sliding down in slow motion, my eyes rolling back in my head.

"Oh my God, Vicky." He sighed. He came over just in time to help lower me onto the floor, where I fell in and out of consciousness, a pool of urine beneath me. Apparently, I fainted *and* lost control of my bladder. So helpful.

At that point, my mom handed the 911 dispatcher over to Brian. She paced, tsking, shaking her head, worried about my dad, and now me, since I fainted. She was second in command, ready to help Brian and take care of the girls when they woke up.

The sun started coming up as I came to, wondering why I was lying in the hall with my pants all wet. Brian told me my dad had hit his head on the nightstand and fallen to the floor. He was going to the hospital to get checked out. Brian would ride in the ambulance with him, a first for both of them.

"Are you calling your work?" I asked, concerned because Brian was relatively new and hated to miss work, knowing it would make the surgery schedule that much more grueling for his anesthesia partners.

"I got it, Vicky. Go change. The ambulance is coming," Brian said. I heard the wailing sirens approaching.

I was wide awake now, but the girls were still sleeping soundly, oblivious to the scene unfolding in our apartment.

The doorbell rang and in walked the firefighters and EMTs. It was straight out of a *Law & Order* episode: men in full firefighting gear,

carrying a stretcher and stomping through to the bedrooom to rescue my dad.

For some reason, a second ambulance was called, and the traffic blocked our one-way street for an hour. Ironically, the trucks prevented patients from getting to their appointments at the hospital where Brian worked, only two buildings down. When Brian called to explain our emergency, his boss was understanding in part because the medical office had a front-row view of the commotion. "If you look out front—those ambulances are for my father-in-law. He hit his head, and I need to go with him to the hospital," Brian said.

It would have been scarier, but my dad perked up quickly after they got him on the gurney. The shock from his fall wore off, and he was fully awake in the ambulance.

Brian chuckled when he told me the moment he knew my dad would be fine. "He was talking during the whole ride."

"Brian, you have to call in sick today? Day off work, huh? Not so bad."

"This happen a few time before. I black out before but never hit my head like this."

"I guess I need to move the nightstand away from the bed. The corner sharp."

"I wonder how much this ride cost."

My dad got fourteen stitches down the middle of his forehead, just a centimeter from the scar left by his run-in with that jeep fifty years earlier in Sài Gòn. He underwent a battery of tests and scans on his brain. Everything came back normal.

It scared me, this early morning emergency, which came out of nowhere and concluded with no full explanation that we could dissect to prevent a future recurrence. I thought about how my parents were getting older and what would have happened if they hadn't been just down the hall.

My dad came back home late that night, black stitches running down the front of his face as if he was a Tim Burton character if the director cast Vietnamese grandpas. "Dad, that was so crazy. Like, you had so much blood on your face. Do you remember hitting your head at all?"

He didn't. My dad said he woke up early, sat up, and the next thing he remembered, he was on the floor, bleeding from his head.

He blinked and raised his eyebrows, shrugging. "It happen. From time to time, all my life, I pass out, but no one know why." He shook his head, thinking of how much worse it could have been. Then, he concluded that he'd come out on top. "Lucky it's miss my eye," he said, and smiled.

Even with a massive gash in his face, after a long day of needle pokes and scans, my dad was the same. I was relieved. We also learned that I don't respond well in emergencies involving lots of blood. But Brian and my mom worked together like pros, remaining calm and self-possessed, wired to take care of this family.

As refugees, my parents and I have become familiar with the uncertainty of evolving in new spaces. That discomfort has given me something singular and valuable, like a tiny piece of grit that irritates the tissue inside an oyster but eventually forms a pearl. My pearl is understanding what it took to get here, literally. I don't take my life for granted because I know my history.

In 1979, a brave captain navigated by the stars across the South China Sea and brought this boat baby to freedom. As I was growing up, my parents willed the stars to align again and again by their will to survive and provide. Through their struggles and successes, I have learned how to grow as a daughter, a wife, a mother. One constant in all the tumult: family, and what it takes to be one.

Letter to My Girls

Dear Emmy, Odessa, and Bonley,

While I dedicated this book to Grandma Liên and Grandpa Huy, I wrote it for you girls too. It took me a long time to evolve from "woman with children" to "mother," but I now feel officially qualified to call myself a mom. I have a long way to go when it comes to raising you into confident, self-assured, generous, kind, resilient human beings, but I want you to know how deeply you're loved.

Unlike your daddy, who I fondly refer to as the real MVP, "Most Valuable Parent," I did not grow up thinking what a great mother I'd be or how I couldn't wait to have kids to teach them all kinds of things—like how to do a crossover in basketball or pack a suitcase perfectly. I was fully self-absorbed and never thought too far ahead. That's probably why I fancy myself a warrior and not a worrier. I focus on the challenges of now, and I'm content to let the future work itself out accordingly.

Every day, and I mean *every day*, there is a moment when I'm walking to the studio or I'm riding home on the train, or we're on a family dog walk, and I think about you, and I smile. I am most grateful for the gifts that are you.

Your smarts, your senses of humor, your descriptive stories, and your evolution keep me in a state of wonder at what's to come. You give me something to look forward to. What's life without that? You're also highly entertaining. You do a lot of what I say, and I enjoy that you

respect my "authoritah" as Cartman would say on *South Park* (which you're not yet allowed to watch).

You surprise me all the time—not just by popping out of duffel bags, but with your questions, curiosity, and observations. I have purpose as your mother. I think I actually do have some useful things to teach you as you grow up. Much of what I learned from your Asian grandparents is shared here, so now you have a reference. Next, we need Daddy to write his own book so you can better know that side of your family too.

I challenge you to approach your lives with confidence that there's no one like you, that your lives have limitless value, and that you can make a difference every day with your actions. Newton said objects in motion stay in motion, and that is my wish for you. May you move through life, learning and growing, and never giving up when things get tough.

I pray you know your strength, find partners and friends who support you, and leave people better than you found them. And always, always, know your mama loves you.

Emerson, Odessa, and Renley: Let's do our best, and forget the rest.

Mommy

Acknowledgments

Boat Baby was made possible by the contributions of so many people. First, thank you to my family, immediate and extended. You're all giving main character energy: Mom, Dad, Brian, Emerson, Odessa*, Renley, Uncle Quang.

To my acquired family Gary, Marilou, Mike, and Jason: I'm grateful every day I married into this clan. You have been part of my life since I was a teenager, and your influence has guided and shaped me in the best ways. I hope you know how much I love and appreciate you every day.

My aunts, uncles, and cousins—the extended family who never made me feel lonely as an only.

My teachers—all of you who've taught me through my life and especially Ms. Mansell, Ms. Michiels, Mr. and Mrs. Milkoff, Professor Robertson at USF, Mr. and Mrs. Hauth who taught me taekwondo, discipline, and confidence.

Dear friends mentioned in the book as well as those not: Kevin for keeping all my deepest and darkest secrets and always taking my phone calls even when you're stationed on the other side of the world.

* Thank you for proofreading my early drafts and being so interested in each version of the story.

Lisa Sun for being the ultimate book mother and life guide ever since I met you.

Jane Park for your generosity and early feedback to help me shape this book. Toan Lam for being the catalyst who helped me see I could pursue a career in journalism. The families: Do, Baty, Goldman, Su, Teng, Tsai, Zhu, Barnes, DeRousseau, Dorr, Gambino, Mincak, and Nakai for being the greatest to spend time with and compare parenting notes on both coasts. Joyce B: thank you for all your cover advice and hanging with me in Oneonta as I typed away.

The amazing team of people I work with at NBC News, *Today*, *Nightly News*, and my own show *NBC News Daily*, including Joey Cole, Sean Reis, Chelsea Blume, and Lindsay Garfield, I treasure my relationships with you and have learned so much from working with you.

The special effects team who helps me look my best every day and for my book photo shoots and serve as smart sounding boards for all of life's issues: Gina DiPentima and Madison Bermudez. You are the closest I have to actual therapy.

And to my extended hair and makeup family who look after me when Gins and Mads go on vacation: Dina, Vadee, Sonia, Adam, Suzy, Waltaya, Mary from *Today*, Mary from MSNBC, Laura, Kelly, Edna, Kim, Nicole, Deanna, Wilbert, and Bianca (Go Dubs). These professionals give the best advice and know everything. Everything.

Tien: You ensure I'm never late to a show or shoot and you tell me all the great spots to visit on the East Coast.

Traci Wilkes Smith: Thank you for representing me with integrity and ambition and encouraging me to aim big and try to land a book contract.

Peter McGuigan: You have been a book agent extraordinaire who answered my many questions, stepped in at all the right times, and injected some testosterone when it was needed. Your directness is deeply appreciated.

To the female-powered team at Simon & Schuster led by Priscilla Painton, who believed I had a story worth telling and who warmly welcomed me to the publishing world by giving me a book deal; Hana

Park for being an incredible editor who saw me through the ups and downs of what to include and why it would matter; and the following team members who contributed to so many details to ensure *Boat Baby* would have the best chance at success from the words to the beautiful cover, to the font and layout:

Samantha Hoback, senior production editor

Susan Brown, copy editor

Jackie Seow, art director

Amanda Mulholland, managing editor

Shannon Hennessey, publicity

Julia Prosser, associate publisher and publicity

Irene Kheradi, associate publisher

Elizabeth Venere, marketing

Paul Dippolito, interior design

Felice Javit, legal

Deborah Feingold for spending an afternoon taking my beautiful publicity photos and allowing me to say I worked with someone who also shot photos of Madonna, Tina Turner, Mick Jagger, Keanu Reeve, Lenny Kravitz, Lisa Bonet, Johnny Depp, Susan Sarandon, Bill Gates, Cyndi Lauper, etc. That's one degree of separation!

Thank you to the NBC folks who stewarded the book: Karen Toulon, Dominique Donahue, and Abigail Russ.

Special shout out to Hoda Kotb, Savannah Guthrie, Libby Leist, Tom Mazzarelli, Janelle Rodriguez, and Catherine Kim who have encouraged and supported me in ways huge and small since day one.

Al Roker, Craig Melvin, Sheinelle Jones, Dylan Dreyer: I've relished all my moments sitting with you as a "cousin" and our candid conversations during commercial breaks and mini-meetings where I ask you about how it's all supposed to work in this crazy industry. You never hold back.

My consumer producing team at NBC News: Jamie Nguyen, Lindsey Bomnin, Joe Enoch, Conor Ferguson, David Paredes, Lindsey Ashcraft, Michelle Tak, Merritt Enright, and Jean Lee. You allowed me to step into a Ferrari and see how fast we could go. You helped me build a strong

foundation in my network beginnings, and I'll always be rooting for you and grateful for our experiences together in the trenches.

Erin Farley—thank you for being a partner in producing all things *Boat Baby* and beyond.

The correspondents at NBC News who have my admiration and respect because they're at the top of their game and so inspiring.

My producing teammates and colleagues at NBC Bay Area, including Rich Cerussi, Stacy Owen, Stephanie Adrouny, Matt Goldberg, Bob Goldberger, Raj Mathai, Janelle Wang, Jessica Aguirre, Mike Inouye, Kris Sanchez, Tony Kovaleski, Elyce Kirchner, Chris Chmura, Kevin Nious, Michael Bott, Robert Campos, Liza Meak, Liz Wagner, Rachel Witte, Jeremy Carroll, Felipe Escamilla, Michael Horn, Mark Villarreal, Alyssa Goard, Raji Ramanathan, and Candice Nguyen, my protégé and former intern who is as inspiring as she is brilliant. Working with you all honed my skills in people management, pivot tables, digging through data, visual storytelling, and true, impactful investigative journalism. You are forever in my heart, and I wish you would leave California and come work with me but I totally get it, the West Coast is the best coast. (Don't @ me, people. The food in Cali is better than NY. I said what I said.)

Jonathan Dienst: That text led to a cascade of career and life highlights. I owe you chocolate forever.

Rich Greenberg and Robert Dembo: If there's no you saying "Hire this woman," there's no *Boat Baby* book with all these chapters about the network. You changed my life.

"Angel": You know who you are, and my family owes you a debt of gratitude for sharing information that made a material difference in my earnings for life. I am eternally grateful for your generosity and openness.

My team at CAA—Michael Glantz, Brian Jacobs, and Ali Spiesman: You've always been excited about my career and what's possible. Thank you for being in my corner. I'm looking forward to what's next.

Vicky Bruce! What are the odds I would hit it off so well with a co-writer by the same name? You brought out tremendous details from my

parents with your genuine curiosity and commitment to storytelling. You helped me organize my thoughts and my chapters, and you guided *Boat Baby* safely to the shore. You're a joy and delight and I thank you deeply for your kind and care with this first-time author.

Readers and viewers: You are the audience, and what I do doesn't really have purpose unless you're there. Thank you for introducing yourselves, sending emails, waving on the street, and taking selfies with me. All that talk about public service during my days at USF really imprinted on me, and I am jazzed I get to live up to that task every day in my work. As *Dateline*'s Josh Mankiewicz wisely advised me, the audience is the customer. And the customer is always right in the service business.

About the Author

Vicky Nguyen is an anchor and correspondent for NBC News and the *Today* show. Her reporting gives consumers valuable information for how to live healthier, wealthier, and safer lives. Vicky's dynamic story-telling has led to impactful changes at the local and national level and resulted in numerous awards, including a National Emmy, the Gerald Loeb Award for Business and Financial Journalism, and the duPont Columbia Award for Broadcast Journalism.

She graduated as valedictorian from the University of San Francisco. Vicky is based in New York, and when she's not working she enjoys spending time with her husband, their three daughters, and tiny dog Moose.